SECRETS OF
PROSHOW® EXPERTS:

THE OFFICIAL GUIDE TO CREATING YOUR
BEST SLIDE SHOWS WITH PROSHOW 5

Paul Schmidt

Course Technology PTR
A part of Cengage Learning

COURSE TECHNOLOGY
CENGAGE Learning

Australia, Brazil, Japan, Korea, Mexico, Singapore, Spain, United Kingdom, United States

COURSE TECHNOLOGY
CENGAGE Learning

Secrets of ProShow® Experts:
The Official Guide to Creating Your
Best Slide Shows with ProShow 5
Paul Schmidt

Publisher and General Manager,
Course Technology PTR:
Stacy L. Hiquet

Associate Director of Marketing:
Sarah Panella

Manager of Editorial Services:
Heather Talbot

Senior Marketing Manager:
Mark Hughes

Acquisitions Editor:
Dan Gasparino

Project and Copy Editor:
Karen A. Gill

Interior Layout:
Shawn Morningstar

Cover Designer:
Mike Tanamachi

DVD-ROM Producer:
Brandon Penticuff

Indexer:
Larry Sweazy

Proofreader:
Sam Garvey

For product information and technology assistance, contact us at
Cengage Learning Customer & Sales Support, 1-800-354-9706

For permission to use material from this text or product, submit all requests online at **cengage.com/permissions** Further permissions questions can be emailed to **permissionrequest@cengage.com**

Photodex, ProShow, and the Photodex logo are registered trademarks of Photodex Corporation.
All other trademarks are the property of their respective owners.
Photographs provided by Sherron Sheppard and Drew Cowan.
Permission to reproduce or use images other than as part of personal exercise in conjunction with the material in this book requires the express permission of the photographer.

Library of Congress Control Number: 2012930800

ISBN-13: 978-1-133-59505-2

ISBN-10: 1-133-59505-7

Course Technology, a part of Cengage Learning
20 Channel Center Street
Boston, MA 02210
USA

Cengage Learning is a leading provider of customized learning solutions with office locations around the globe, including Singapore, the United Kingdom, Australia, Mexico, Brazil, and Japan. Locate your local office at: **international.cengage.com/region**

Cengage Learning products are represented in Canada by Nelson Education, Ltd.

For your lifelong learning solutions, visit **courseptr.com.**

Visit our corporate Web site at **cengage.com.**

Printed in the United States of America
1 2 3 4 5 6 7 14 13 12

I dedicate this book to the Schmidt family,
and especially my daughter Michelle.

Acknowledgments

Thanks to the publishing team at Cengage Learning, especially Karen Gill.

Thanks to my publicist Amanda Eddy, who keeps me in line.

Thanks to all the slide show enthusiasts, from housewives to media professionals, from entrepreneurs to executives, who have pushed the limits of exploring what is possible from the average person's point of view.

Thanks to the many people at Photodex who were part of this process. A special thank you to Leslie and Dylan, who did a great job with the artwork for both illustrations and DVD examples.

Thanks also to everyone involved in the development of ProShow over the years who has made the technicalities of all of this real through an amazing amount of work.

About the Author

Paul Schmidt is the founder and president of Photodex Corporation. His visionary expertise has helped steer the evolution of slide shows and digital content management in the digital age. For more than 20 years, Paul has managed software development for Photodex, including his most important work to date: the ProShow product line. In *Secrets of ProShow Experts*, Paul shares his insider knowledge with readers by explaining the techniques of what makes a great slide show and taking readers behind the scenes with a look into the world of ProShow that no one else can deliver. His expert knowledge of ProShow makes this book a must-read for anyone wanting an insider's look at the most popular multimedia slide show software on the market today.

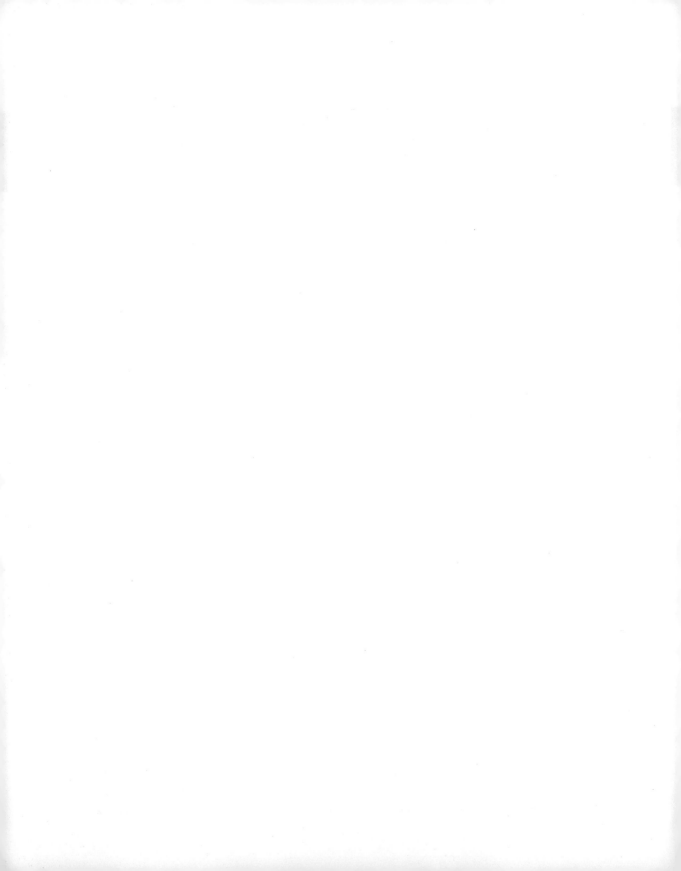

Contents

Introduction . xvii

Chapter 1
Technique—Not Technology 1

Process . 4
 The Right Way Is Whatever Works . 4
 Sight Versus Sound . 5
Understand Your Goal . 7
 Why Are You Doing This? . 8
 Target Audience . 8
 Messaging . 9
 Emotional State . 11
Review . 11

Chapter 2
Telling Your Story 13

Use Emotion to Convince Your Audience . 14
Tell a Story . 15
 Make the Show Artistic . 17
 Find a Theme . 17
 Order Your Visuals in Time . 17
 Include Plot Twists . 17
 Communicate Thoughts and Feelings . 18
 Eliminate Unrelated Subjects . 18
 Avoid Overdoing It . 18
 Don't Leave Loose Ends . 19
 Be Careful with Captions . 19
Break Your Production into Sections . 20
Review . 22

Chapter 3
Ways to Work Smarter 23

Plan Your Workflow . 23
 Know the Process. 23
 Edit . 25
 Don't Resize Your Photos. 25
 Understand All Possible Delivery Mediums . 27
 Resolve Resolution. 30
 Use Styles. 32
 Use Copy+Paste for Consistency . 35
Find More Ideas . 37
 Photodex Resources. 37
 Online Forums . 37
Review . 38

Chapter 4
Space and Simplicity 39

Space—It Is Your Density . 39
 Focus . 41
 Edges, Frames, and Letterboxing . 41
 Balance . 43
 Layout . 46
 Portrait Images. 50
 Captions . 54
Simplicity . 60
 Everything Needs a Reason . 60
 Avoid Gimmicks . 61
 Include Necessary Content . 62
 Remove Unnecessary Content . 62
 Be Conservative. 63
 Add Style, Not Distraction. 63
Review . 64

Chapter 5
Motion and Timing 65

The History of Motion . 65
 Movement, with Reason . 66
 Move Slowly . 67
 Control Flow of Focus . 68

Motion and Audio . 68
Common Motion Examples . 70
Timing and Pacing . 72
Consistency . 72
Pacing . 73
Timing . 73
Caption Timing . 73
Music and Pacing . 75
Review . 75

Chapter 6
Basic Techniques 77

Beginnings and Endings . 78
Simple Curtain Opening . 78
Layered Curtain Opening . 79
Movie Reel Intro . 80
Motion Picture–Style Captions . 80
Endings . 81
Image Presentation . 85
Move and Hold . 85
Full Frame . 87
Backgrounds . 89
Photo Frames and Borders . 92
Black Point and White Point . 93
Grayscale, Sepia, and Colorization . 94
Transitions . 96
Cuts and Fades . 96
Fade Through Blank Slide . 98
Fade Through Colorization . 99
Spinning Out and In . 99
Cut Blast . 100
Portrait and Landscape Transitions . 101
Shaped Transitions for Progressive Changes 102
Panning Transitions to Shift Entire Slide 102
Captions . 103
Animation Tricks . 108
The Road Trip . 108
Highlighted Bullet Points . 109
Using a Pointer . 109
Using a Highlight Image . 110
Animated GIFs . 110

Audio . 110

Common Mistakes . 113

Review . 115

Chapter 7
Better Content, Better Results 117

Photography Tips . 117

 Shoot Horizontal Only . 117

 Shoot More Than the Whole Picture . 118

 Move Around . 119

 Try Different Angles . 121

 Shoot Related Subjects . 122

Why Use an SLR Camera? . 124

Rapid-Fire Shots . 126

 Bride and Groom Walking the Aisle . 126

 Sunrise, Sunset . 127

Post-Processing Photos . 128

Review . 128

Chapter 8
Tricks with Source Material 129

Cropping and Adjustment . 130

Borders . 130

 Simple Photo Border . 131

 Polaroid Border . 132

 Picture Frames . 132

 Reusable Picture Frames . 134

 Photo Stacks . 135

Caption Motion . 136

 Caption Graphic with Transparent Background 137

 Big Panning Caption Effect . 137

Vignettes . 140

 Adding a Vignette to a Photo . 140

 Using Multiple Images with Fuzzy Borders 142

Image Stylization—Canned Effects . 143

Fake Masks . 144

 Employing Holes and Windows . 146

 Creating Layered Depth . 148

 Controlling Attention . 149

Chopping Up Photos . 150
 Changing Backgrounds . 151
 Using Pieces of Photos . 152
Tricking ProShow Gold with Video Output+Input 153
 Creating Moving Backgrounds . 154
 Morphing Images . 155
 Cheating with Animated Caption Layers . 155
Review . 155

Chapter 9
Audio and Synchronization 157

Importance of Audio . 157
Audio as a Reinforcement of Emotions . 159
 Select Music for Emotion . 160
 Use Music as a Background . 160
 Match the Music to Your Visuals . 160
 Amplify Emotion with Musical Events . 160
 Be Wary of Music Legalities . 161
Beat Synchronization . 163
 Cut to the Beat . 164
 Load Example Shows . 166
Voice-Over Tips . 166
 Don't Be an Announcer . 167
 Relax, Slow Down, and Enunciate . 167
 Avoid Pops . 168
 Use Better Equipment to Get Better Audio 169
 Create a Do-It-Yourself Audio Booth . 169
Sound Effects . 170
Segue Between Topics Using Audiovisual Gap 172
Review . 172

Chapter 10
Multiple Images 173

Head Shots and Objects . 174
 Single Subject Overlay . 174
 Multiple Subject Overlays . 175
 Highlighting People and Objects . 176
Orientation . 183

Horizontal Image Blending. 184
 Multiple Image Composition. 184
 Vignette Masks with ProShow Producer . 185
 Multiple Images Through Time . 186
Transparency Tricks. 187
 Background Transparency . 187
 Partial Transparency. 188
 Transparent Pieces . 189
Tricks with Multiple Slides . 191
 The Impossible Fade . 191
 Symmetrical Montages. 193
Creating Looping Video Backgrounds. 196
Review . 198

Chapter 11
ProShow Producer Techniques 199

How Is ProShow Producer Different? . 199
Producer Techniques. 201
 Big Panning Caption . 201
 Background Image Blur . 202
 Collapsible Curtain . 203
 Photo Frame Glass. 203
 Soft Focus . 203
 Radial Soft Focus . 204
 Sliced Masks . 205
 Sliced Adjustment Layers. 207
 Image Reflections. 207
 Quick Image Morph . 208
 Object Wipe . 209
 Combining Adjustments with Transitions . 210
 Adjusting Part of a Photo. 210
 Falling Pieces Using Keyframing . 211
 Slow Motion Video . 212
 Travel Path Animation. 212
 Modifier Examples. 214
 Feats of Complexity and Amazement. 220
Review . 226

Chapter 12
Delivering Your Show 227

Video Versus Real-Time Playback . 227
 Video Playback . 228
 Real-Time Playback . 229
 Both Is Better . 230
Discs: CDs, DVDs, and BDs . 232
 PC Playback Discs . 233
 DVDs . 233
 BD—Blu-Ray Discs . 240
 Disc Packaging . 243
 Professionally Manufactured Discs . 254
Video Files . 255
The Internet and Web Shows . 257
 Photodex Show Sharing . 257
 Photodex *.PX Format . 257
 Facebook, YouTube, and Vimeo . 259
 Flash Video Output . 259
Live Shows . 260
Review . 262

Guest Experts and Their Insights 263

Kelli Etheridge . 264
Jennifer Clark . 266
Barbara Coultry . 267
Leslie Gray . 268
Dale L. Fenimore . 273
Jean-Pierre Druffin . 276
Stacey and Kelly Chance . 277
Drew Cowan . 278
Simona (Mona) Wiener . 280

Index 281

Introduction

What makes a good slide show great? In reality, most of us have an intuitive idea of how to create a basic slide show, but without careful study, most people underestimate the number of tricks that make a great slide show. When you're ready to go beyond the basics and do more with your shows, when you're ready to create a piece of art and not just another slide show, you'll find this book is for you.

Before I started writing this book, I knew there was a gap in the available educational material about one of the most common things that people want to do—make slide shows. The capabilities promised by the computer and photography industries had stretched people's expectations far beyond simplicity, and few were educating how to do it. I didn't realize how much of a gap there was until I had committed to this book.

In my research for the book, I was shocked that I could not find a single book precisely on this subject. There were many books on business presentations, video editing, and film making. Even these books were surprisingly sparse on the tips and tricks I already knew made great slide shows work.

Why had nobody written a good book on the subject? The simultaneous evolution of digital photography, computers, and television had collided, causing a vacuum of knowledge, superimposed on a geyser of technical capability, combined with a fantastically large number of consumers with the same agenda: slide shows. These consumers have different media than previous markets. The media they have is produced with different intentions than before. The customers want results that are slightly differently from what's been done before. And they want to know how to make that happen.

This book is about what makes a great slide show; this is not just a book about ProShow, though. I intentionally don't explain how to use ProShow's user interface or exactly how ProShow works. Instead, ProShow comes with a comprehensive User's Guide that you should refer to for that. I've included ProShow examples on the included DVD, and I strongly encourage you to study them to understand what I've done to construct them.

The content of this book could easily be applied to any number of different types of software, including business presentation programs, video editors, and 3D animation programs. ProShow is used as the example application, but most of the core principles apply.

This book is about concepts first and methods second. To make a great show, you really do need a solid understanding of the concepts. Without this, you won't understand why the methods work. Once you understand the concepts, you'll be able to refine your own methods using the starting points I offer. My hope is that you will take what you learn from this book and apply it in new ways to audiences. I'm hoping I can see examples of this in the future and learn from those who have learned from me.

The approach I've taken is one I hope will expedite the learning process. I intentionally do not include step-by-step instructions for controlling ProShow. Instead, I teach the basics and use them to build more and more detail. Finally, I give examples as much as possible to demonstrate one new thing at a time. As you read the book and study the examples, you'll be absorbing one trick after another and gaining what I hope is a much more complete understanding of the factors that affect slide show construction as a whole.

This being the second edition of this book, I was overwhelmed and humbled by the positive feedback and rave reviews from our first edition. With this edition, you'll notice we kept much of the teaching the same since this book covers concepts as a whole as opposed to step-by-step instruction. (If you're looking for that, check out our 600+ page manual, which is free and available on our website!) You'll see many new screenshots, and the example DVD includes a trial of both ProShow Gold 5 and ProShow Producer 5 so you can follow along with the examples.

We also reached out again to our 10 guest Experts highlighted in the back of the book. You'll see some fresh new faces and some familiar ones, all offering invaluable tips and tricks for creating your best slideshows.

Using the DVD Examples

The DVD included with this book is organized into three folders: one called Example Shows, containing executable (*.EXE) files for each example in the book; one called ProShow Gold Materials, containing all show files and styles for all examples compatible with ProShow Gold; and one called ProShow Producer Materials, containing show files and styles for all examples in this book.

Readers can refer to all *.EXE examples in the Example Shows folder.

Readers with a license for ProShow Gold will not be able to load the ProShow Producer show files into ProShow Gold because they require ProShow Producer. One way to see these examples is to download and install a trial version of ProShow Producer and use the trial version to inspect the show files for the ProShow Producer examples.

Readers with a license for ProShow Producer can ignore the ProShow Gold folder, because all the examples in the book are included in the ProShow Producer folder.

In each of the ProShow Gold Materials and ProShow Producer Materials folders, there are two subfolders: the Example Show Source Material folder containing show files for each example in the book, and the Slide Styles folder containing ProShow style (*.PXS) files, which can be imported into ProShow.

All executable (*.EXE) files, show (*.PSH) files, and style (*.PXS) files have been named using this format:

*Chapter ##-Number ##.**

Each example in the book is uniformly named with a chapter number and sequence number. You can easily find an associated file on the disc by matching the numbers.

Other Sources

If you find yourself overwhelmed with being able to reproduce the examples I give in this book with ProShow, you may also benefit greatly from checking out our blog, which has daily tips and tricks on how to use ProShow, and our YouTube channel, which has tons of free training videos and sample slide shows to get your creative juices flowing! The links are here:

Photodex Blog: www.slideshowblog.com

Photodex on YouTube: www.youtube.com/photodexcorporation

I hope you enjoy reading this book as much as I enjoyed writing it.

DVD-ROM Downloads

If you purchased an ebook version of this book, and the book had a companion DVD-ROM, you may download the contents from www.courseptr.com/downloads. Please note that you will be redirected to the Cengage Learning site.

If your book has a DVD-ROM, please check our website for any updates or errata files. You may download files from www.courseptr.com/downloads. Please note that you will be redirected to the Cengage Learning site.

1

Technique— Not Technology

Before I jump into working with slides, I'm going to spend this and the next few chapters covering concepts that form the foundation of the techniques you'll learn later. These early chapters contain hard-learned rules and tips that will improve your composition and change the way you approach creating slide shows.

The main point of this chapter is that a show's success is more about technique and less about technology. Technology can play a role in success, but most success has more to do with technique. Technique involves the overall process, understanding of your goals and audience, the role that emotion plays, and how you've structured your story. The relative importance of each of these categories depends on what you're trying to accomplish.

First, what is a slide show? Up until the 1980s, slide shows were a presentation shown by someone operating a carousel projector using film transparencies (slides). The carousel held up to 130 slides and worked by projecting images onto a wall or screen. This gave birth to the term *slide show.* Most often presented by family elders, these slide shows included family photos and vacation shots, and they were usually quite boring. Background music in those days pretty much didn't exist, which added to the monotony.

In the 1990s, computers and digital photography started maturing. Slide shows grew into a progression of still images with no other effects. Background music was still rare, and small computer displays made it impractical to watch these shows in a family setting. They didn't really take off. In the 2000s, the term *slide*

show exploded and came to mean a full-on audiovisual presentation including a soundtrack, still images, video, sound effects, and an ever-increasing array of special effects. Even the medium the slide show is presented in doesn't really matter anymore. (I think of a slide show as a *rich-media presentation* rather than a video or a web show.) We can now produce high-definition output and deliver our family history in dazzling ways in our living rooms or on the web. We finally have background music to alleviate the boredom! Slide shows have evolved so far that the difference between what you see and hear in a slide show and a high-definition television commercial can be virtually indistinguishable.

I noticed in the 1990s that there was a huge rush toward digital photography and away from film. For the first time in history, photography was freed from the expensive, time-consuming, and toxic disadvantages of film. At the same time, the entire computer industry was almost completely ignoring what appeared to me as obvious: people weren't going to print most of their photos. Reputable companies like Kodak were predicting wholly unrealistic digital scanning and printing forecasts. Everyone I knew using digital photography was just not printing.

I saw a different future. I watched what people actually did with digital photography and imagined what I considered to be an efficient, and therefore the most likely, outcome. People wanted to share photos and video with the least effort, with a polished feel, and with minimal cost and time investment.

I created ProShow as a new way for you to use this digital technology. The idea is simple. ProShow provides an easy way for you to use digital stills and video. My main goal was to design the user interface in such a way that the average person could achieve professional-looking results without having to be an expert in the field.

What's the difference between video and a slide show? As I mentioned earlier, I think of a slide show as a rich-media presentation. A slide show is usually created with slide show software, and video is usually created with video-editing software. This limits video to the medium of video. This may seem like a pointless distinction until you realize that people usually think in terms of still image slide shows and not video editing. Most people consider video editing as a series of scenes, which are much like still images in their minds. Video clips are much more cumbersome to work with and more difficult to edit than still images. Nearly everyone has more still photographs to work with than video. This is especially true of most businesses. Slide show software works with media in a way that is more like the way most people think about it. This makes it easier to understand. Modern slide show software can create similar results for most people in much less time, and with much less training. Video-editing software is better at some things, but it's usually just those things that are meaningful only to professional videographers or hard-core video enthusiasts.

Ultimately, the goal is to create a show that your audience will appreciate, and one that does not come across as amateurish or difficult to watch. If people notice the production quality of the show, a change could probably make it better. If you have tried making any kind of production already, you may have discovered that making a good one is easier said than done. Creating a truly artful work of audio-visual wizardry is more difficult than most people first assume. After all, we are assaulted every day by fantastic multimedia works of art and rarely consider what it takes to create them.

Please don't get the idea now that polishing a slide show is so difficult that you'll never improve. Quite to the contrary, with just a few blended techniques, an otherwise boring composition can be made to *pop*. Also, the simplest and easiest-to-remember techniques make the biggest improvements. Figure 1.1 shows a "before and after" example that uses perhaps eight or so relatively simple techniques you can learn from this book.

Figure 1.1

Just a few stylistic techniques are used to make this visual better.

Most people take for granted the mountains of expertise that professionals conjure to work their magic. In fact, a top-dollar 15-second commercial is usually produced by several teams of highly trained and highly paid professionals. Yet, we rarely think about this because we see so many commercials. Commercials we remember look great! We see them as *average* or *normal*. Don't feel bad if you don't achieve this level of perfection right away. I still have to work hard at it because it takes a lot of experience and effort to get things just right.

When you sit down to make your masterpiece, you must first take some time to understand that you will never feel like you are as good at it as you could be. As you practice, you continue to learn, refine, tweak, and fiddle with your projects.

At some point, you decide you're done, either because you've run out of time or because you get sick of your project and need to move on to something else. No matter what you do, your projects will never feel *done*.

Don't feel alone, because even the best professionals in the industry feel the same way. Even after decades of reworking and tweaking a slide show, your projects never quite feel finished. You can tell when you've done a good job when you can see that you achieved the goals you set for yourself.

Creating a great slide show involves some basic discipline and a lot of tricks. You need to understand the process you'll be going through, some basics about the medium you're working with, and what you're trying to accomplish. You need to know who your audience is and how they might react to different things you can do.

Process

There are many ways to make a slide show, and there is no single *right* way. This section should give you some ideas to help you decide on a process that will work for you.

The Right Way Is Whatever Works

Musicians are often asked how they write their songs, and the answers are always different. Some musicians have a rigid process they go through, and others end up at their goal through different paths each time. There really is no right way or wrong way to make a slide show, just as there is no right or wrong way to write a song.

Depending on what kind of slide show you need, there may be ways you can structure your workflow to be efficient. The idea is to create a *process* out of it. For example, if your goal is to do wedding slide shows as part of a photography service, what you're doing for each client will end up being similar each time. With this kind of business model, you should spend a lot of effort refining your process to the point where each slide show takes the minimum amount of time. This takes more planning, but it reduces the overhead for each production. In business, the art of making an easily repeatable process is the best way to be successful.

If you're making a slide show for a business—a looping trade show commercial, for example—most of your effort should be spent on your messaging and the technical look and feel of the work. In that environment, you have only a few seconds to capture people's attention, and they may start watching at any point. Thoughts about how long the show needs to be can be critical. What colors and stylistic

layout will you use? What are the most effective ways to add text in the right places, and at what times? How will you maximize the understanding of your product to the customers?

Or, perhaps you're documenting things about your family history and your target audience is your relatives. For them, the emotions of the story and reliving the memories are the keys to success. For these kinds of shows, visual quality isn't nearly as important, but respect and completeness are. Often, arranging the story to show feelings in an event can be the most powerful tool you have.

Perhaps you're a music promoter and you need to make short, interesting clips for a website promoting various music groups. For these, you need to highlight the music but also show visuals that aren't simply accompanying the music. For these kinds of clips, the show guides the listeners' thoughts and should enhance the music. Distracting listeners from the music would be the worst thing you could do! If you can find a way to use the visuals to make the music more memorable, you've got a real winner! This is exactly what music videos attempt to accomplish.

Maybe you're a portrait photographer using slide shows as a way to get photographic proofs to your clients. In this example, the music can make or break the emotional experience and should not distract from the photography. The music sets the tone, and the tone may change the customer's perception of the photography in good or bad ways for your sales. The photos must be the focal point, and you should spend a lot of effort figuring out how to add visual branding so you appear professional and competent. If you pull off the right mix, the customer will be much more confident in you and will order more prints and refer you to friends. Word-of-mouth advertising is incredibly powerful.

> **Note**
>
> If your goal is to tell a story, make sure you've done your homework constructing the story. If your goal is to tug on emotions, make sure you're using what you can maximize: the emotional response.

Depending on what you're trying to accomplish, the focus will be on different categories of the overall production.

Sight Versus Sound

Planning the process of making your show can be troublesome because there is no right way to do it. However, depending on what you want, thinking about the music first or the visuals first may help.

Visuals direct the audience's eyes and generally guide your thoughts. In general, they rarely guide emotion. Music can guide the audience's emotional response and set the tone for the visuals. I'm fascinated by the way that a subtle change in music can change how the audience feels, and it can do it without anyone in the audience realizing it has happened! When music and visuals are carefully combined, they can produce a surprisingly powerful—sometimes explosive—emotional response.

Most people do not realize just how emotionally powerful slide shows can be. I can remember back several years ago when a mother posted a ProShow slide show she had helped her son make. It was the most powerfully emotional show I have ever seen. I burst into tears. I showed it to others and had to get away from it before it started because I couldn't avoid crying if I saw it or heard it. There was nothing special about the production quality; in fact, it was quite poor. There was nothing professional about her son's voice-overs; they were technically pretty bad. What then could cause me, a seasoned businessman who has *seen it all*, to burst into tears and instantly want to do anything to help this family?

The boy, perhaps 6 years old, had just lost his father in the Iraq war. His mother helped him create this slide show as a way for him to say goodbye to his father and perhaps offer some closure for the loss. His terribly narrated voice-overs talking behind the pictures of his father smiling in the desert, telling his daddy that he would see him in heaven, was enough to make any adult cry. Not once did the brave little boy cry in the voice-overs. All of this was set to a popular patriotic song about America. Just the memory of that show haunts me. This show offered an absolutely horrific situation anyone would empathize with, combined with an audio track that reinforced the innocence of the boy with the heroism of his lost father. All of this was packaged in a context of the grieving mother helping her son to somehow deal with his horrible loss. These are powerful archetypal story elements, and each amplifies all the others. This is why the show was so powerfully emotional. The show's situation instantly hit me. I wish that family my best, yet I've never met them.

Another show I noticed was one a talented photographer posted on the Internet. The photographer carefully planned the story and did photography with a model to tell the tale. The production quality was not superb, but it wasn't shoddy either. It was, for lack of a better way to say it, human. In my opinion, had the production value of the show been much better, the story may not have worked as well. The common feeling of the show made it much more believable and *close to home*.

The show started with an average man getting out of bed, showering, shaving, drinking a cup of coffee, and looking at a schedule where he has a date with a woman at a certain time that day. He cleaned himself up very nicely. As the progression of still images and loving music moved on, some photos of his lover were occasionally shown so you could imagine the woman he would be meeting.

The man, looking very dapper and happy indeed, left his house, bought flowers, got in his car, and drove for a while. He eventually reached a lush, grassy park and proceeded toward his meeting. All at once, you realize the woman he was to meet was his deceased wife, and he went to the cemetery to pay his respects at her headstone. The architect of this story took advantage of our human instinct to make assumptions about pieces of a story that we aren't sure of, combined with building a sense of caring about likable characters and a likable situation. The normal response is to anticipate the most likely outcome. This plot twist used your growing anticipation to rip your happy assumptions away from you all at once and replace them with an awful change. This caused a sudden, violent emotional shift that resulted in an overwhelming feeling of empathy. Once again, I was hit by this piece.

There is no way I can communicate just how powerful the emotional impact of a well-constructed show can be. Just as a movie can make people cry, so can your slide show. If you have the right story, the right music, and the right visual elements, you can create the emotional response you're after in your audience's mind.

If the audience is emotionally attached to the subjects of a slide show, this effect is intensified. For example, a bride watching a show about her wedding is emotional by default because it documents the most anticipated day of her life and gives her an opportunity to relive it. I'll cover more about matching audio with visuals later in this book.

For informational shows like sales presentations, you can think of background music somewhat like packing material in a box: it should never get in the way of what is in the box. The music shouldn't distract from the content of the show, but it can be used to set the tone in the audience's mind—the emotional tone. For a military contractor, military or patriotic music could be used. For a kids clothing company, something fun and childlike could set the tone. Don't go overboard on music, and make sure to focus on your message first, using music only to set the emotional tone.

Understand Your Goal

Understanding what you are trying to accomplish sounds like a simplistic or even obvious thing—something we should take for granted. However, not knowing what you're doing in advance is one of the most common reasons projects get stalled, abandoned, and confused. I hope this section gives you some things to think about to make sure that before you begin, you have a clear vision of why you are making a slide show.

Before you start to plan how to put your show together, you need to know why you are doing the show in the first place, who your intended audience is, what you intend to say, and what emotional feeling you want the show to have. Take some time to think these things through, because your full understanding of each of these categories can considerably change the planning of your show.

Why Are You Doing This?

Understanding your goal is the process of answering the question, "Why am I making this show?"

Before you begin, you should make an effort to understand what you are trying to accomplish. It sounds obvious, but it is surprising how much this focuses your efforts if you keep asking yourself this question during the process. You need to know who you want to view your show (your *target audience)*, what you intend to say (your *messaging*), what emotional state you are trying to achieve (your *tone*), and how you intend to deliver your show to your target audience (your *medium*).

Target Audience

Before any other details, you should have a clear target. Who do you want or need to reach? Regardless of the messaging, constructing a show for businesspeople would most likely end up being a much different endeavor than constructing a show for children.

If you are making shows as a business, you may need to think a bit more about your own business model. Sometimes the majority of the audience is *not* the most important audience. In many Westernized countries, wedding photographers target the bride and the bride's father when they create their shows because it's all about business psychology. The secret is in the buying decision. The bride's father most often pays for the wedding. This means that if the father feels it necessary to buy, he'll buy. He'll have to like the show to do that. But often more importantly, the key to convincing the father is the bride's reaction. If the father sees the bride cry, he'll be much more likely to buy. For any successful businessperson, the target is about who writes the check and what goes through that person's mind at the point of making the decision. In the wedding photography business, there's a saying: "When they cry, they buy."

Whatever your purpose, make sure you form a clear idea of who you intend your show to speak to. Visualize that type of person and ask yourself what she would respond to. Is she more stimulated by emotional messaging? Does she respond well to humor? Will she only care about the information? Will she be able to sit through your complete message, or do you need to cut it down? Thinking about these kinds of things and getting a clear understanding of your audience does wonders during the planning and creation of your production.

Note

I've had conversations with videographers who talk about how much better their training videos would teach the intended audience if only their managers didn't constantly gear the material toward the egos of the decision makers writing the checks. Some business hierarchies are often inefficient simply because the people in power don't always understand as much as the experts they employ. Perhaps more decision makers should defer to their experts a little more and make sure their experts are competent.

Messaging

What can you say? What do you want to say? What do you need to say?

To answer these questions, you need to have a firm grasp of your target audience. You need to understand what action you expect them to take. This differs greatly depending on your goals.

With a family show, the messaging is more about the visual documentation of events. It is less about information and more about reliving an event. It's sometimes important to make sure that members of the audience are represented so they don't feel left out. Think about the event and the personalities of the audience. Often, there is a family member who is very sensitive to the fact that the funny—and perhaps irritating—things he does are mentioned. Other family members may be getting older and want to see the kids more than the adults. Only you know your family, and making lists of these things helps once you get started. This can also guide you when you start to remove material, which is one of the most important editing tasks to be done later on.

If your show is business oriented, you're probably most interested in reducing the overall scope of the message to only the major points necessary to get the audience to agree with the proposition you're offering.

For example, let's say you're selling a product or service and need a commercial for a trade show. This kind of show should be short and to the point. The goal is to get people's attention as they walk by, and you have mere seconds to do it in. First, you need to get people's attention and convey value as quickly as possible. Second, you may need to focus on advantages over competitors in case they already have a solution. In that case, you want to get people to switch to your product or service.

The visuals of business shows are important aesthetically, but this section is about messaging. What can be shown in the visuals that will be instantly recognizable as valuable? What can be eliminated because the audience will assume it to be the case anyway? What can be shown about your product or service that is different? What will be immediately seen as worth looking into for the average passerby?

Think about the words and phrases you'll use. The shorter, the better. Try to choose words and phrases that are easily understandable, easily readable, and as memorable as possible. You may catch someone's attention for 1–2 seconds before she is distracted by something else, and you want her to remember what she saw for that short time so she'll remember to come back.

If you're not familiar with what I call *ad speak*, it is the art of using bad grammar that works better in certain situations than correct grammar. This is extremely common in advertising. And there it is again. In the previous paragraph, I used the sentence fragment, "The shorter, the better." I know this is grammatically incorrect; it would earn me a lousy grade in a middle school English class. However, I know you understood it. One could argue that I could have used the correct sentence, "Short is better." After all, it is fewer words, right? But the phrase I used is a common saying that triggers a familiar memory reflex that a correct sentence wouldn't have. I used it because people intuitively recognize it. My only goal was to communicate; being correct with my grammar would have actually hurt my goal. The incorrect solution was simply more efficient. It's always preferable to focus first on success and only secondarily on grammar. In business, optimizing the process for the customer makes more money. (*My former teachers are likely reeling, but at the end of the day, I'm published and they're not.*)

With training shows, a trainer will probably have a series of ideas to teach. This is a *curriculum*. Most of the production focuses on the material, so the show production becomes more of a visual presentation exercise than a battle with messaging.

Weddings, Bar Mitzvahs, Bat Mitzvahs, christenings, and other family events are most often about documenting the event and less about messaging. But there is a messaging component if you're creating these shows as a service. The introduction of the show and the credits and ending of the show can help you brand your business. What can you put in these places to benefit your business? Once again, you have just a few seconds to make an impression. Don't overdo it, because nobody likes to be *spammed* with overdone advertising, but at the same time, it is often expected that you can tastefully advertise in the process. Just make sure the show looks refined and that you're only saying what you need to say. If done well, branding actually adds value to a show because it gives it a professional and well-produced appearance.

Emotional State

Creating an emotional state in a show is a matter of music, the speed the show takes as it moves along *(pacing)*, and to a lesser extent, visuals. These three elements should agree with each other, or the results will be confusing.

> **Tip**
>
> An interesting concept I've learned over the years is "the problem that people cannot articulate." In other words, the average person cannot tell you what is wrong with something. For example, if the music and pacing of a show are slow but the pictures are of race cars, many people won't be able to tell you what is wrong with the show; they may even tell you it was *good*, but it doesn't get a *great* reaction. Another example is a family show with slightly dark or haunting sounding music. It just seems wrong to most people, but not perhaps wrong enough to pinpoint it. Most people can't explain what's wrong unless things are very out of whack. It's often necessary to look for this kind of subconscious problem when you get mediocre responses. When you get it right, people rave about the results.

Music can be energetic, slow, or loving. It can have a country feeling, a historical feeling, or maybe a futuristic feeling. If your show goes through sections that should be faster or slower, make sure the music agrees. You can use changes in music to alter the pace of the show and vice versa. You don't have to play every song you use all the way through. If the show is moving on to a different section, fade the current song out and fade into a new song that matches the new feeling you want.

Together, visuals, music, and pacing create a style. The elements of the style should agree for the best results. Watch what others have done and ask yourself about the style of those shows. What songs worked and didn't? Which things did you like or dislike about the visuals in other shows? When you watch commercials, think about how the music and pacing work with the visuals. Think about the emotion the style creates and about how different elements can be used to get the emotion you want.

Review

Technique involves a lot more than what this chapter has described. It could be argued that this entire book describes technique. I hope I've described some important things to consider that you may not have thought about before. Knowing who you are targeting, how to express yourself, how emotions play into it, and how the mind works with sound and visuals are things you need to continually question if you want to get better at creating great slide shows.

2

Telling Your Story

When presented with the term "story," most people think of a storybook or a fiction novel. This common definition of "story" is correct, but it's not exactly what I have in mind for this chapter. I am trying to get you to think about the way you present information to your audience as a story. Stories usually have a purpose, a theme, and a story line. Even if you are simply presenting photos from an event or information for a marketing pitch, it is most effective to tie the photos together with a reason and a theme from the beginning.

This is one of the most misunderstood skills in making good slide shows.

You may be thinking, "But my slide show isn't a story; it is just a sequence of photos." This thinking is common, but I'm encouraging you to take just one more step in the way you consider your slide show. For example, instead of thinking, "These are just photos from my vacation," think instead that your show is the story of how your vacation was relaxing, or how many surprises you had, or how luxurious it was. Build your theme into your show as a story line. If you can take this one extra step in your thoughts toward the show, your show will be much more entertaining and meaningful to your audience.

It really does help to think in terms of a story. Good stories have beginnings, middles, and ends, and they're tied together somehow with a creative theme. Think about this when you consider your overall show. How will you tie it together? What themes can you think of? What will the point of the show be? How will the story end? What will your audience think of your story after the show is over?

This chapter gives you ideas about how to think about your shows in terms of a story. Even if your message isn't a story in the same sense as a novel, there is still a point to your show. Thinking about your show as if it were a story often helps you stay on track and get your point across.

Use Emotion to Convince Your Audience

Many philosophers believe that all human decisions are first derived emotionally and then rationalized with logic. You can easily see how television commercials prey on human perception by convincing you how nifty it would be to have a shiny product in an emotional way. Only after you're convinced emotionally are you told any rational reasons to buy. For example, at the end of the commercial, it says, "*Buy now and save 30%!*" That *deal* only works if you're already in an emotional state that makes you want to buy. If marketers did it the other way around, you'd be in a rationally defensive mindset when they tried to sell you the emotional reasons to buy a product. Selling doesn't work as well unless emotions come first followed by rationalization.

Emotion drives feelings of empathy, or caring about others. Getting an emotional reaction out of people can be accomplished in several ways. The easiest to understand is through individual scenes, like a shocking war image or an image of a grandmother that conveys a strong feeling of love.

Another type of emotional response is created by a story—a progression of images that leads the audience through a series of situations, adding understanding as the story progresses. This kind of emotional experience can be much more powerful than individual scenes because the audience, over time, learns more and more about the characters in the story and develops a sense of caring about what happens next. The audience is said to become *invested* in the outcome because they care about it. As the story delivers new information, the audience is led through the experience. Hollywood film professionals refer to this as *the ride*, because any good story is like a roller coaster ride. (I'll talk more about that in the next section.) When the ride takes an emotional turn, the audience can be counted on to go along with it.

As you construct each part of your show, you should be aware of the feelings the audience is likely to have and the thoughts that will be going through their head at each moment. (This is useful when you're working on pacing, which will be covered in detail in Chapter 5, "Motion and Timing.") Unless shock is what you're after, try not to do things that will change the audience's feelings too much, or the change will seem jarring.

When Photodex originally started creating the ProShow products, I didn't realize just how emotional a slide show could be. The general population does not understand

how people relate to others they know when they see a slide show. When people see even the simplest of slide shows of an event they attended, they almost *relive* the experience. What goes through their minds is much more than just what they see on the screen. It is difficult to express just how much emotion can come pouring out when family members relive an event they attended. It is hard to understand just how earth-shattering it is for new grandparents to see the first pictures of their grandkids this way. It is truly awe-inspiring to watch people cry when they view a slide show of their wedding. Anyone unrelated to the family or event would just shrug this off as *nothing*, but it really is important to understand. Keep this emotional element in mind if you're creating shows for your family. They *will* appreciate your work, and it will most likely have deep meaning to them.

Music has much to do with emotional response. You can bet that putting a couple's special song behind pictures will conjure up all sorts of emotions. Try to match songs you use to the eras of the people who the show will be important to. People tend to relate to music that was popular when they were between the ages of 13 and 25. For older people, this might be Frank Sinatra, Peter Paul and Mary, or the Beatles. If you can't find anything you like, ask people what music they liked as a teen. They probably won't know why you're asking, and you don't necessarily have to tell them!

One point about music is the match between lyrics (words) and the show. I like to tell people that lyrics in a show can easily be too distracting. It is best to only use lyrical songs when the lyrics somehow enhance the meaning of the show or fit with it perfectly. If the lyrics of a song are completely different from the point of the show, it will be a distraction. I noted in Chapter 1, "Technique—Not Technology," that people might not be able to tell you what's wrong with a show; this is one of the reasons for it. Unless you can find a song where the lyrics blend well with what is happening in the show, don't use it. Use something without lyrics, if possible.

Tell a Story

People are storytellers. Following stories is a big part of our human makeup. A presentation of information without a story can be useful, but it isn't nearly as interesting or meaningful as a show held together with a story. Sometimes a story can be as simple as a theme that bonds a set of images or events together. Information by itself is just information, but information tied together with a story can create emotion and a powerful conclusion.

A complete story has a beginning, a middle, and an end. The beginning is an introduction that explains the setting or premise and gives the audience the information they need to learn what the story is about. Remember the classic beginning of many children's stories: "Once upon a time…" Even simple stories begin by clearly

setting a time frame, even though the time wouldn't seem important to an adult. Without a solid beginning, your audience will not understand what you are trying to communicate. They may be confused when presented with new details that aren't explained.

For an informational slide show, the beginning is where you state your objectives; you are setting up the premise for which you are going to add information. Try to think about your show first in terms of people who have no idea of what you're about to show them. The audience starts with no information, so you have to find a way to give them whatever basic information you can to set the stage for the rest of the story.

The middle of a good story is the part that takes the audience somewhere. It feeds them new information in small, manageable bites so they can understand more as the story moves forward. This is the majority of the story and is sometimes called *the ride* by Hollywood movie professionals. Think of it like a roller coaster: it may have ups and downs, fast and slow parts, and surprising plot twists. Overall, the middle, or *ride*, takes the audience somewhere that is different from where they started. In an informational presentation, this is where the interesting information is presented.

The end of a good story, or the *conclusion*, either summarizes the premise set at the beginning of the show or changes how the audience feels about the belief presented in the beginning of the show. Informational shows summarize the points presented in the show and can state a conclusion based on everything presented. Dramatic stories leave the audience with a feeling that is created from the movement of the story. Drama often attempts to change how the audience feels by showing a situation the audience may not have anticipated, but it somehow means something because of the understanding they've learned by watching the middle.

For dramatic shows, you can think about the story like this:

Beginning:	Someone believes something.
Middle:	Events lead audience through new understanding.
End:	Events change how audience feels about the beginning.

For informational shows, you can think about the story like this:

Beginning:	Introduce reason for presentation and summarize what will be presented.
Middle:	Reveal information and reasoning.
End:	Summarize information presented and explain conclusion.

The following tips should help you avoid many common slide show pitfalls.

Make the Show Artistic

Shows whose only point is to present artistic work, such as artists trying to show-case their work, can use metaphors or themes as a powerful tool. Rather than a show that simply sets a series of images to music, try to relate the artwork to something the audience can think about. For example, a show about graffiti could be started with a question about whether graffiti art is a positive expression of art or a crime. By the end of the presentation, the show may very well have demonstrated that graffiti can indeed be beautiful and have value. This both gives the audience a context with which to judge what they see as they move along through the show and leaves the audience with a sense of value in the imagery they've just seen. Were there no theme, the audience would just be looking at a series of images without having a suggested question to answer.

Find a Theme

People often run into a problem when they have to make an interesting show from a series of photographs that are something of a jumbled mess. Perhaps it is a set of photos taken at an event or even a mish-mash of events of the same family: a wedding, a couple of birthdays, a trip to the zoo, a vacation. Once again, the idea of a story can help. Try organizing the images in various ways until a story emerges. Perhaps the story can focus on a particular person who is present in all the events. Perhaps something the family likes can be used as a constant theme surrounding the story. Perhaps the family dog can be the narrator, telling his side of things as the show progresses. If you come up with a theme or story for this kind of content, it holds the show together and makes your audience much more interested as they watch the presentation.

Order Your Visuals in Time

When organizing your visuals, pay special attention to ordering them correctly in time. Sometimes this isn't necessary if your story directs the purpose of images so much that the order in time is unimportant, but usually it is very important. If your show jumps around in time, the audience easily becomes disoriented and confused. When documenting events, keep things in the correct order so people can relive the event as they watch.

Include Plot Twists

Fictional stories are much easier to make interesting because of unexpected plot twists. Set up situations where the audience expects to see one thing happen but something unexpected happens instead. This is a *plot twist* that is common in movies.

If you are working on fiction shows, your story is much more interesting if you find ways to trick the audience into believing something is about to happen and then surprise them.

Communicate Thoughts and Feelings

Humans aren't just visual; they think and feel emotions. Use this to your advantage. Communicate with thoughts and feelings. This is easy and effective with captions and recordings of someone's voice (*voice-overs*). If you're the speaker in the voice-overs, make sure to talk about the feelings and thoughts of the people in the photos or your thoughts and feelings about the photos. Avoid talking about what the photos show—people can already see that. If you can record voice-overs at the event, ask people to answer questions about how they felt or what they were thinking. *"What did you feel like as you danced?"* you might ask. You can edit the audio for the voice-overs to only include the answers to the questions. Especially with documentary-style shows, these kinds of voice-overs are very effective. They help guide the audience and add a lot of emotional value to a show.

Eliminate Unrelated Subjects

Remember the target audience for your shows. Avoid including photos of people who aren't important to the central theme of the show. You may have so few images that you need to include every image you have, but if you have more than you need, cull the visuals down by removing the images that aren't central to the meaning of the show. There are usually quite a few people at a wedding, but having all of them in the show isn't going to make the show better. In fact, it usually makes shows longer and less interesting to watch.

The exception to this rule of elimination is when a visual shows strong emotion. Even people unrelated to the family in a wedding can enhance the show if a photo shows them reacting with strong emotion. For example, a couple crying while watching the ceremony could be a great shot to use between other photos, even if nobody seems to know who they are. You could use this kind of shot to break up some other photos that would otherwise be boring to watch.

Avoid Overdoing It

When working on informational shows, avoid *beating subjects to death*. There are really two issues here: avoid overproving single points, and prove only points that are important. Overproving a single point happens when you keep demonstrating something in different ways, but you do it so much that any reasonable person will get tired of it. Choose the best proof points, and state only those. Feel free to mention that there are many other ways to show the same thing.

Proving only the important points is a matter of convincing someone enough, but avoid using too many examples.

Imagine watching a show that dispels some myth—perhaps the *tooth fairy*. You could probably come up with tens of reasons why the tooth fairy cannot exist. However, putting this exhaustive proof into a show is most likely going to cause most people to stop watching. Instead, make your list of tens of reasons, and then go through it and choose the best three reasons, make strong arguments for those reasons, and then summarize by mentioning that there are many other reasons the tooth fairy cannot exist. You'll make your point, and the audience will appreciate that you didn't make them sit through more.

Don't Leave Loose Ends

Review your show, and make sure to summarize all the points you've made. If you've shown something, summarize it at the end. Make sure the story doesn't leave the audience in a situation where they wonder what happened. You've probably seen this at the end of a movie where each of the main characters is shown with a caption that describes what the character went on to do later in life. This kind of *tying up* leaves the audience with a sense of completeness about the story. Without it, the audience may wonder what happened.

Be Careful with Captions

Captions are something to be careful with because they can be distracting. We'll cover caption style guidelines in Chapter 4, "Space and Simplicity," but here are some quick thoughts to follow when integrating captions into your show.

Keep your captions short—perhaps 7–10 words at most. Try hard to reduce the wording of captions so they say what they need to say without unnecessary wording. In this example, you can reduce the caption by introducing Gloria Devry earlier in the show and reducing the wording in the caption.

Avoid Unnecessary Words

Bad: Gloria Devry dances with her father, Robert Fulton

Good: The Father's Dance

Why does this work? Well, because people know that at weddings, fathers dance with their daughters. Simple. (The point of your show probably shouldn't include education about the structure of weddings.)

Use simple language. Captions do not need to be works of literary art. Think of it as speaking to the audience verbally. Using complex language makes it difficult for the user to get the point. You want the audience to be able to glance at a caption

and then go right back to looking at the visuals that go along with it. In this example, the shorter caption isn't as accurate as the longer one, but it won't matter because of the context of the show. Everyone will understand that Robert is looking at his daughter and that she is happy.

Simplify Your Captions

Bad: Robert looks proudly at his daughter, the new elated bride

Good: The proud father

When you need a long caption to describe something, avoid mixing the caption with an important visual. Instead, transition to a *caption slide*, which looks simple except for the caption itself. Make sure to give the audience enough time to digest the longer caption (also discussed in Chapter 5), but make sure the complexity of the visuals does not distract from the caption. Long captions should be the most complex-looking thing on a slide.

Always use a consistent look and feel for captions in the show. People notice changes, and if the look and feel of your captions changes, the audience must concentrate on something that is unrelated to the show. When captions look the same, the only thing the audience notices is the message.

Break Your Production into Sections

When your production starts getting too long, you need to start thinking about how to break it into sections. Hollywood movies have evolved to the point where people expect more than two hours, but believe me, the budget to make a two-hour movie watchable is enormous. I suggest not even trying it unless your goal is to be a professional film director and you have a lot of time to learn.

As you gain more skill in making your shows better, you'll become better at extending the lengths of shows. You'll have a better story or more interesting ways of keeping the audience's attention. Until then, be aware that as you make the show, it is usually more interesting to you than it will be to the audience because you know everything about how it went together and why you put it together that way.

Different limits work well for different types of shows. Business shows should be as short as possible and focus only on the main points you need to stress. Commercials on television can be as short as 5 seconds but are usually 10–20 seconds long. This sounds impossibly short, but try actually timing the length of a commercial. You'll be surprised how much information marketers pack into such a short time.

Death by Slide Show

I'd like to take this opportunity to share a funny little concept we've developed at Photodex. It's called *death by slide show*. I don't know that it is actually possible for a slide show to cause death, but you get the idea. As you may know, ProShow users upload their slide shows to the Photodex show-sharing system for free, and millions of shows are seen each year by their friends and families. Some of our users have produced slide shows that consist of thousands of images, all set to music—sometimes tens of music tracks! Imagine for a moment that you're the unfortunate recipient of a link to a slide show that Uncle Bob made and is very excited for you to see. You start to watch. Sure, it is interesting for a few minutes, but then you get a sinking feeling and realize that this slide show will never end. You continue because you don't want to disappoint Uncle Bob. Eventually, the torture overtakes you and you give up. I regret that Photodex has not yet developed a way to communicate that people have a limited attention span, even if they love you!

For family slide shows, 4–6 minutes is recommended, or perhaps the length of one song that you'll use behind the visuals. If each slide will be visible for 3 seconds with a 2-second transition, you'll have time for around 50–70 images. Usually an event has more photos than this, which means you should probably eliminate all the images that aren't critical. Figure 2.1 shows a comparison between a typical short show and a longer one.

Mark Ridout, a good friend of mine and a well-known wedding photographer, typically uses hundreds of photos to produce wedding shows. His shows average about 20 minutes. I have yet to watch one of his slide shows that hasn't captivated me from start to finish. His shows use several songs as background music, and each show goes through different moods. Constructing a show this long takes rare talent and close attention to pacing to make sure that it remains interesting. Mark is a master at wedding slide shows.

Topics that require a lot of information, such as documentary shows where you really want to cover a lot of ground, should be broken into sections. A great, common example of this is shows that document cruises. The vacationers have different sets of photographs from each place they visit, and there may be many destinations covered in a single cruise. This same idea works with any vacation where multiple destinations were visited. Break each destination into a separate section to reduce the size of the shows.

Breaking up a show lets the audience watch each piece separately when they have time. It also makes it easier to plan each piece, because each piece can have a different flavor. For example, you can easily give each piece its own theme or story.

Figure 2.1

Short shows require less planning because they typically use only one song. Longer shows use multiple songs together; some care should be given to how the songs fade together.

If you break your show into pieces, you need to remember the rule of the story, which is to have a beginning, a middle, and an end. Make sure you include an introduction show and a conclusion show—perhaps the credits. This creates a nice envelope for the overall story and ties it all together.

People have limited attention spans. Everyone has had to sit through something for longer than they wanted. If your shows are too long, you'll get that reaction from your audience. Make your shows shorter and more focused, and you'll have a much happier audience!

Review

Build your show around the message you're trying to communicate. Even if your show doesn't tell a story like a novel would, try to think about it like a story. This enables you to think in terms of what the audience will perceive.

3

Ways to Work Smarter

Before you begin and as you progress with your shows, there are many things to consider to make your work easier and more productive. This chapter gives you an overview of some processes and ideas that can help save you time and effort along the way.

Plan Your Workflow

Planning your workflow almost always saves a lot of time. Most people learn this only with hindsight. Start with ideas and content. If you don't have all your content, plan how you'll get it. You'll likely be putting together visuals, music, voice-overs, and artwork, and you'll be working on the visual layout, timing, and pacing of the overall show.

Know the Process

Know what your purpose is, how much time you have, and what kind of look and feel you want. What kinds of emotion do you want to convey? Do you already know how to accomplish these things? Perhaps you need some practice and mock-ups to prove that you can accomplish the visual style you want.

Don't be afraid to experiment with ProShow. Sit down and play with it. Think of ideas and try them. Some things will work and some things won't, but you'll quickly gain confidence and skills that will enable you to make better shows.

Once you prove your style and quality level, you have a better grasp on how long a show will take. You may already have artwork as a result of your experimentation. At the very least, you have a much better idea of how to estimate the time it will take to create the artwork you need for different parts of your show.

To estimate how much time you need to put together the whole show, play with ProShow and do a segment of the show—perhaps four or five slides. If you are synchronizing events in the show to music, play with the timing to prove to yourself that the audio is synchronized to your liking and that it looks good. Once you get these first slides to look and feel good, you can better estimate how long the overall show will take, whether you need more or less content, and how much time you need to complete the show.

If you're making a show for your own enjoyment, take as much time as you like. Some hobbyists get much more joy out of sharing their work than they do out of making it perfect quality. Others experiment with trying to get different emotional reactions. And some are motivated by political or societal advocacy messages. Be yourself, and do what makes you feel good. If you create shows for enjoyment, then feeding your enjoyment is all that really matters, and you can happily ignore those who might criticize quality.

The process of making a show boils down to putting audio and visual elements together, setting the visual elements in place, specifying how they move, adjusting timing and transitions between slides, setting up captions, and adjusting the whole show for consistent pacing and emotional flow. The time you spend on this whole process is up to you.

I tend to be a perfectionist. Once a show gets to a certain level, I have to constantly ask myself whether the changes I make from that point are worth the time. If I didn't do this, I would go on editing and making it better for months. Sure, the show would be a little better, but how much? It is most likely that nobody would notice the quality improvement enough to justify my time spent tweaking. Finishing a creative project never feels comfortable, so don't expect it to. Just expect to get better at it as you gain experience.

The rest of this section focuses on tips that help your workflow by reducing the amount of work you do. Some of these tips are inspired by common misconceptions and myths that have circulated in ProShow's user community. Be aware that you may need to change your understanding if you find that you've been believing a myth!

Caution

Be careful of what you hear! It's easy for others to jump to incorrect technical conclusions when they don't know the details. The computer industry is full of elusive gotchas. In other words, it's easy to guess and look like you're right, even when you're completely wrong. I've seen a lot of technically incorrect ProShow information posted online by people who claim to be experts. If you have a question about ProShow, call Photodex and ask for a straight answer.

Edit

Editing can turn a *so-so* slide show into a *great* slide show. I won't go into much detail here because I cover this in better detail in Chapter 4, "Space and Simplicity." As part of your workflow, plan on spending a lot of time going over and over your show to work out the kinks. The major categories are removing poor content so the good content shines, refining pacing and timing, and playing with musical transitions. Editing takes time, so plan for it if at all possible.

Don't Resize Your Photos

Users often ask what size their photos should be when they're brought into ProShow. With few exceptions, the best answer is *whatever you have*. Some users like to scale their photos down before they bring them into their software because they are afraid the software won't be able to handle the high-resolution files. This is a historical problem that was created years ago before software was good at dealing with large photos. Some software today may have trouble with high-resolution photos, but ProShow doesn't.

Tip

The one caveat to this rule is when you're working with ridiculously large photographs that were taken with super-high-resolution slit cameras or stitched together from a lot of photos. These files can be tens of thousands of pixels in each dimension. If you're using enormous files like this, you may need to do a little bit of math, or rendering may get very slow. A good rule of thumb is to avoid reducing images below a resolution that is 2.5 times the pixel dimensions they'll be rendered at for any output resolution. So, for example, if you are out-putting to a high-definition device like a Blu-ray disc, don't reduce your images to a resolution lower than 4800×2700.

If you know you're working with super-huge images, feel free to downscale them if it makes you happier. A high-resolution display benchmark is 2560×1600, which is the resolution of the monitors I have in my office. If you use the rule of allowing for 2.5 times the size of the largest possible display, this means you should resize images so that they are no more than 6400×4000. A photo that completely filled that frame would occupy about 102MB of RAM, which is still plenty small enough to work with in ProShow. Note that the preview in ProShow will be using a version that has been scaled down to 1600×1000, because this is the reduced size of the image that will fit within a 1600×1200 frame. This may produce a little fuzziness if you're extremely picky about the preview in ProShow, but the final output will be as clear as the original images can produce.

ProShow's imaging engine can handle images up to 65,528 pixels in each dimension. If you had a JPEG image this large, the amount of memory it would take up is about 16GB of RAM, which is more than the 2GB of available memory Windows can give to a 32-bit process. In short, you're not going to have an image that large. Even if you did, few products would work with it. Even the products that do work with it would not be presentation products. Resolutions that large are simply ridiculous to present at that resolution.

As of the writing of this book, modern pro SLR cameras typically have imaging sensors that are around 18 megapixels and take pictures occupying about 64MB of RAM in memory. (Note that the size of a JPEG file has almost nothing to do with the processing requirements of the machine that is presenting it.) This is fine for ProShow to handle, even with multiple pictures in each slide.

How ProShow Handles Preview Resolutions

For those who want to know exactly what ProShow does with images internally, there are two cases: the first case is for working with the photos in ProShow, when you're constructing your show. In this case, ProShow uses the original images if they are JPEG format and if they are below 1600 pixels wide and 1200 pixels tall. This means that while you're working with ProShow, no image can occupy more than 8MB of RAM, and that makes the program run a lot faster. All other formats are automatically scaled down and converted into a 1600×1200 frame. All video is imported into an internal format so it is quicker to use in ProShow. Note that scaling images down like this is *only* for the preview in ProShow. For output, ProShow always goes directly from the original files to the output format to attain the highest quality possible.

Caution

The numbers in this section are stated as of the writing of this book. At Photodex, we're working on all sorts of technology internally, and it is quite likely that in the future these numbers will increase. Computers are getting very powerful.

Understand All Possible Delivery Mediums

When you finally complete your show, how will you need to distribute it? Will it be available on the Internet through a website? Will you burn DVDs or Blu-ray discs? Will you pay to have hundreds of discs manufactured using a professional service? What about artwork for the discs and perhaps covers for them? Will you be delivering a video file to a company? What kind of video do you need? What is the maximum resolution of the video? Will the show ever need to be played on a computer in a live venue? What will the maximum resolution of the display be? If you're going to be using a projector, what will the capabilities of the projector be? Would an executable real-time show be better than a video file? What kind of computer will be available to play it?

These questions sound obvious but can save you time. (I'll cover show output in detail in Chapter 12, "Delivering Your Show.") For example, if you need to be able to burn a Blu-ray disc, the maximum resolution will most likely be 1920×1080. If you intend to do anything in a show that zooms in to about double the size of the image, you'll need source images that are at least twice the dimensions of the screen (3840×2160.) If you do not have images with this resolution, you'll end up with some blurriness. If you need to use a live display, you may have similar issues.

If you're using high-resolution images, ProShow will use the original images in the preview unless they're larger than 1600×1200 pixels, in which case, they will be scaled down in the preview. In final output, ProShow will use your original images—you don't risk losing anything. This is a best-of-all-worlds design because you never have to worry about how to second-guess the software. It'll just work fast based on the requirements. But be aware that if you're doing extremely high-resolution work, the preview may be using the 1600×1200 versions, and any blurriness you see on the screen may not be there in the final output.

Some things can be done in output mediums and some things can't. This usually isn't a ProShow limitation, but a limitation of the output formats. For example, the VCD specification makes it impossible to include more than 99 shows on one VCD.

Why DPI Doesn't Matter

I'd like to dispel a long-standing myth about resolution. DPI and PPI have nothing to do with resolution unless the output medium is a fixed size in inches rather than pixels. Digital presentation has no fixed size in inches—it depends on how many pixels the display has. Adobe highly publicized the DPI myth in the 1990s, I believe as a convenient way for Adobe to sell Photoshop to the users of Adobe Illustrator. When Photoshop was released, it was the only tool around that could set the DPI value in a TIFF file. And it cost a bundle! Illustrator couldn't change this value. To set the size of a photograph in Illustrator, the user had to buy Photoshop just to set the DPI value. Adobe could have easily allowed the user to specify this number in Illustrator, but that wouldn't have been nearly as profitable as forcing a user to use Photoshop.

The result of this DPI myth has been a couple of decades of DPI confusion. The bottom line for digital presentation: *DPI doesn't matter*. Instead, think of the number of pixels in each dimension and compare them to the pixel dimensions they'll need to be displayed at. Need proof? Ask yourself why Photoshop imports Kodak PhotoCD images as 72 DPI when they were scanned with a Kodak film scanner with a resolution of more than 1800 DPI. The answer is that the PhotoCD file format specification has no DPI value. Photoshop defaults to the old legacy screen resolution of 72 DPI. Even funnier is that almost no digital displays ever actually had an exact resolution of 72 DPI. The computer industry is fun, in a painful sort of way!

Another example is that DVD output resolution is required to be 720×480 at 29.97fps (*frames per second*) for NTSC and 720×576 at 25fps. No matter how hard you try, you're not going to get a DVD with a higher resolution or better frame rate. If you did increase the resolution or the frame rate, you wouldn't have a DVD anymore.

If your shows may be output in a different way in the future, think about resolutions beyond your current needs. You may only have a requirement for DVD this year, but what about next year or two years from now? Blu-ray is now the worldwide standard for high-definition video on a disc. Its pixel resolution can be 6 times that of DVD. Make sure you are using imagery that will look good when you output to Blu-ray later.

For web output, you have to deal with many trade-offs. The best quality and the smallest download burden is had from the Photodex Presenter. This is a free plug-in that anyone can install. It doesn't have spyware or other harmful elements. It's merely a way to display the output from ProShow in a web browser. However, the fact that it is a plug-in means that many users either will not or cannot install it. Some companies, for example, forbid the installation of plug-ins that are not already approved by the IT department. This is unfortunate, because the alternatives are often dismal in comparison.

Tip

How do you make the most compatible DVD? The best way is to get professionally replicated (*pressed*) discs because they will be compatible with nearly all players on the market. This is because professionally produced DVDs are *pressed,* rather than being optically *burned* with a laser. For lower-volume production, use DVD+R media with a drive that can do *bitsetting*. Not all drives can do bitsetting, but both ProShow Gold and ProShow Producer support *bitsetting*, and it will work if ProShow detects the drive. Bitsetting writes to the inner portion of the DVD that specifies the disc's media type and overwrites it with the signature of *pressed* disc instead of DVD+R disc. The signature literally means DVD-ROM (*Read-Only Memory*) instead of DVD+R. Few DVD players can distinguish between a DVD+R that has been bitset and a professionally *pressed* disc. From our tests at Photodex (of well over 100 different players across all major manufacturers), bitset discs are about 10 times as compatible as the next best non-bitset discs. Many people recommend DVD-R over DVD+R, and there is a lot of hot air flying around about what works best. I don't believe anyone recommending DVD-R has actually run thorough tests to prove it as we have. DVD+R with bitsetting is definitely the way to go if you cannot get professionally *pressed* discs.

The alternatives to the Photodex Presenter are almost all video options. Video is a way of encoding visual data using some tricky compression schemes. They're all basically the same idea. The problem with delivering video over the Internet is the size of the data versus the quality. As the quality increases, so does the size of the data. If you want small data, you're going to have poor quality. Depending on your show, video can be about 10–20 times the size of a Photodex Presenter .px file and is guaranteed to be lower quality. The higher the resolution, the more the data size difference will be.

Sharing on the Internet is one of the best and easiest ways to showcase your work. Free services like YouTube and Facebook are fun, easy, and effective. If possible, stick with highly standardized forms of sharing like YouTube and Facebook. ProShow offers various ways to put your shows online. Some take no experience and technical know-how, and others require much more knowledge of web development.

If you're going to be playing back a show using a projector, you need to focus on a few special points to prevent an otherwise embarrassing experience. In these situations, using video can be better in some ways than depending on nonvideo playback. However, video comes with compromises—the biggest, perhaps, being quality. The advantage of video is that it usually requires less CPU power to play.

Note

Photodex often receives support calls describing problems with Internet access and how some people have problems viewing shows online—both with Presenter and video formats. Most people don't realize that the Internet is not a direct connection to Photodex or any other server. There are usually 5–20 connections (*hops*) between the user and a server on the Internet. If there's a problem with *any* of those connections, there will be a problem with what the user sees. Another huge source of Internet connection problems is the software configuration of the user's machine. Usually, connection problems happen outside of the control of the company running the site.

This is not necessarily true if you have high-resolution video, by the way. Real-time playback is technically perfect in visual quality but can suffer from speed limitations of the machine and software configuration.

The best rule for those giving live presentations is to rehearse whenever possible. Use the same computer and projector you'll be using in the same environment. If you don't, something is bound to fail. Don't just assume that if you show up with a laptop, the right cable will be available for you to hook it up to the projector. Don't assume you'll be able to get the audio to work. Even something as simple as not having the right audio adapter can destroy your day. Get as much information as you can in advance, and if possible just before the event, test everything by hooking it up and rehearsing your show.

Resolve Resolution

I'm going to step out on a limb here and say some things that may raise a few eyebrows. Brace yourself, because this does make sense.

Resolution just doesn't matter very much to most people.

There. I said it.

If you author a DVD in the United States, it is limited to 720×480. You can worry about megapixels, quality, and focus for a super-huge image if you really want to, but it just won't matter unless you can see a problem in the resulting DVD. Most people won't.

Most people are driven by emotion, friends, family, and events. They are not driven by megapixels or the ability to print wide-format posters with breathtaking clarity and sharpness.

Playback Jerkiness

Users sometimes describe problems with *frame rate* and *jerkiness.* There are two major sources of problems; one is intuitive and the other is not. The intuitive one is the *frame rate*, and it boils down to the computer not being powerful enough to play back a given show at full speed. This causes the frame rate of the show to slow down. It may speed up and slow down at different parts of the show, because the speed is directly related to the complexity of the show. More layers, for example, take more time to render and lead to slower playback. This is the lesser of the two major problems.

The greater problem is *jerkiness,* which happens for completely different reasons. ProShow is a Windows application that depends entirely on the timing of the operating system to play back each frame of the slide show. Unfortunately, Microsoft has never claimed that Windows is a *real-time* operating system. This is a clever way of saying, "You have no guarantee *anything* will happen at *any given time.*" In reality, this is not a huge problem because most modern machines do have the performance required to get perfect or near-perfect playback. The bigger source of the problem is other software that slows things down or makes things break completely. The worst offenders are poorly written device drivers, anti-virus products, and anti-spyware products. These products get in between the operating system and ProShow, creating delays that make it impossible to play back slide shows without occasionally jerky playback. If you have trouble, please contact Photodex. Sometimes these problems are difficult to diagnose, but there's often an easy work-around.

There is much talk in the industry about resolution, quality, and similar technicalities. This has historical roots among professionals because they are paid based on the quality of their output. They have highly trained perception for such things, and they cannot be competitive in their jobs without paying attention to these details. Sometimes professionals become so focused on technical details that they overstate their importance.

Professional standards are often quite different than those of the average person. Most people are more interested in the substance of what they see rather than the technicalities.

To illustrate the relative importance of image resolution, consider the change from black-and-white television to color compared to the change from color television to HDTV. These two changes show clearly that as resolution increases, people care less about it. When color television hit, people loved it. It had a huge impact, and the advantage was obvious to everyone. Nobody questioned that color televisions were much better, and everyone knew they wanted them. HDTV is a little bit different. Many people don't immediately see the benefits compared to the costs, and the overall value of HDTV is much less of an improvement on color television. All you get with HDTV is a clearer picture.

The interesting thing here is that HDTV is a much larger technical leap than the shift to color television. Color television didn't change the amount of data in a video nearly as much as HDTV. The difference in size between an NTSC television and an HDTV is shown in Figure 3.1. Besides the surface area, NTSC video uses interlacing, which cuts the video data in half. HDTV generally does not. So the difference in data rates isn't just the difference in surface area in Figure 3.1, but double. Shouldn't HDTV be even more valuable than color televisions were?

Figure 3.1

A comparison between the amount of video information in an HDTV compared to the older NTSC standard.

The reason the shift from color television to HDTV is less valuable has to do with what the viewer sees. The value of an HDTV image just isn't that much more compelling because viewers aren't focused on the resolution—they're focused instead on the message. The message is the same. As long as you can see what's going on, most of the value is there.

Keep this in mind when you consider the value of resolution. When accepting advice from others, consider whether they're overestimating the importance of quality for your purposes.

If you think what you're doing looks okay, it most likely is.

Use Styles

The concept of *slide styles*, shown in Figure 3.2, was added to ProShow Gold and Producer early in 2009. Three years later, I am still amazed when I see how much power these little widgets have added to ProShow. They save enormous amounts of time and make exchanging the construction of show elements effortless. Since Photodex first introduced style packs, many third-party publishers have also developed their own style packs for ProShow. As of this writing, there are already thousands available for sale—many even for *free,* and the market continues to grow every day.

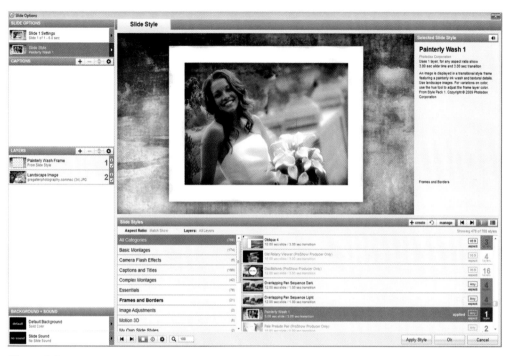

Figure 3.2
The ProShow Slide Style tab of the Slide Options dialog.

One huge advantage of these style packs is that they can make your shows consistent. If you like the way a certain slide turns out, it is incredibly easy to save that slide as a style. At any time in the future, repeat the exact style with a couple of clicks. Be careful to vary your slides, though, because using the same style on each slide can quickly become boring.

Another thing I'd like to mention that most people may not immediately be aware of is that you don't have to use styles exactly as they look. If you find a style that is almost what you want, you may be able to adjust it. Go ahead and choose the style, and then fiddle with the layers after you've selected the style. Perhaps a photo won't end up exactly where you want it, but that's okay! You can change where it moves using ProShow's usual interface. You can modify all the attributes of all the layers even after a style has been selected. If you screw up, you can easily undo your adjustment or even just reselect the style and start over. Think of a style as a starting point instead of an ending point, and it will become even more powerful than you may have realized.

Caption styles are another handy tool. Although they are available only in Producer, I'll tell you how to cheat on this. But first, let me describe Producer's caption styles and why you should use them.

Consistency is important, especially with captions. If you use caption styles, you get two things for *free*. First, you never again have to remember what the exact settings are for your captions; second, you can change your mind for the whole show later. Imagine completing an entire show and then deciding that you want to change the font in all the captions. Having to go back and change the text attributes for each caption would be a nightmare. This is why we introduced caption styles into Producer, and it has saved us a lot of time. I'm sure this will save you time as well.

If you're using ProShow Gold, you don't have caption styles. However, there is one thing you can do to get some of the functionality of caption styles. This doesn't solve the problem of changing your mind, but it will make it easier if you have to switch back and forth between a couple of different caption styles.

ProShow is designed to make *best guesses* about what you intend to do based on what you did last. You can see this when you add a new slide to a show by dragging a photograph. ProShow always uses the slide time and transition time from the slide that is centered closest to the exact point you drop the new photo. It has done this ever since version 1.0.

One of the *best guesses* ProShow makes has to do with font attributes for new captions. All new captions are created with the default font attributes of the last caption that was edited. What this means is that if you go to a slide containing a caption that has the attributes you want, go to the Caption tab and make any change to the text in a caption, the *default* caption attributes will be set to the attributes of the caption you've just changed. So, all you need to do is make a change in a caption that won't hurt anything in the caption. Click on the bold button, and then click on it again. You've just bolded and unbolded the caption, which leaves it in the same state it started out in. Voilà! You've made a *nonchange* to the caption, and the next caption you add will have the same text size, color, and so on.

This little trick saved me a lot of time when I was making shows before ProShow Producer was introduced with caption styles.

Another trick uses styles as a way to save ideas. After you've created a slide you really like, save it as a style. Give it a category name like "ideas." It only takes a few moments, and you'll be able to replicate that style in the future very quickly without thinking much about it. This category of "ideas" ends up being a little library of yours that you can refer to later. You can even use a presaved style as a starting point for a new slide later. If you get a lot of ideas going, you can filter the style list so it only shows you your ideas.

I'd like to say one last thing about styles: share them. ProShow allows you to import and export styles, and each style file that is exported is a single file that contains all the necessary information and media to fully implement that style on

another machine. This makes it easier to move all your styles to another machine or give them to others. They're powerful, so share them!

Use Copy+Paste for Consistency

A handy trick to keep a consistent feel for slides is to copy an existing slide and replace the important content. Let's say you spend an hour setting up the visuals and captions for a complex slide. It turns out great, and you're happy with it. After three or four simpler slides, you want to make a slide that is somewhat similar but perhaps a little different. Perhaps the captions need to be basically the same, or there are only two photos in the new slide instead of three, but the basic theme should look and feel the same. Click on the first slide you made, press Ctrl+C (or right-click and choose Copy), click on the next slide, and press Ctrl+V (or right-click and choose Paste).

Hot Keys Are Your Friends!

I'd like to point out here some valuable experience I learned in the late 1970s that has been almost lost today in the computer industry: *hot keys save you a lot of time!* Using Ctrl+C for copy and Ctrl+V for paste at first may seem complicated if you are a novice user. This is *only* because it is new to you. Within a few uses, you'll get used to it. Hot keys are faster than using the mouse. One huge reason is that you can leave your left hand on the left side of the keyboard while using your mouse with your right hand. You can press Ctrl+C and Ctrl+V without moving either of your hands away from the standard typing home position. This means your mouse is used primarily for navigation of the user interface and not for performing the action. If you ever want to see just how much faster a seasoned professional is because of hot keys, watch a professional artist work with Photoshop. It is dizzying how fast this person can make the software jump without using the mouse. He appears to just magically be telling the software what to do. He uses his left hand for every conceivable action and his right hand for user interface navigation and positional control of objects. With hot keys, a user of ProShow or Photoshop can easily work several times faster.

Once you copy your original slide, you can more easily replace the important content and adjust it to suit the new slide's requirements. You may need to replace every caption or change the number of layers. You may need to adjust the position or movement of certain pieces. The key benefit of this technique is that the overall look and feel of the slide will not change unless you change it. Most of the structure stays the same.

Another variation of this same technique is useful when you know you have several slides that will need to look and feel the same. For example, in a business presentation, you may need 15–20 slides that each use captions to form bullet lists.

Make sure these are consistent so the audience doesn't focus on look-and-feel changes. To do this, create a fake slide that has the maximum number of bullet points you expect to use. You can make captions for each of these that say simply "Bullet point 1," "Bullet point 2," and so on. The idea is to put everything in this slide that can appear on any of the slides you'll use it to create. Figure 3.3 shows how this might look.

Figure 3.3

To keep bullet lists consistent in a business presentation, start by creating a template slide for all of the bullet list slides. Copy the slide for each new slide, and then edit the captions to fill them in with the real bullet points.

I think of this as a *template slide*, but I want to make sure not to confuse anyone. This doesn't have to do with the template feature in ProShow Producer. I think of it as a template slide simply because I'm using it as a template to create other slides.

Spend enough time making this template slide look exactly the way you want it to, because it will take more work to change everywhere you've used it afterward.

As you make your show, copy this slide, select where you need a new bullet point slide, and paste it. Then change the captions to say what your bullet points need to say. Remove bullet point captions that aren't used. Set the timing for the appearance of each bullet point to the voice-over of that slide. In general, modify the slide as necessary, but retain the original look and feel. Voilà! Instant consistency!

Once you're done with your show, delete the template slide. In the final show, nobody will know that the fake template slide existed in the first place.

> **Note**
>
> With ProShow Producer, you can more easily create this template slide in a separate show file using Projects. This is functionally equivalent to using a template slide in ProShow Gold as I've described here, although it is a little more organized. I should add that Projects in ProShow Producer have far more uses than just this little trick, and this trick isn't the intent of ProShow Producer's Projects feature.

Find More Ideas

If you are like most people, you may feel like you don't know anybody who can help you with issues relating to slide show production. This section talks about two great places you can get help and material for your shows.

Photodex Resources

Photodex runs an active blog (www.slideshowblog.com) and YouTube channel (www.youtube.com/photodexcorporation), both of which offer great training videos, how-to articles, and tips about creating slide shows with ProShow. If you haven't yet, check out the blog and YouTube channel online. They're free resources that are updated almost daily with new information, inspiring sample slide shows, and cool give-aways for users.

Photodex also sells a collection of style packs, which add preformatted slide styles to ProShow. Not only are these usable right away, but they give you ideas for visual effects you can create in your own ways. Many professional users buy the style packs and then study the construction of the styles to come up with their own effects.

Online Forums

Thousands of people online will answer your questions and give you new ideas. One great resource is the unofficial ProShow Enthusiasts Forum at www.proshowenthusiasts.com. This is a user-run forum started by Mike Gregg that is completely outside the control of Photodex Corporation. The users who frequent this forum are genuinely interested in how to make the best slide show, where to find answers, and which resources are the most helpful. Members post links to shows they've created, ask for feedback, and discuss the different approaches they've taken with slide shows. Some are hobbyists, some are professionals, and many produce slide shows for a living.

Another great resource is the Photodex fan page on Facebook (www.facebook.com/photodex) with thousands of active daily users sharing ideas, asking questions, and posting their slide shows for others to see.

Review

In this chapter, I've tried to point out the importance of how you do things. The rate you can complete shows depends on how efficiently you can complete tasks. As a general rule, I say, "optimize your optimization!" Think about how you do things, and notice when you can do them quicker by changing or reorganizing steps. You'll be surprised at how fast you can get things done if you constantly optimize your own methods.

4

Space and Simplicity

Slide shows contain visuals and audio in a format that plays through time. Think of visuals, audio, and time as separate elements that are related. They are three dimensions of slide shows. Each is a separate discipline that you can study and refine.

This chapter is about ideas that have to do with visual space—the two-dimensional space that represents the visual part of your show. To master slide shows, you need to think about still visuals as well as moving visuals. Most of this chapter talks about still visual composition—not moving slide shows played over time.

To be clear, this chapter refers to a *visual* as what you see at any instant in your show. Most of this chapter assumes there is no motion happening.

Space—It Is Your Density

As a person living in modern society, you are undoubtedly used to seeing visuals like the cover of this book. Go ahead and take a look at it. What about it looks professional? What gets your attention? Close your eyes for a moment, try to think of nothing, and then look again. This time, take note of the first thing you notice about the visual image that attracts your attention. If you do this several times, you notice that certain things about the cover tend to grab your attention and other things do not. Good graphic designers do this kind of analysis to figure out what needs to be changed as they work with artwork for such things.

> **Note**
>
> Grab a can of soup or a similarly labeled item from your kitchen and carefully remove the label. Flatten out the label on a table and look at it as a rectangular piece of paper. On another piece of paper, make a list of individual elements of information that you see on the label that would have to be present with any similar product. With your favorite paint program, try to make a label for an imagined product from scratch. You will most likely be shocked at just how difficult it is to make this kind of artwork look like something you'd expect to see in a store. This is called *product packaging*, and it is a very specialized career within graphic arts!

It is surprisingly difficult to produce artwork that looks professionally produced. This is why graphic artists have a job! Becoming an expert on visual artwork is a full-time career, and artists who are really good at it are rare. With a few basic tricks, however, you can clean up your visuals nicely.

One key aspect of art to watch for is *density,* or how *busy* each area of your visual is. If you have a lot of small text in one area and a large open space in another, those two areas have different densities. You can judge density by looking at the whole and seeing if there are differing areas that cry out for attention. Some artists refer to this concept as if the art is talking to them, which is an effective way to think about it. Figure 4.1 shows two examples of density contrasting different intended purposes for each image.

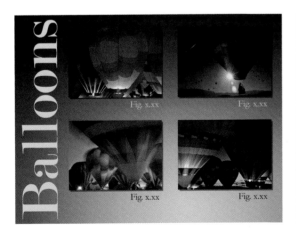 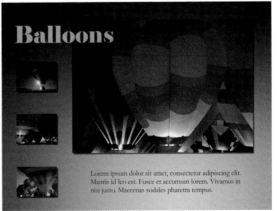

Figure 4.1

Each area of your visuals should look balanced, and each part should have a proportional density to its purpose. (Photo Credit: Sherron Sheppard)

Focus

At Photodex, I am known to state various adages that have grown out of lessons I've learned over the years. One of them is that you can claim success when your target audience doesn't notice what you did except to buy whatever it is you're selling. In other words, if they don't notice, your visuals looked perfect. If the audience talks about the visuals first, your visuals distracted from the point of the show.

Regardless of how much polishing you do with your visuals, remember that the subject of your visuals should be obvious, and anything that is not important should not attract attention. For example, never use a background image that is more interesting to look at than the foreground. Further, do not be afraid to use boring backgrounds! If you are successful, the audience shouldn't notice the backgrounds. If they do notice, they certainly shouldn't think the background is out of place.

It's better to make your point clearly than it is to have it look so polished and professional that you lose the audience's interest. Some of the most professional advertisements are shockingly simple in construction.

Edges, Frames, and Letterboxing

The edge of your show is important. Not realizing this is one of the simplest and most common oversights beginners make when composing slide shows. The sizes of images included in a slide show and their placement relative to the edges of the show have an impact on the overall composition because of the edges of the show.

Letterboxing is a common result of this kind of interference at the edges. Almost everyone has seen a *letterboxed* video because of the difference between older television standards and new widescreen televisions, as shown in Figure 4.2. The black rectangles at the edges are caused when the original images are fit within the frame of the output. In other words, the show isn't the same size as the visual being displayed, so the black background shows through.

2.35:1 (theatrical) image in 16:9 frame

16:9 image in 4:3 frame

3:2 image in 16:9 frame

Figure 4.2

Top left: theatrical movie fit into a widescreen television. Top right: widescreen DVD fit into an older 4:3 television. Bottom: 3:2 photo from a camera fit into a 16:9 frame.

This kind of composition isn't so distracting for a movie because the entire movie will be letterboxed the same way. However, in a slide show where different visuals are presented and scaled differently, it is distracting.

Think about this problem in terms of a picture frame. Figure 4.3 shows a photo in a picture frame without regard to the border around the frame. Would anyone ever really frame a photo like this? Of course not; it looks awful. The same is true of visuals in a slide show. Think of the edges of your slide show as a picture frame, and this edge rule may become clearer.

Figure 4.3

The photo on the left was framed without regard to the overall composition. The right photo looks much better.

Slide show software defaults to fitting images into the show frame, which is the best assumption that can be made. Unfortunately, this is only done as a starting point, and it is up to you to adjust the scaling of your images so the composition looks good.

Always be aware of the space between the edge of the show and the images it contains. Either scale your images up so they fill the entire show frame without a background showing through, or make them smaller so there is a comfortable space around them. When the edges of your visuals get too close to the edges of the show, an uncomfortable letterboxing feeling results, and the audience becomes distracted.

Figure 4.4 shows a common framing example that happens if an image is fit into a slide show and the image does not quite fill the frame. Notice the black areas to the left and right of the left visual that are avoided when the image is zoomed in just a bit, as is shown in the visual on the right.

Image not scaled optimally

Image scaled to fill frame, eliminating distracting gaps

Figure 4.4

Notice how the visual to the right looks much more finished without the black borders on each side.

Balance

The size and look of objects should be similar if they are of similar importance to the audience. If one object should be more important than another, it should be larger or at least grab more attention than the other. If they are reversed, your emphasis can easily be lost. Figure 4.5 shows how a slight difference in size and position can create an unwanted emphasis where there should be none and make the composition look unfinished.

Figure 4.5

The left visual shows two images with slightly different sizes and alignment. The right visual looks more polished.

Rule of Thirds

The rule of thirds is a simple way to position visuals so they are easier to look at and more pleasing to the mind. The rule works for many reasons, but in a nutshell, when followed, it makes the mind spend less energy accepting what it sees.

Figure 4.6 shows visual space divided into nine regions, with two horizontal lines and two vertical lines. There are four intersections where the lines cross. Each space between lines is one-third of the space. This is why it is called "the rule of thirds."

Figure 4.6
The rule of thirds.

Our minds like it when interesting things are positioned on the lines. They like it even more when things are positioned on the intersection points. The results are better when there are more interesting subjects appearing on lines and points. Results are better still when the space away from the lines and points is completely uninteresting because it leaves all your attention focused on the lines and points. ProShow's previews include a right-click option allowing you to turn on and off composition lines, which can be used as a guide for the rule of thirds.

When a subject is directly in the center of the field of view, the audience's mind focuses on it completely and spends energy figuring out how it relates to everything else. The audience might even feel a sense of confrontation. When the subject is moved to one side, however, the composition feels much more natural and friendly. This is shown in Figure 4.7.

Figure 4.7
An image moved to one side feels much more natural and friendly than one directly in the center.

Figure 4.8 shows the effect of moving an image up or down in comparison to centered vertically. You can see from different examples that when the horizon line is centered, your mind tries to decide whether the sky or land should be dominant. When it is moved up or down to a third line, the composition feels more natural because the dominance of the sky or the land is obvious.

Center **Up** **Down**

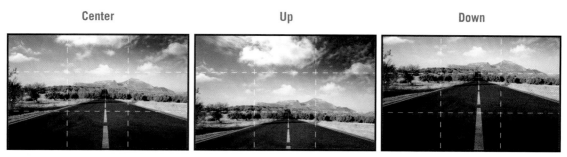

Figure 4.8

Placing horizons on third lines is much better than centering them vertically.

Figure 4.9 shows multiple objects aligned with thirds, producing a nice composition. Notice how the graduate on the right isn't quite aligned with a third line. The rule of thirds is a guide but does not always have to be followed precisely.

Figure 4.9

This example shows a photo with multiple objects aligned with thirds, producing a nice composition.

The rule of thirds is handy, powerful, and always worth thinking about. Sometimes, though, you'll find a reason to break this rule, and once in a while, breaking it can provide the artistic *punch* you want to turn something ordinary into something remarkable. There is no single set of rules, so use your judgment.

Angular Agreement

When possible, line up edges so they are parallel. Avoid using a lot of different angles unless the overall composition overpowers the different angles. Figure 4.10 shows an example of how a small change in angle can remove a subtle conflict that otherwise distracts the audience.

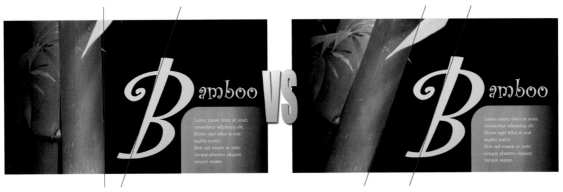

Figure 4.10
The illustration on the right shows that when things are aligned, an image is much easier to look at.

Sometimes there are so many regularly sized angles in an image that they are unimportant to the overall message. In this situation, angular alignment might actually get in the way of the goal.

Layout

Layout is a description of how visual elements are arranged. Arranging objects in different ways can dramatically change how we see the visual.

Focal Flow

When you look at a visual, your eyes scan from one object to the next. How your mind decides which object should be looked at next has a lot to do with the object's density, its visual complexity, and where it is relative to other objects. After quickly studying what you see, you eventually become disinterested when you feel you've gotten the overall idea. You may look at each object several times with increasing levels of study. The creator of a visual can direct the order in which you see objects by arranging the objects in certain ways. This arrangement is the layout. An example of a visual that clearly directs the order in which you see things is shown in Figure 4.11. Which element of this visual jumps out and grabs most of your attention?

Figure 4.11

This illustration uses layout to control the order of things the user sees.

I find it effective to place visual objects toward the left of the visual with supporting objects or information to the right. This probably has to do with my native language being English, which is read from left to right. In any case, I find that point lists, for example, work better when placed to the right of an illustration. If the illustration is *eye candy*, or unimportant artistic "fluff," it's often better at the right. Figure 4.12 shows an example whereby the image to the left has been added only to make the composition look better.

Figure 4.12

A common theme for point lists shows an image to the left and supporting information to the right.

Note

Eye candy: Things put into a visual for the sole purpose of looking good. Eye candy has no real value but makes people feel like the visual has more value.

Fighting Versus Cooperation

You can create a sense of peace or conflict by changing the direction people are facing. Figure 4.13 shows two men positioned differently to imply different situations. When people are shown face-to-face, they are thought of as cooperating and getting along, depending on their facial expressions, of course. If they are peers, it is often best to show them facing the same direction. If they are back to back, they are thought of as enemies or likely disconnected from each other.

| Peers (same facing) | Cooperative (facing) | Opponents (back-to-back) |

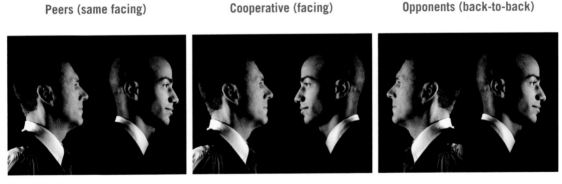

Figure 4.13
The direction people are facing can have an important-but-subtle effect on the way the audience perceives their relationships.

Face the Middle...Mostly

Always try to arrange photos such that people look across the middle of the visual. When people's faces are looking away from the center of a visual, the audience subconsciously moves its attention away from the visual. When people's faces—and especially eyes—look across the visual, the audience stays focused toward the center of the visual. Figure 4.14 shows an obvious example of how much attention you can direct with image placement. The last thing you want is your audience looking away from your show.

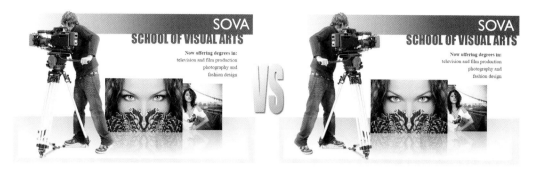

Figure 4.14

The camera in this comparison shows how much attention can be directed either away from or into the important content of a visual.

One interesting exception to this happens when a photo is used almost as a background image. For example, you can use a person looking out of the frame to cause a thoughtful feeling and put the attention of the viewer on something else in the frame (see Figure 4.15).

Photos of a woman whose face is pointing a different direction than her eyes can be used effectively to direct the audience's attention. This is the rare type of photo that can be faced in the opposite direction because the eyes can be made to be looking at something else across the visual.

Figure 4.15

Notice how the person looking out of the frame puts the audience in a thoughtful state of mind. This works well with poetry.

Barriers

Barriers are useful because they change how we relate objects to each other. Sharp edges give the impression of separation, and soft edges give the impression of relation. Figure 4.16 shows how the types of barriers between images create either separation or relationship among the images.

Figure 4.16
Notice how the barriers clearly change the impression of which elements are related.

Portrait Images

Portrait images are taller than they are wide. Landscape images are wider than they are tall. Digital displays are almost always wide, which is why they are called *widescreen* displays. Displays are wide indirectly because we evolved on the surface of the earth, which seems much wider than it is tall when you're standing on its surface. As humans, we look to the sides a lot more than we look up and down because there are far fewer important things above or below us. The early designers of televisions knew this and widened the early television displays because of it. Widescreen displays are almost twice as wide as they are tall, and motion picture displays are about one-third wider still.

As Figure 4.17 shows, widescreen displays work well with landscape photos. Composing shows with landscape photos is natural because of the similar shape of the widescreen displays and the landscape photos. However, portrait photos cause all sorts of composition problems. Once you've scaled a portrait photo to fit in the frame of the widescreen display, what do you do with the blank area to the left and right of the portrait photo?

For years I've told photographers to stop taking portrait photos and instead take landscape photos. I ask them to simply ignore the image to the left and right of the subject. It is always easy to crop a landscape photo into a portrait if necessary. Many photographers now shoot only in landscape mode and crop to portrait when printing. It takes some getting used to, but it makes slide show composition much easier, and there is virtually no reason to shoot portrait anymore.

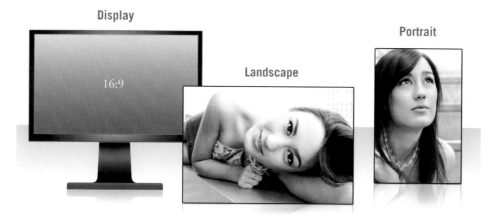

Figure 4.17

Widescreen displays work well with landscape images but not so well with portrait images.

When you find yourself having to include portrait images in a show, you might try some of the following ideas to avoid awkward-looking results.

Side-by-Side

Try including two portrait images next to each other. Be careful to crop the images to the same aspect ratio and have them scaled identically, because the mind is sensitive to symmetry. Figure 4.18 shows a comparison between almost symmetrical composition and an exactly symmetrical composition.

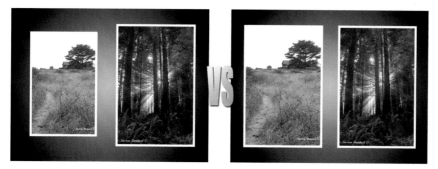

Figure 4.18

The visual on the left shows that the photos aren't quite positioned correctly and aren't quite cropped the same. The image on the right is exactly symmetrical, which makes it look much more professional and polished. (Photo Credit: Sherron Sheppard)

ON THE DVD

Example *Chapter 04-Number 01*: This example demonstrates the difference between slightly misaligned photos and perfectly aligned photos.

You can also blend two images with a fade as shown in Figure 4.19. This is a good-looking trick that can be accomplished with a photo-editing program to create the transparency for the blended edge. Alternatively, you can use a mask layer with ProShow Producer to create the same effect.

Figure 4.19
This example shows two portrait images scaled and blended together with a fade.
Neither of these images would have fit nicely within the frame without the other to fill the frame.

ON THE DVD

Example *Chapter 04-Number 02*: This example shows the result of blending two images with a fade.

Alternation

When you have several portrait images, show them in sequence, but position them as if they were next to each other. However, only use one in each slide, alternating which side is used for each slide (see Figure 4.20).

Figure 4.20
Alternating between two images is a clever use of time and layout to present portrait images and create separate interest in each photo. (Photo Credit: Sherron Sheppard)

Example *Chapter 04-Number 03*: This example shows the result of alternating portrait photos on each half of the show.

Avoid Mixing Portrait and Landscape Images

Avoid mixing sequential portrait and landscape images unless you do something different to incorporate the change into the overall style of your show. The layout necessary for portrait and landscape visuals is vastly different. When you switch from one to the other, the change in orientation demands mental energy from the audience. This is always a distraction and always bad.

Instead, try to show batches of each orientation together, as in Figure 4.21. When you switch from one to the other, use a different type of transition to give the audience a mental cue that something is different. A short fade through a black slide is an effective way to do this.

Rough progression

Smooth progression

Figure 4.21

Avoid identical transitions between portrait and landscape images.

Example *Chapter 04-Number 04*: This example shows the difference between a sequence of slides that switch directly between portrait and landscape photos as compared to sequences of slides that form batches of portrait and landscape photos.

A trickier way to do this is shown in Figure 4.22. When switching between portrait and landscape images, you can use a slide that rotates portrait images into the landscape or vice versa. Be careful with this kind of effect so your show doesn't become a showcase of special effects. Effects should not distract the audience from the point of the show.

Figure 4.22

With creativity, you can stylize the changes between portrait and landscape such that
the change itself becomes a slick part of the show.

Example *Chapter 04-Number 05*: This example shows a trickier way to
transition between portrait and landscape photos to separate batches.

Captions

Captions are strings of text that convey information. In general, avoid using cap-
tions unless it is necessary. Never show a caption that says something the viewer
can derive by simply looking at the visual. Never describe the visual. Instead, use
captions for information that the audience could not get from the visual or voice-
over. Describe things like what people are thinking, what they are feeling, how it
feels to be there, or something about the story. Figure 4.23 shows the difference
between a caption that adds little to the composition and a caption that adds
humorous information that cannot be derived from the visual alone.

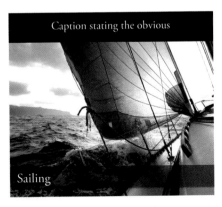
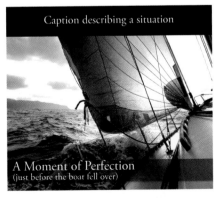

Figure 4.23

Use captions to describe things that are not obvious about the visuals in the show.

Another general point about captions is to consider using voice-overs instead of captions when possible. Voice-overs work well and do not add visual complexity.

Font Choice

Choosing fonts is one of the most overlooked tricks in making a show feel unique. Good graphic artists know that a good font choice often changes people's feelings about what they see.

There are no hard and fast rules about how to choose a font, but there are four things I ask you to think about when choosing fonts: uniqueness, readability, personality, and the two-font rule.

Uniqueness is simple: avoid default fonts. This means don't use Arial or Times New Roman, and avoid Comic Sans! This is because everyone using a computer has seen these fonts and is tired of them. You'll have better luck if you use almost anything else. Remember that most people use the default fonts; this simple trick of font uniqueness will set your show apart.

Readability describes how easy the font is to read. It is directly proportional to how plain the font is. Remember that captions exist only to convey information. Don't add so much style that people can't read your captions. Serif fonts, like the font used for this book, are easier to read when there is a lot of text. San Serif fonts are more difficult to read but appear more sleek and modern. They are good for short captions. This is a balance—you want your captions to be unique but not so stylized that they are difficult to read. Figure 4.24 shows a contrast between Arial, a simple and easy-to-read font, and Old English, which is difficult to read.

Figure 4.24

It's easy to choose a font that's boring, but it's just as easy to choose a font that's nearly impossible to read.

Personality describes the feeling you get when you look at a font. Choose fonts that match the intent of the show you're creating. For kids' shows, you can be more creative and silly. For business shows, choose more of a conservative and powerful font. For romantic shows, try a script font, but keep in mind that the text must be readable to be effective. Figure 4.25 shows the three major types of fonts.

Figure 4.25

Three common font categories.

The two-font rule is a simple rule I learned from typesetters in the 1970s. Choose two fonts that look good together, and then use only those fonts. You can use bold and italic to vary these two fonts, but be careful not to overdo it. It is amazing how unprofessional a visual can look with more than two fonts. On the other hand, if you use only two fonts, it is difficult to have a bad-looking design as a result. Figure 4.26 shows what happens when too many fonts are used.

Figure 4.26

As you can see in this example, using too many fonts can easily make a visual look poorly done.

Outlines, Shadows, and Colors

Try to use the same color, size, and style across all the slides in a show, or at least in each section of a show. Changing the style or size is a distraction to the audience.

Be aware of the background behind your captions. Some captions may appear on dark backgrounds and some on light backgrounds. When the caption color is too close to the background color, the audience can't see enough contrast to read the caption. You can make a caption style work in both situations by using a high-contrast outline. For example, if you use white caption text, consider a black outline. Shadows also help add contrast by darkening the area behind the caption.

See Figure 4.27 for a great example of how trying to keep all the captions one color can be nearly impossible.

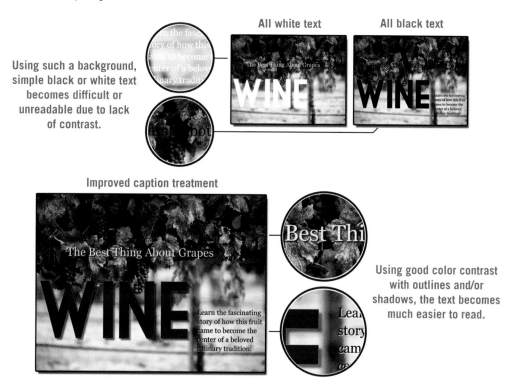

Figure 4.27

Varying the color, outline, and shadows of text can greatly increase the readability of the captions.

I always tell people to avoid using red caption text except in specific stylistic situations. Red text is tempting to use, and I've seen it used far too much. Red is almost never a good choice, though. The only place red text looks good is where the style of the show is specifically designed such that bold, red captions with a powerful font are a good part of the feeling. A good example of this is a Halloween slide show where the red text is used for effect.

In general, white or nearly white text with a black outline and a dark shadow is a standard and safe choice. If you choose to use other colors, make sure you are consistent through the show, or the captions will be distracting to the audience.

Placement

The bottom one-third of the visual area is called *the lower third.* This area is exactly as it says—the lower third of the image, as shown in Figure 4.28.

Figure 4.28

Caption bar shown in
the lower third of an image.

If you watch television, you have probably noticed a lot of captions placed in the lower third, especially in news programming. This is because it is generally the best place to put caption information without interfering too much with the way people perceive the rest of the visual.

Depending on the type of show, you can also place headings at the top of the visual or in various other places. For general information, though, putting your captions in the lower third is a safe choice.

When the captions are the primary focus of the visual, it is often effective to place them at the top of the frame or on the sides, as is shown in Figure 4.29. This usually is most effective when the captions set the context of the overall visual rather than the other way around.

Figure 4.29

An example showing a caption
heading at the top of the visual
and on the side.

Animation

Caption animation is useful to break up the monotony of a slide show, but it should be used carefully and consistently. Avoid using too much animation, and limit the timing of the animation to something that isn't distracting. Caption motion is similar to font choice in that if you use many different types of caption motion, it wastes the audience's energy, and the audience is more likely to see it as unprofessional.

Bullet lists in a business presentation are a great place to use careful caption animation. Be careful, though, because you don't want your presentation to merely be a showcase of show technology. Anything that distracts from the information gets in the way of your message, but a little pizzazz can make the show less boring.

Caption animation can also be used stylistically to introduce things in a show. Once again, be careful to use this kind of effect sparingly and when it is not going to detract from the point of the show.

ON THE DVD

Example *Chapter 04-Number 06*: This example demonstrates some basic caption animation used to polish the style of a show.

Consistency

Inconsistency is one of the most common errors that novices make, and unless you've been told why things look out of whack, consistency is difficult to learn on your own. The style, colors, placement, and attributes of your captions should be consistent throughout your show.

When I wrote this book, I really wanted to place this section before the rest of the caption points, but I didn't. It's important to know about all the other caption issues first. The caption variables should be consistent across every slide of your show.

For example, when you have a caption in the lower third of a visual, make sure it appears in exactly the same way as in the other slides that have a similar construction. This includes color, size, font, attributes, style, caption motion—*everything!* You can easily do this by copying earlier slides just to make sure the construction of the caption area is identical between the slides.

Every time you change anything about caption display, it demands more mental energy from the audience. Be careful to avoid wasting your audience's energy. Be very consistent about how, when, and why you use captions the way you do.

Simplicity

I'm sure you've heard the *KISS* adage: *"Keep It Simple, Stupid!"*

Although this adage certainly has merit, the full wisdom responsible for this adage is often not fully understood, at least when it comes to communications.

The key is *efficiency.* Your show has a point. This point requires that you convey some amount of information. Natural laws demand that you have to do specific things to convey this information successfully. You can think of your show as *demanding* energy to convey information.

Now consider your audience. People have a limited attention span, which can be thought of as energy. Simply put, the audience needs energy to pay attention to your show. For your audience members to receive information, they have to expend energy.

You give the audience members information, and they consume it. Every bit of information they consume uses energy. If you demand too much energy, audience members lose interest.

Simple, right? Actually—yes! Unfortunately, although this concept is relatively easy to understand, it can take a lot of practice to get really good at it.

One of the cardinal rules of audio-visual editing is to remove anything that doesn't need to be included. This is why movies are filmed with excess content and edited down to a final form.

This simple idea applies to almost everything in a show. It applies to sections of your story, to individual snippets of artwork you use to embellish part of a slide, and to special effects you use to make things look better.

Everything Needs a Reason

"If you can't think of a good reason to do something, don't."

—*Countless film and video-editing professionals*

A great example of a bad reason to include something is that you are proud of being able to do it. There are a lot of special effects possible with modern editing tools. Remember this: just because you *can* do something doesn't mean it helps your show. Focus on the reason you're doing the show in the first place, and put your technical accomplishments aside. As you get better and better at show construction, you'll be able to include more and more complex effects without detracting from your show.

Success is measured by how much the audience receives the intended message or has the intended reaction. Similarly, failure is measured by how much the audience doesn't *get it* or how much of an unintended reaction members have.

The best results occur when the trickery used to create the show is invisible. When I say *invisible*, I mean *psychologically invisible*—not truly invisible! In other words, in a really well-done show, the audience focuses only on the intended message of the show, not the techniques used to make the show. When your techniques *stick out*, they should probably be revised until they don't attract attention by themselves.

You have succeeded when the audience focuses on the topic you intended rather than the construction of the show. You have failed if the audience focuses on the construction of the show.

When you do a really good job with a show, you may have people raving about how good it was. They may want to talk about the technicalities. As you consider their feedback, try to determine whether they are raving because the techniques helped them get the message or whether they were just impressed with the technicalities. Hopefully, the techniques you used helped deliver the message and didn't just wow them.

Delivering a strong Wow! factor isn't bad, but it should never obscure the point of a show.

Avoid Gimmicks

Every decent audio-visual system includes an arsenal of flashy effects. Some of these are well known, such as the caption animation style first popularized by George Lucas in the introductory sequence of the motion picture *Star Wars*. Shown in Figure 4.30, this caption effect is well known and may even seem like a good idea to use in a show. However, unless you're doing a show for your close family or your show is directly related to *Star Wars*, avoid this effect.

Figure 4.30

Try to avoid using gimmicks like this caption effect unless it is absolutely necessary.

Avoid this effect and others like it because *you don't need them*. Everyone who sees this effect will instantly associate your show with *Star Wars*. Subconsciously, their minds will try to understand why the association is relevant. Except in rare situations, it isn't relevant at all. Instead, using excessive or gimmicky effects ends up wasting valuable energy with little or no value to the point you're trying to make with your show.

Typical gimmicks that are often overused are fancy transitions, unnecessary font changes, unnecessary special effects, caption motion, and bright and changing color choices. Avoid any trick that would distract the audience from the main topic of the show without adding anything useful.

Include Necessary Content

It seems like it shouldn't be necessary to mention this, but it is. Make sure you include information necessary to fully explain your story to the viewer. Make notes before you make your show, watch it as you're making it, and constantly ask yourself if you're leaving anything out.

If you miss a piece of information that the audience needs to make sense of what you're saying, the audience will use valuable energy trying to figure it out from that point forward.

The story is more critical than the details. Some details are important to the understanding of the overall message, but many aren't. If you can remove details and still get the larger point across, definitely remove them. Try to minimize the information the audience is expected to focus on. Audience members are much more likely to understand the message you give them if there is less to think about.

When you make a show, you see the content of the show over and over again. You may be 100 times more familiar with the show than your audience. You know the original intent of the show in advance, which is a luxury that the audience doesn't have. In most situations, the audience sees the show only once, so that first time has to count.

Remove Unnecessary Content

It's much more difficult to remove things from a show than to make sure everything is included. For each thing that could be removed, ask yourself if there is a reason for it to be there and understand why it should be there. This takes a lot of energy during the show creation stage and can be exhausting.

Depending on the type of show, you may be able to get more source material than necessary. This is usually a good idea because you'll start with a more-than-complete set of information and be able to decide what to remove. It is always

much easier to start with more information than necessary than to have less than you need and to have to figure out how to fill in the gaps when you don't have source material to do so.

If you're starting with a large set of information—perhaps wedding photos—you should pare down your content to only the best of the best. It's often better to have a shorter, more compelling show than a slightly longer show with lower-quality content.

One term I use to describe the process of removing unnecessary content is to be *ruthless* about removing things. You may like a photo and want to include it. Instead, only include it if it is one of the best photos or helps tell the story in a necessary or powerful way.

Keep two things in mind when deciding what content to include:

1. You can prioritize the importance of sections of your show in a simple way. The overall point of the show is the most important thing there is. Anything that has to be there is essential.

2. Sections of the show have to be successful within the show.

Only then do you get to the importance of slides or photos, which you can remove completely if they don't need to be there for the show or sections of the show to be successful.

Be Conservative

If you're like I am, you should probably watch out! I have an active imagination with an active sense of humor. Trying to be funny can open up the possibility of a lot of trouble. It's often better to be careful and reserved than it is to risk embarrassment.

When you think more conservatively, you also widen your audience. More people can relate to what you're saying if you're not too edgy.

Once again, cracking a joke in a show can easily end up being a huge distraction. If the joke fails, the audience will be focused on the failed joke instead of the point of the show.

Add Style, Not Distraction

Style is not essential—it's not the main topic. Any time you embellish your show in a way that is distracting or takes energy to view, you subtract from the effectiveness of your show.

One way to ensure that you're not taking away energy is to meticulously enforce consistency across your entire show. Check the captions for consistency. Check the cropping and border styles for photos. Check the color choices and font choices.

Only add stylistic elements when necessary. Sometimes adding a gradient background to a slide can actually help the audience focus on the photo or captions in the foreground by providing a nice background. But sometimes a gradient background can be so distracting that it robs the visual of its effect. When you do add stylistic effects, try to do so in the same way across your entire show. This prevents the audience from seeing changes throughout the show.

You can enhance the emotion of a show by adding stylistic elements, such as color. Warm color choices as borders and backgrounds and simple graphics embellishments around photos can add a romantic feeling. Cooler colors like green and blue can give more of a feeling of business or importance. Avoid bright colors unless you're trying to shock your audience.

ON THE DVD

Example *Chapter 04-Number 07*: This example shows the use of background colors to create feeling.

Fading to black or even a color can give a pause for the audience to think and can enhance the emotion of a scene.

ON THE DVD

Example *Chapter 04-Number 08*: This example demonstrates the use of fading to black to enhance the emotion of the show.

Review

Layout and simplicity go hand in hand. They affect each other and are one and the same in some ways. These topics easily could fill a book by themselves, and indeed many exist. I've tried to cover the basics of some of the best topics to think about.

There is no one right way to think about any of this; different situations demand completely different handling. For most shows, you can use the information in this chapter. Keep in mind, though, that there are always exceptions. As you gain experience, you'll be better equipped to balance the trade-offs.

5

Motion and Timing

The most noticeable visual difference between a simple show and a more polished show is motion. For something to move, it needs time to do it. Timing is naturally tied to motion. One cannot exist without the other.

Timing goes one step further than controlling the speed of motion. It also crosses over into synchronization with the beats and flow of the sound behind a slide show. This chapter covers these topics and includes a simple audio discussion as well.

The History of Motion

Decades ago, an aspiring film director won a contract to create a documentary series about the Civil War in nine episodes covering a total of 11 hours of video. The majority of the source material was 16,000 black-and-white still photographs from the mid 1800s. Imagine the task of creating an epic documentary with nothing but old black-and-white still photos!

To create a dramatic feel, the director used a technique that, although he did not invent, he clearly popularized because his documentary became a huge success. The technique involved pulling on a rubber band tied to the control arm of his tripod. The rubber band acts like a shock absorber and smoothes out the panning motion. This smooth motion combined with excellent narration and haunting violin music produced a compelling documentary.

The director's name is Ken Burns, and he is credited with this style of documentary. To this day, this slow panning motion is casually referred to as the *Ken Burns Effect*.

Movement, with Reason

Like anything else in your show, only use motion with a reason. Don't just add motion blindly. Ask yourself if what you're seeing in your visuals should be moving and, if so, why? If there is no reason to pan or zoom, perhaps it's best not to move the image. Usually, I find that even in a general slide show with no particular story, about one in four images should not move. This often gives the still slides more importance in the audience's mind. If every slide moves around, variety is lost, and the show seems tedious.

What is the focal point of each photo? Perhaps there is a particular person to focus on. To focus on an individual, zoom in to that person. To show how that person relates to a scene, start closer to the person and slowly zoom out to show the rest of the photo. A simple example is shown in Figure 5.1.

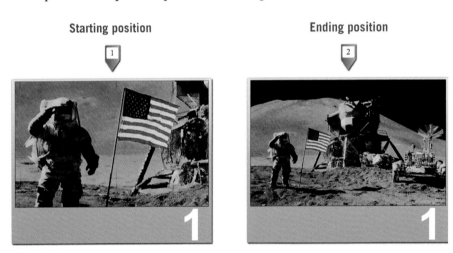

Figure 5.1
This slide starts with the main subject of the astronaut and flag and zooms out over time to show the whole scene.

Avoid overusing rotation. I suggest using rotation in at most one out of four images. Rotation is disorienting, so try to use it only with images that seem to match an idea of rotation anyway.

When an image moves, the subject matter moves along with the image. Use motion to align subjects with each other during a transition. For example, if you have one photo of a person to the left of the frame and another photo of a person

to the right of the frame and you need to use these photos one after another, try starting full frame with the first photo. Zoom in to the person's face slowly so it ends up in the middle of the frame during the transition to the next slide. In the next slide, start zoomed in so the second person's face is at about the same place as the ending position of the first person's face. Finally, zoom out of the second person's face in the second slide. This kind of positioning makes it easier for the audience to follow your intended subject matter because you are directing where their eyes will be during transitions. An example of this is shown in Figure 5.2.

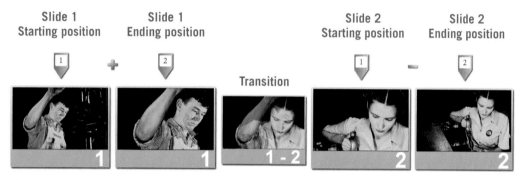

Figure 5.2
Matching two slides' focal points when they transition prevents the audience's eyes from needing to move during the transition.

 Example *Chapter 05-Number 01*: This example shows how a photo's area of interest can be positioned closely with the area of interest of the next slide during the transition.

Use this kind of positioning technique in various ways. Think about where the audience's eyes will end up at the end of each slide, and fit the slides together using the starting and ending point of each subject. Their eyes may not end up in the middle of the visual.

Move Slowly

If you are new to making slide shows, read this short section *carefully!*

Pan and zoom slowly! The single most common tip for improving a slide show is to slow down panning and zooming. Remember, you have seen the material you are working with for a long time, but your audience will be seeing it for the first time. Your intuition will be to try to make the show more exciting. This usually results in wanting to add a lot more motion than you need.

Slow down and take your time. When seeing a visual for the first time, people scan it with their eyes and take it in piece by piece. It is difficult to do this if the image is moving too quickly.

Have each image moving gently, almost as if it is floating gracefully in space. Make sure to leave the image on the screen long enough for the first-time viewer to see it and understand it fully.

ON THE DVD Example *Chapter 05-Number 02*: This example demonstrates the use of slow, floating motion to avoid distracting the audience with too much motion.

Making things move slower is sometimes confusing to those who haven't worked with slide show software before. To make something move slower, just add time. The more time a photo has to get from start to finish, the slower it moves. The inverse is also true: the shorter the time, the faster it moves. If you have trouble making an object move slower, increase the time it uses to get there. This may be as simple as making your slide time longer.

Control Flow of Focus

Motion is used to control which parts of a photo the audience sees first and last. You can surprise the audience by starting zoomed into part of a picture, only to reveal the rest of the picture as you zoom out. Perhaps the whole picture is much funnier only after the audience sees the rest of it. Or, perhaps panning to the right of an image slowly reveals the story being told by a narration as it continues.

The audience will be sensitive to faces in photos. Avoid beginning or ending a slide with people's heads showing partially at the edges of the visual. Usually it is better to pan or zoom in or out a little to leave each person's face either completely visible or completely invisible. One of the reasons we humans are sensitive to this is because we often want to see the rest of a person's face if we can see any of it at all. Figure 5.3 shows the Effects tab of the Slide Options dialog used to create the motion of zooming out.

Motion and Audio

Your visual and audio senses are separate, but you think about them at the same time. Motion gives your mind visual stimulation to see, whereas audio gives you something to hear. Voice-over narration can add information to explain more than what the visuals show.

Motion Effects window
Zoom and pan used to direct viewer's attention

Figure 5.3
ProShow Gold's Slide Options dialog showing motion revealing a photo.

Constant, gentle motion is a soothing element in a slide show. Compared to a still image, it adds enough stimulation to your visual senses to soothe you, but not enough to distract you. It invites your mind to rest a while and listen to what is being said. Without it, the audio messages are considered much more separately, and most often, not listened to as carefully.

Carefully tuned, the combination of slow, smooth motion, a well-matched soundtrack, and voice-over narration is a highly effective method of communicating a message. Think about each of these three pieces separately. Without any one of them, the message wouldn't feel nearly as well produced.

ON THE DVD

Example *Chapter 05-Number 03*: This example contains the same sequence, but with different elements of the composition removed. It should give you a good idea of how important the combination of the elements are to the audience's perception of the show.

Common Motion Examples

Next you'll see several simple examples of some effective and common motion. These are not complex examples, but they help to get you up to speed with the more complex examples later on in the book. Most examples of techniques are included as ProShow slide show files (*.PSH files) on the DVD accompanying this book. Referring to these examples is an excellent way to follow along and make sure you fully understand each concept.

Move and Hold

This technique is what I call the *move and hold* style of motion. It is simple and can be accomplished using three slides for each photo in ProShow Gold. With ProShow Producer, it can easily be done much quicker in one slide using Producer's keyframes. Figure 5.4 shows the idea.

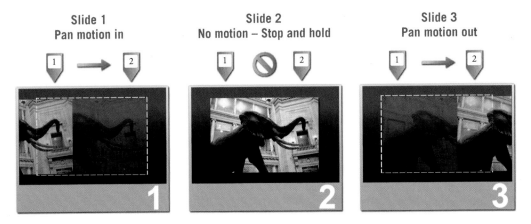

Figure 5.4

The move and hold motion style. A photo moves into place, stays in the same place for a while, and then exits.

Example *Chapter 05-Number 04*: This example demonstrates the move and hold technique.

The *move and hold* technique is used any time you introduce something, need it to stay visible for some amount of time, and then gracefully exit. For example, you may use this as a way to talk about a photo for a given amount of time. Each photo transitions in with subtle motion, stops, and then transitions out. The narration you provide happens while the photo is still.

Group Pan

Use this technique when you have a group photo that you want to make sure everyone can look at closely. This technique is similar to the move and hold example, except the hold part of the logic pans across instead of staying still. Figure 5.5 shows the idea.

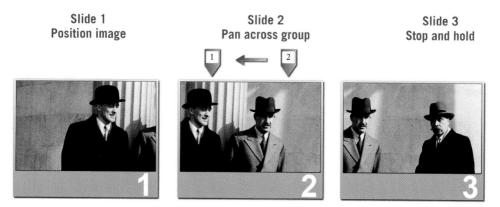

Figure 5.5

Group photo motion. The idea is to move across a group as a narration explains more about the people in the photo.

 Example *Chapter 05-Number 05*: This example demonstrates using the move and hold technique across multiple people, holding at each person using separate slides.

This technique is effective when used in conjunction with narration that explains more about the people in the photo.

Background Motion

Slowly moving backgrounds can enhance your show with subtle variety. Be careful not to move too quickly. Figure 5.6 shows the idea.

 Example *Chapter 05-Number 06*: This example demonstrates moving a background image slowly to add style to a slide.

Figure 5.6 is a great example demonstrating that motion isn't just for photos in a slide show—it can be effective when used with a background. Remember that a slide's background should not be distracting because it isn't intended to be the focus of the visual. Instead, it should be soothing, as is shown in the example.

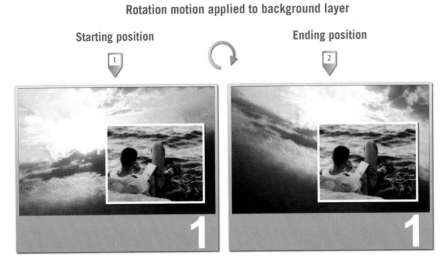

Figure 5.6

Rotating background image used to add style to a slide.

A good choice of colors is always important with this kind of subtle effect. To accomplish this effect, the background layer is not created with the background feature in ProShow, but is a layer underneath the foreground layer. This allows you to move the background layer slightly to produce a more polished effect. Also, audiences are sensitive to rotation, so don't rotate too much or too fast.

Timing and Pacing

Now that you have a good introduction to how and why to make things move, you need to understand timing and pacing. *Timing* has to do with when things happen, and *pacing* has to do with the rate you provide information to the audience.

Consistency

As with all parts of a show, consistency is important to the perception your show communicates. Avoid using different rules for timing in different parts of your show. Avoid speeding up and slowing down how fast you provide new information. As you watch parts of your show repeatedly, you'll get a better sense of pacing and timing.

Always keep in mind that you are going to be far more familiar with the contents of your show than your audience will be. You need to constantly *reset* your thoughts when you watch for pacing. Try to imagine you are watching the show for the first time and you have never seen the images before.

Pacing

Pacing is the rate at which you provide new information to the audience. You can think of this as the general rate the show moves along. Your show should move at a pace that is slow enough to allow the audience enough time to absorb your message but fast enough to hold its interest.

Pacing is difficult to plan. Don't be afraid to construct your show without worrying too much about pacing, knowing you will return later to work on it.

Pacing sometimes benefits from making judgments only when you have not watched the show for a while. Take breaks for a few hours or even a few days before deciding what to adjust. Pacing is a good thing to work on at the beginning of a session because you have had a good break from it and can look at your show with a fresh state of mind.

Clear your mind and try to imagine you are watching for the first time—as if you have never seen the show before. Avoid trying to make adjustments as you go. Instead, pause the show whenever you sense it is moving too quickly or too slowly. Take notes about where you feel it moves too fast or slow. When you're done making notes for a complete pass, go back and make adjustments to each section.

Each time you finish a pass, you have gotten *closer* to the show, so you want to avoid making too many passes at a time. You'll need a break to detach yourself from the show so you can more easily watch it as if you'd never seen it before.

Timing

Timing deals with when things happen or how fast things happen. When objects or transitions move too quickly, the audience's attention can be easily drawn away from the point of the show.

Similar to pacing, it is best to work on timing after you've been away from your show for a while. Watch the show as if for the first time, and let your mind allow your eyes to focus on things you see. If something catches your eye, pause the show and make a note. Once you've seen the whole show, go back and make the adjustments you noted.

Make sure similar movements in your show are consistent with each other. People are sensitive to differences, and differences that aren't necessary end up distracting the audience from the point of your show.

Caption Timing

Producing a show is different from watching someone else's show for the first time. Remember this as you adjust caption timing. You know what the captions say because you put the show together. Subconsciously, you read the captions much

faster than a person who has never seen the captions before. For most people, this ends up being about two to three times faster.

To get the caption timing right, you might try different methods. One simple trick is to read the captions two or three times in a row. If you can read them several times while they appear on the slide, the caption is probably on the screen long enough for a first-time audience to absorb.

Another trick some producers use is to imagine a narrator in your mind who is reading the captions slowly, as you'd see in a television program or a movie. As the caption appears, listen to the narrator in your mind reading the caption. When your imaginary narrator is done, the caption should be leaving the focus.

When you have multiple captions appearing as the audience reads them, be aware that the audience will read each caption in sequence as it appears. Each caption should be easily readable before the next one appears, but without too much of a delay between each. This kind of effect takes more work than just putting a block of text on the screen, and it pays off by keeping the audience's attention exactly where you want it. Figure 5.7 shows the slide structure of such a show.

Figure 5.7

You can use separate slides to control the audience's focus by showing them only a certain amount of new information per slide.

ON THE DVD

Example *Chapter 05-Number 07*: This example shows the use of multiple slides to add captions at a rate that the audience can absorb. Timing is used to make sure the audience doesn't get ahead of the messaging.

There is no trick that works perfectly for everyone, but one of these methods should work for you.

Music and Pacing

The emotional tone of a piece of music sets the feeling the audience has while watching your show. If you use slow music, the visuals should feel slow. If you use fast music, the visuals should feel fast. If the music and the visuals do not match, the audience will perceive your show as strange, although they may not be able to articulate exactly what is wrong.

One of the most interesting exercises you can do to practice with music is to create a slide show using the same visuals, but with completely different music. Select a few pieces of music that have completely different feelings, such as a country song, a love ballad, a fast rock song, and a dance song. Construct a slide show using similar visuals, but try to make the slide show *work* with the different types of music. You will quickly see how the music sets the tone of the show and can make or break your slide show. Which songs worked for your visuals? Which didn't? Which effects worked with each type of music?

Review

Motion adds a powerful flowing effect to modern slide shows that helps the audience more easily absorb your message. The timing of these elements is important not only to control the speed of motion, but the pacing of your show. Remember to match the timing, pacing, audio, and music to complete a balanced experience for the audience.

6

Basic Techniques

This chapter is a collection of techniques as examples to learn from. I believe that learning from other people's examples is one of the most powerful ways to learn. Each technique here is matched with a purpose, a description, a screen shot, and a full set of files on the DVD accompanying this book. I highly encourage you to use your computer and the accompanying DVD to follow along through this chapter. You'll get a lot more out of this book if you study the DVD examples.

This book is mostly about making a good slide show, not about the specifics of ProShow. I intentionally do not describe exactly which options to set or how to use the software.

Instead of spelling out exact details showing how to create any of these effects, I provide the files you can load into ProShow with your computer. Keep in mind that all these examples work with a trial copy of ProShow Gold or ProShow Producer, so there is no requirement that you purchase the software to learn how to make a good slide show. You can download a free trial copy from www.photodex.com.

Nearly all examples in this chapter are compatible with ProShow Gold and ProShow Producer. I've clearly identified those that are specific to ProShow Producer. If you're using ProShow Gold, you won't be able to load these Producer-specific show files. I've done this only for examples that demonstrate a much better way to do things with ProShow Producer. Usually, this is the result of powerful features in ProShow Producer that make it much easier to do specific types of things. It would be incomplete not to show the ProShow Producer users these features because it will save them time overall.

This chapter is primarily focused on a set of basic techniques that you can easily carry out with ProShow Gold. It is a good cross section of ideas you can use to spice up your slide shows using the concepts covered earlier in this book. The ideas here should be relatively easy to follow regardless of your level of expertise.

This is the chapter that should get you off the ground toward making much better slide shows.

Beginnings and Endings

Every slide show needs a beginning, a middle, and an end. How do you make a beginning look like a beginning? How do you make an ending look like an ending? Here are a few ideas to get you started.

Simple Curtain Opening

This is a simple technique that demonstrates using a transition to appear as a special effect. To my knowledge, pro photographer Mark Ridout first used this curtain opening technique when ProShow was just becoming popular.

The idea is simple: in the first slide, show nothing but a photo of a theatre curtain. Next, use ProShow's Doors Open transition to transition to the next slide—the first *real* slide of your show. You can adjust the speed of the curtain's motion by changing the duration of the transition. Voilà!

ON THE DVD Example *Chapter 06-Number 01*: This example demonstrates the simple curtain opening technique.

The valuable lesson to be learned from this example is that what you see is not always as it appears. To come up with this kind of effect, Mark had to think differently about the available tools. The idea of using a transition effect between slides as a curtain is not obvious unless you visualize what the result looks like instead of what it actually is. It's almost a coincidence that the audience perceives that the curtain moves naturally instead of realizing it's a simple transition that could work between any two visuals. Try to get in the habit of imagining your visuals combined with the tools you have available. Visualize how they might fit together. Ask yourself, "What if I used this effect with this visual? What would that look like? What would happen if all the parameters were set in different ways?" Repeat this over and over in your mind and imagine the possibilities. You're bound to stumble on ideas that work!

Layered Curtain Opening

This curtain opening technique is done in a completely different way than the previous example. Using layers, you can easily create the illusion of a theatre with a moving curtain. This is done using layers to hide the curtains as they slide open.

Start with a picture of the inside of a theatre. Use a photo editor to create separate image files for the theatre with a transparent hole where the stage is, the left side of the curtain, and the right side of the curtain. You'll also need the photo that the opening curtain will reveal, but you won't need to do anything special to prepare it for this technique.

As shown by Figure 6.1, the photo of the theatre is on top, the left and right curtain pieces are below it, and the photo to be revealed is at the bottom, covering the visible slide area. At the start of the slide, the curtains are positioned such that they completely cover the left and right side of the hole in the theatre photo. At the end of the slide, the curtain pieces move left and right, opening for the duration of the slide.

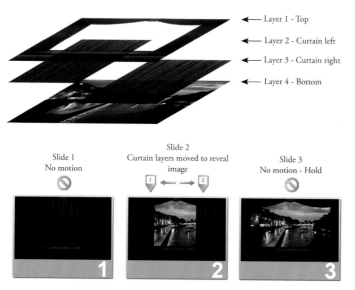

Figure 6.1

The Layered Curtain Opening effect.

Notice that I've set the motion for the left and right curtain halves to Linear rather than the default value of Smooth, as shown in Figure 6.2. This is simply because it looks more natural to the audience. You may like it with the other settings better. As they say, "Your mileage may vary!"

Motion effects window

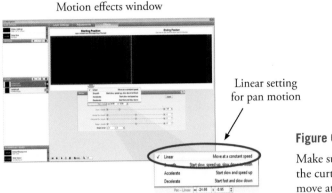

Linear setting
for pan motion

Figure 6.2

Make sure to set the motion style for
the curtain layers to Linear so they
move at a constant speed.

This effect cries out for being combined with other embellishing techniques that
will be covered as we go. Without embellishing touches, the effect may seem unfin-
ished, but don't worry about that now. Instead, concentrate on understanding how
this individual slide works. Adding the simpler finishing touches is easy. By the
time you understand the other examples, you'll be able to combine these effects
to make just about anything you do feel more finished.

ON THE DVD

Example *Chapter 06-Number 02*: This example demonstrates the use
of layers to create a better curtain opening effect.

Movie Reel Intro

This example uses a video of an old film projector playing a movie reel. The idea
is simply that showing the audience a projector and transitioning into your show
puts the audience in the mindset of being about to watch a movie. This is simple
but surprisingly effective!

ON THE DVD

Example *Chapter 06-Number 03*: This example uses a video of an old
film projector playing a movie reel. The idea is simply that showing
the audience a projector and transitioning into your show puts the
audience in the mindset of being about to watch a movie.

Motion Picture–Style Captions

There are many ways to implement movie captions, but certain ways really *look*
like movie captions. This example gets your mind started on ways to spice up your
captions with different fonts and placements to draw your audience's minds into
your show.

ON THE DVD

Example *Chapter 06-Number 04*: This is an example of various types of captions you might see in a motion picture.

This is a vague category because there are so many stylistic possibilities. Instead of explaining each one, I've tried to give you a variety of examples to get your creativity flowing. Depending on the type of show you're doing, your needs will change, as will the degree of creative flair you should use.

Endings

Have you ever noticed that funny movies often end abruptly with a black screen and loud music right after the punch line of a joke? You may not have noticed this, although you have probably seen it many times. This is one example of a great way to end a comedy because it leaves the audience laughing, and that laughter transitions smoothly into a realization that the show is over. The editors hope the audience members leave the show happily remembering the parts of the movie they liked. After all, that's the point of a comedy.

Sometimes shows end with rolling credits and sometimes with a slide that says, "THE END." Whatever way you choose to end your show, consider the feeling the audience members will have at the point they realize the show is over. For maximum impact, you should leave them thinking about the overall point of the show.

Fade the Music

One of the most common oversights is letting the background soundtrack cut off abruptly at the end of the show.

Watch the two examples of this show on the accompanying DVD. The only difference here is that the first show cuts off the audio at the end and the second one fades out. This simple detail makes a huge difference in the perception of your show, and at a critical time—right when the audience is forming an opinion of your show for the first time! The end of the show is the last place you want to leave your show unfinished.

ON THE DVD

Example *Chapter 06-Number 05*: This example is a comparison of the ending of a show with the audio track faded out nicely compared to the same show with the audio cutting off abruptly.

To fade the music, first use the Tab key to toggle to the timeline view. Use the right mouse button menu and select the Stop Track Here option to trim the background soundtrack to the end of the show. Hold the Ctrl key while holding the

mouse over the soundtrack, and use your mouse to adjust the knobs shown on the audio track to adjust the exact length of the soundtrack and the length of the fade. Figure 6.3 shows the timeline view with an audio track highlighted this way.

Soundtrack with fade-out applied at end of show

Figure 6.3

Hold down the Ctrl key while the mouse is over the audio graph in the timeline view to adjust the audio tracks.

Remember the Story

Remember that the story is the point of the show. The ending of the show is how you tie it up. The instant the audience members realize the show is over, the thought in their head should be the point you're trying to make.

Think about how you want people to remember your show. Suggest it to them. Don't be shy. For example, a good friend of mine likes to end his wedding shows with a caption that says, "The Beginning…", to point out that what the audience has just seen is the beginning of a new life for the lucky couple—*not* the end of a wedding. What a great way to end a wedding show!

Still Credits

Still credits have category headings and names of people or organizations listed for credit. Each category usually has its own slide, although less important categories may be grouped on single slides. Remember to keep the details of style and placement as uniform across these slides as possible to avoid changes that might distract the audience.

ON THE DVD

Example *Chapter 06-Number 06*: This example show demonstrates one way still credits can be handled. The captions are obviously simulated, but you get the idea.

A trick to make still credits easier is to create one credits slide as a master template and then copy that slide over and over again before filling in all the information. When you're done with the credits, delete the template slide, and nobody will know it was there in the first place. This is shown in Figure 6.4.

Still credits template

Template copied multiple times, ready to adjust

Figure 6.4

Create one master slide to copy multiple times to make sure your captions are consistent.

Scrolling Credits

Rolling credits are common, especially if they're legally required to give music credit or other credit to participants or content providers.

ProShow includes a caption behavior for scrolling credits from the bottom to the top, just as is seen in major motion pictures. This is a simple behavior that works with any caption. Just type in your credits, select the Full Pan Up caption behavior, and ProShow slides them up over the duration of the slide. This is shown in Figure 6.5.

Full Pan Up selection ⟶

Classic scrolling credits - From bottom to top

Figure 6.5

The Full Pan Up caption behavior can be used to create scrolling captions for your show.

Remember that the slide time for a long credit roll needs to be long enough. If the text is scrolling too fast, increase the slide time to give the text enough time to go at a good speed. Don't be afraid to have this one slide visible for tens of seconds if not minutes, depending on the height of the image being moved. Increase and decrease the time to change the speed of scrolling. Remember, the audience will be reading the captions and will not be worried about how long the slide is.

ON THE DVD Example *Chapter 06-Number 07*: This demonstrates a creative example of scrolling captions with some style added using moving images.

Scrolling Credits with a Big Image

You don't need to use captions to do rolling credits. The current version of ProShow limits each caption to one font style, which makes different font sizes and colors within the same caption impossible.

This technique is an example of "Things are not always as they appear." This example uses a photo editor to create a tall image that contains all the text of the credits. This allows complete flexibility to include any font styles anywhere you want, and you can even include imagery. Furthermore, you can make the background for this image transparent so the background behind your scrolling credits can be a different image or pattern. This is shown in Figure 6.6.

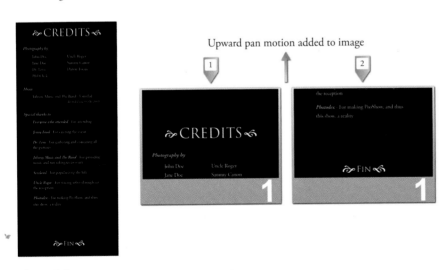

Figure 6.6

Scrolling credits can be created using a large image layer panning from below the frame to above the frame.

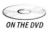

Example *Chapter 06-Number 08*: This example demonstrates using a large scrolling image of credits prepared in an external photo editor.

Notice that I've set the movement style of the credits image to Linear rather than the default of Smooth. If you don't do this, the credits start moving slowly, get faster halfway through, and slow down toward the end. Although this works nicely as a default for photo motion, it isn't a good setting for scrolling credits.

Image Presentation

This section gives you some techniques to help you polish the presentation of your photos and videos. For a professional slide show, it isn't enough to put photos on the screen and be done with it. There are many ways to polish your show and give it that finished look that you're after.

Move and Hold

I've talked about the *Move and Hold* technique a lot because it's used a lot. Toward the end of this section, I also describe how ProShow Producer's keyframe features change the way this technique is done.

The idea is simple—when something appears and you intend to move it, it's better if the object in question appears still for a while before it starts moving. In this example, we start with a photo that we want to zoom into. You can also think of this technique as *Hold and Move and Hold*.

Figure 6.7

Having a photo start still, then move, and then stop is an effective way to have an image be still during transitions around a slide.

ON THE DVD

Example *Chapter 06-Number 09*: This example demonstrates using multiple slides to move a photo, hold it, and then move it again.

With ProShow Gold, this technique is implemented using multiple slides, as shown in Figure 6.7. This is easy to understand once you know how it's done. Think of the main part of your slide as the slide where the action takes place. The other slides around it help the timing appear more natural to the audience.

Make sure you set your transition times to 0.0 seconds between these move and hold slides so you don't get the *transition double image* problem described as a common problem at the end of this chapter.

Note

The remainder of this section is specific to users of ProShow Producer. If you're using ProShow Gold, feel free to skip to the next section.

ProShow Producer users can use this technique in the same way but carry it out differently. ProShow Producer supports *keyframing*, which is a much more sophisticated way to accomplish this without using multiple slides. Keyframing goes much further and accomplishes many movement and special effect techniques that are simply impossible without it (see Figure 6.8). ProShow Producer keyframes can be set up so objects can start and stop their motion and effects at any point in time, while other objects move smoothly, starting and stopping arbitrarily. Every motion and effect transition can happen at any point in time, without interdependence between them. With ProShow Gold, the points in time when objects start and stop have to line up with slide boundaries.

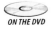

ON THE DVD

Example *Chapter 06-Number 10*: This example demonstrates the use of Producer's keyframes to cause motions that are impossible with ProShow Gold. I've added a cloudy sky background layer moving smoothly across the screen to prove this as well. The sky's motion is impossible with ProShow Gold, but it's easy and obvious with ProShow Producer.

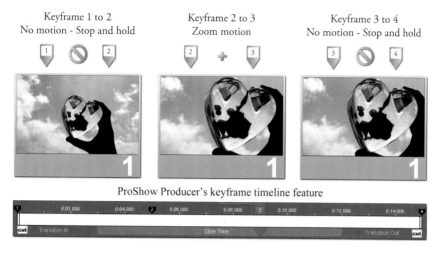

Keyframe 1 to 2
No motion - Stop and hold

Keyframe 2 to 3
Zoom motion

Keyframe 3 to 4
No motion - Stop and hold

ProShow Producer's keyframe timeline feature

Figure 6.8

ProShow Producer's keyframes tell the layer when to hold and when to move.

Full Frame

Think of the visible area of your show as a cropping tool. By enlarging or reducing the size of things inside this rectangle, you are controlling what the audience sees and therefore focuses on. This is exactly what you would do with a picture frame, with the added dimension of movement happening over time. This is also what motion picture directors do with their hands while visualizing a scene (see Figure 6.9).

Figure 6.9

Think of what you can do with motion just as a movie director might do with his hands while visualizing how he wants to shoot a scene.

When you enlarge a full frame image over time, the audience members naturally focus on the part of the image that appears to be "where they are going." If you want to focus on a particular person in a group photo, for example, you can slowly enlarge the image so that the person of interest is heading toward the center of the screen. This motion changes the cropping of the overall visual. This enlargement tends to make people start with the whole scene and transition their thinking toward focusing on the individual.

The opposite is also true when you zoom out. Start with an enlarged image and reduce the image slowly over time. The audience naturally focuses on the individual first and transitions to thinking about the whole scene as the larger image is revealed by the slow reduction in size. You can see how this works in Figure 6.10.

Larger-than-frame zoom in

Larger-than-frame zoom out

Figure 6.10

These examples never show the entire photo. Instead, they use motion to direct the audience's focus.

ON THE DVD

Example *Chapter 06-Number 11*: Listen to the voice-over included for these two sequences in this example. They illustrate how the combination of the voice-over and the movement can guide what the audience thinks as the motion happens. Motion and voice-overs are a powerful combination.

Panning large images is similar, as shown in Figure 6.11 and Figure 6.12. The audience will always be looking toward where the motion is going to determine what to think about.

Larger-than-frame pan across a group

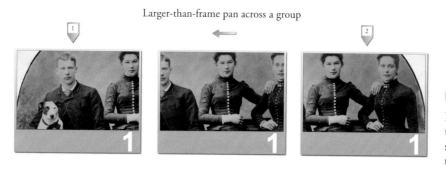

Figure 6.11

In this example, we are talking about a group, so no one individual is the focus.

ON THE DVD

Example *Chapter 06-Number 12*: This example demonstrates how the meaning of the scene is revealed by the panning motion as it progresses.

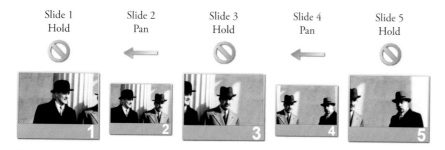

Figure 6.12

In this example, we focus on each person because we need to reveal specific information. Notice that this example requires several slides to carry out the move and hold technique explained earlier in this chapter.

ON THE DVD

Example *Chapter 06-Number 13*: This example adds multiple hold points.

Backgrounds

This section proposes ideas about different basic techniques using backgrounds. All are straightforward, so a lot of instruction shouldn't be necessary. Refer to the accompanying DVD to learn how to accomplish these techniques.

It's important to understand that the background feature in ProShow does not support motion, and for good reason. The background feature in ProShow is intended as a quick way to do a background, but it doesn't give you all the abilities of a layer that covers the entire background of a slide. For the examples here that have moving backgrounds, the background image is actually a full-frame layer—

not an image specified using the background feature. We use the term *background* here to refer to the visual layer behind everything else of interest in these cases.

For four of these background ideas, I've included some simple styles on the accompanying DVD that you can import into ProShow to make using them easy.

Complementary Colors Under Photo

When you're setting the background color, it's easy to choose a color using the eyedropper. When you use colors from the image the background is placed behind, you'll likely end up with a color combination that matches the photo perfectly. Be careful not to use bright colors unless you need to, because bright colors can easily distract the audience from your photo.

ON THE DVD

Example *Chapter 06–Number 14*: This example shows background colors that were chosen using the eyedropper tool in ProShow's color picker. Notice how the colors naturally agree with the images because they appear in the images.

Consistent Background Under Photo

Often, you can use a consistent background style to create consistency across slides. This example shows several slides with the same background and positioning style for each photo. Keeping the color the same from slide to slide adds consistency and prevents the audience from being distracted.

ON THE DVD

Example *Chapter 06–Number 15*: This example demonstrates several ways to use consistent backgrounds and photo positioning.

You'll probably want to change the color of the background in the slide style I've included. If so, apply the style to a slide, make your changes to the background color, and save the style as a new style for use in your show. Once you've done this, you can apply your new style to the other slides you want to use it with.

Same Photo Adjusted and Enlarged Under Photo

This technique creates a background by using the foreground photo with some image adjustments. The adjustments tone the background photo down so that it doesn't distract the audience from the foreground photo. In this example, I make the background photo larger than the foreground photo and increase the black point adjustment to make the background photo appear much lighter than the foreground photo.

Example *Chapter 06-Number 16*: This example demonstrates the use of a background layer containing an adjusted version of the foreground photo. It is also included as a style that you can import and use to give your slides this same look.

Same Photo Adjusted Moving Under Photo

Add variety to the previous technique by adding motion to the background photo. In this example, the background photo also moves behind the foreground photo.

Example *Chapter 06-Number 17*: This example is similar to the example in the previous section with motion added to the background layer. This example is also included as a style.

Pattern Background with Aggressive Linear Motion

Create a festive look with a repeating background pattern that is dense and subtle enough not to cause unnecessary distraction. I add linear motion here to spice up the look of the show.

Example *Chapter 06-Number 18*: This example shows a dense background image with relatively quick linear motion. This example is included as a slide style.

You can change the background used for this style by applying the style, changing the image for the background layer, and then saving the style as your own. Be careful to use a high-resolution image for the background and one that doesn't distract too much from your foreground photos.

Video Backgrounds

I demonstrate using video clips as backgrounds here because they can add variety to your show. Using them can be tricky because they're distracting, but if the video is well chosen and generic enough, they can be a great break from otherwise still content. Be careful about putting two video background images next to each other on the timeline. Because video backgrounds can move, the potential for unwanted distraction is high.

Example *Chapter 06-Number 19*: This example shows a video used as a background for a slide.

Photo Frames and Borders

When people hang a picture on the wall, they use a picture frame. You can do the same thing with a photo editor by overlaying a photo of a picture frame over another photo so that the photo shows through the middle of the picture frame. This is a good way to show family photos because it brings an element of personality and humanity to the photo.

Explaining how to use your photo editor is beyond the scope of this book. Using photo editors is common, and it should be easy to find instructions on how to do this through many sources, including the documentation for your photo editor. The result is shown in these examples, which should give you some ideas for different types of borders you can add to your photos to give them the feeling you're after.

Bordered image
Layer 1 - Border
Layer 2 - Image

Other examples
of image borders

Figure 6.13
Borders are layers placed over images.

ON THE DVD

Example *Chapter 06–Number 20*: This example shows the use of separate border images placed over the photos of interest.

The frames and borders used with the examples shown in Figure 6.13 are included on the accompanying DVD. Just look in the "images" folder in the same directory as the ProShow .PSH example file.

Black Point and White Point

By using black point and white point adjustments, you can turn an ordinary photo into a great background image. This technique changes the *white point* of the photo to make it look darker, or the *black point* to make it lighter, as shown in Figure 6.14. This is like simulating what the photo might have looked like if it were taken with a different exposure. You can also imagine what is happening to the photo by thinking of it as if you were laying a solid color transparency over the image.

Default settings White and black point treatment

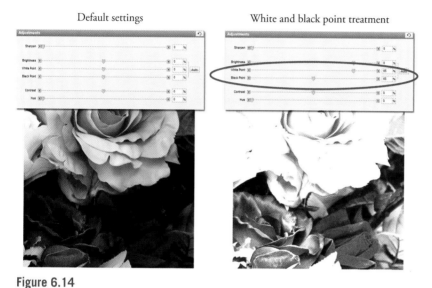

Figure 6.14

An example of using the black point and white point adjustments to "blow out" an image.

Changing the black point or white point reduces the dynamic range of the photo and gives it a dreamy look. This is a quick way to turn an ordinary photo into a stylized background image.

ON THE DVD

Example *Chapter 06-Number 21*: This example demonstrates various ways to use the black point and white point adjustments to add style to your show.

Study these examples, where the photos have been adjusted using the black point and white point adjustments in ProShow. You can even use colorization afterward to transform the images further, as described in the next section.

Grayscale, Sepia, and Colorization

Everyone has seen old black-and-white photos, also called *grayscale. Sepia,* which is a grayish brown color, reminds us of old photos from the 1800s. The effect was originally caused by early photographic chemistry that had a brownish color instead of gray.

Original color Grayscale treatment Sepia treatment

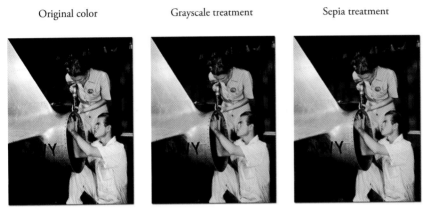

Figure 6.15

This photo has been changed to grayscale and sepia with ProShow Gold's colorization feature. The adjusted photos feel as if they are old or have historical significance.

To change a photo to grayscale or sepia in ProShow, as seen in Figures 6.15 and 6.16, use the *colorization* feature. Grayscale uses 50 percent gray as a midpoint for the colorization feature, and sepia uses a dark grayish orange as a midpoint for colorization. These values aren't set in stone, so feel free to play with the values to get colors you think look good.

Note

ProShow version 4.0 and later include built-in slide styles for grayscale and sepia-tone photos.

As with every effect in a show, try to use colorization only with meaning. If you overdo any effect, it loses impact.

ON THE DVD Example *Chapter 06-Number 22*: This example shows a picture colorized as sepia to create the feeling that the photo is historical.

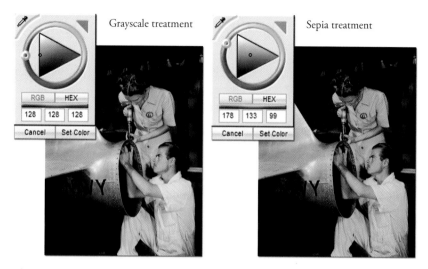

Figure 6.16

Use gray for grayscale and dark grayish orange for sepia tone.

As you've seen, colorization can be used to create both grayscale and sepia images. What happens when you use other colors? The results can be wild and energetic. Use with caution!

Example *Chapter 06-Number 23*: This example uses colorization to increase the perception of energy and make the show more abstract.

Notice how the technique in Example 06-23 is so wild that it creates a sense of energy. The original photos would not have had the same sense of energy without the vivid colors resulting from the colorization feature.

As with any other photo, you can use colorization to change the feeling of the background of a slide. Here is an example showing the same photo as the foreground, but colorized to change the appearance of the photo and avoid distracting the audience from the foreground photo.

Example *Chapter 06-Number 24*: This example shows how colorization can be used to avoid distracting the audience from the foreground photos.

Transitions

If you look for transitions in professionally produced media, you'll quickly notice that the cut transition is, by far, the most widely used. This is for good reason. Using too many different transitions leads to an unprofessional look.

Think of transitions in the mindset of the *two-font rule* mentioned in Chapter 4, "Space and Simplicity." Choose a couple of transitions you want to use, and stick to them. If you use more, it becomes easy to distract the user and appear unprofessional.

The reason that transitions aren't normally necessary is that they don't add to the show—rather, they distract from it. They end up drawing too much attention to the effect rather than the story.

This section gives you some background information about transitions and many examples of how you might use them appropriately. Remember, with the exception of the *cut* and the *crossfade*, these techniques are usually the exception and not the norm. Use transitional effects to accent your shows carefully.

Cuts and Fades

The cut is the most common transition used in video and film. It's an instant change from one visual to the next, which can be distracting if the timing isn't chosen carefully. Video and film editors use cuts more than slide show producers use them. This is because the story delivered by video and film is more heavily scripted, and the audio carries more of the audience's mind than it does with many slide shows. If you're an experienced video or film editor, you have most likely become better at using cuts without causing distraction than most people.

You can see the location of the cut transition in ProShow's transition picker in Figure 6.17.

Cut transition

Figure 6.17

ProShow's transition picker showing the cut transition.

Beginners find that crossfades are easier to use with slide show productions. Video and film editors avoid crossfades for many reasons, but often because they are used only to imply the passage of time in professional productions. Video and film also normally have some sort of motion across the whole surface area of each segment, which makes the cut less of a shock compared to still images.

The cut is easier to use without distracting the audience when the cuts are synchronized with the beats of the music or the audio creates the continuity necessary to smoothly guide the audience's understanding of what is going on in the show.

The *crossfade*—sometimes called a *dissolve*—is one of the most common transitions used in photo slide shows. The crossfade creates a soft barrier between two slides so as not to shock the audience. By itself, the crossfade brings a nicely polished appearance compared to a cut. The crossfade transition is shown in Figure 6.18.

Figure 6.18

ProShow's transition picker showing the linear crossfade transition.

The longer the fade, the dreamier the audience's perception. Be careful using long crossfades. If a crossfade is too long, the audience members become frustrated because they want to see the next slide sooner.

Use crossfades when there is little else for the audience to focus on besides the imagery they are seeing. When accompanied with soothing background music, longer crossfades add to the relaxing feeling caused by the slide show. For example, if the point of the show is simply to be a series of artistic photos as the background for an event, long crossfades work well. On the other hand, if the audience is intently focusing on information being given in the show, cuts work better because they quickly get to the point.

ON THE DVD

Example *Chapter 06-Number 25*: This example demonstrates the difference in feeling between crossfade transitions and cut transitions. Both work well, but cut transitions are better when you want the audience to focus on information rather than pure visuals.

Fade Through Blank Slide

Sometimes a break in the flow of a show is useful to give the audience a cue that something in the show is changing. A simple technique for creating this kind of break is using a crossfade through a solid color slide as a transition into the next slide. The simplest form of this uses a black or white slide. Examples are shown in Figure 6.19.

Fade through black

Fade through white

Fade through color

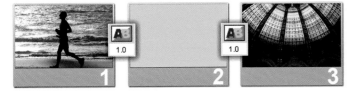

Figure 6.19

Three common color fades: black, white, and a saturated color.

The idea is to insert a slide between two slides and use crossfade transitions. Usually, it is best to use a slide time of 0.0 seconds for the solid color slide so the audience sees constant fading motion without the solid color staying static for any time.

ON THE DVD

Example *Chapter 06-Number 26*: This example shows the difference in feeling between fading through black, white, and a golden yellow color.

Be careful using colors with this effect. Colors are energetic, and the colors you choose should mean something in your show. If the colors are chosen randomly, you'll end up with a distracting effect. On the other hand, using colors as a theme can give your show a unique look. Remember, always use effects only with meaning, or they become a distraction.

Fade Through Colorization

Building on our experience from fading through solid-color slides, we can go one step further and use the photos from the starting slide and the ending slide. The idea here is to have the starting slide become colorized, fade to a colorized version of the ending slide, and finally fade into the ending slide. The slides necessary to create this effect are shown in Figure 6.20.

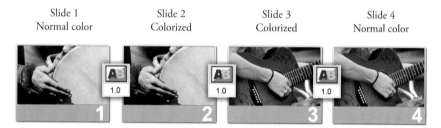

Figure 6.20
Fading from one slide to another using colorized versions of the slides.

Example *Chapter 06-Number 27*: This example shows how to use colorization in separate slides to create a unique transition.

I suggest keeping this kind of effect short. If this effect takes too long, it distracts the audience from the show instead of adding style.

Spinning Out and In

Let's go one step further and actually move the images. This technique spins the current visual around quickly and zooms out, and then the new visual spins in while zooming in. You may have seen this kind of effect in older movies where a newspaper that spins from far away comes closer as it spins, only to stop abruptly showing you the headline.

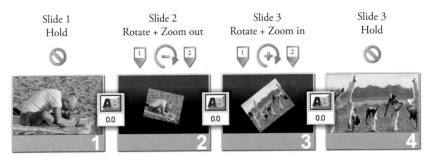

Figure 6.21

Slides used in the spinning out and in technique.

As shown in Figure 6.21, the starting visual is on the left, and the final visual is on the right. The two slides in between have the spinning motion in them. Create the two slides in the middle by copying the starting and ending slides toward the middle and modifying them so their starting and ending points match the starting and ending slides' ending and beginning points. When the effect is complete, the viewer will not realize the slides are changing because the positioning of the visuals will be identical.

ON THE DVD

Example *Chapter 06-Number 28*: This example demonstrates one photo spinning out and another photo spinning in.

By changing the transition between the two spinning slides, you can adjust how the two spinning visuals interact with each other. It can be a 0.0 second cut for an instant change, or you can use a crossfade to create a softer transition between them.

ProShow Producer can achieve this effect in one slide using keyframing. Instead of using multiple slides, keyframes are used to create the different motions.

ON THE DVD

Example *Chapter 06-Number 29*: This example demonstrates how to achieve exactly the same effect as the previous example using ProShow Producer's keyframing. The entire effect is created within one slide.

Cut Blast

Crossfades are soft, whereas cuts get to the point. What if you want to intentionally shock the audience members or force them to pay attention? Try something I call a cut blast.

A *cut blast* is a series of slides that are cut in rapid succession—far faster than the audience can keep track of, as shown in Figure 6.22. This is effective when synchronized with a sound effect, like a drum roll. Cut blasts are *very* energetic.

Series of quick slides separated with cut transitions

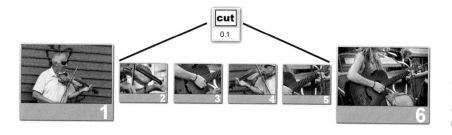

Figure 6.22

Slides necessary for a cut blast effect.

ON THE DVD Example *Chapter 06-Number 30*: This example demonstrates the use of photo and color cut blasts.

This kind of shocking barrier is jarring and powerful. It is almost guaranteed to forcibly distract your audience so they'll be ready for a new topic immediately. Think of using these between sections where you're changing locations or topics completely.

Portrait and Landscape Transitions

If you're dealing with both portrait and landscape images in your show, you can use differences in the transitions to give the audience a subconscious clue that something is changing. Rather than switching back and forth between portrait and landscape images, use batches of each type. Between the batches, insert a fade-through-blank-slide transition effect. Between images of the same aspect ratio, use a crossfade or, if you insist on using something different, use the same transition between each of the same type of image.

ON THE DVD Example *Chapter 06-Number 31*: This example shows the use of a different transition to disguise the change between portrait and landscape photos.

It's a good idea to also make sure you're using a consistent border, size, and placement for all your images. Once again, any changes to style distract the audience.

Shaped Transitions for Progressive Changes

Sometimes it's necessary to show a sequence of changes to a visual, such as a series of photos that document a time-lapse progression of building a house. If you have such a series of visuals, you can use shaped transitions to reveal each change, as shown in Figure 6.23.

It's important that each slide be visually aligned when you do this so that the only changes the audience sees are the differences between the visuals. I suggest the fuzzy linear wipe transitions for these.

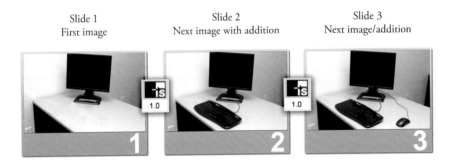

Figure 6.23

Example of using nearly identical images to show progressive changes.

Example *Chapter 06-Number 32*: This example demonstrates the use of a shaped transition rather than a crossfade. This is effective when you're adding objects to visuals with each successive slide.

Panning Transitions to Shift Entire Slide

In some shows, batches of photos are taken in one location, followed by batches of photos taken in another location. Or perhaps the photos switch from one side of a room to another. To give the audience a subtle cue that the scene or point of view is changing, you can use a slide transition between these batches, as shown in Figure 6.24.

Example *Chapter 06-Number 33*: This example demonstrates using a push transition to give the audience a clear indication that the sequence of images is changing. All transitions in this example are cut transitions except between the two slides that cause the topic to change.

Push transition selected

Transition
Push - right to left

Figure 6.24
An example using the push right-to-left transition.

Captions

Captions can be difficult to polish. Two keys are consistency and readability.

An easy way to draw attention to a caption and make it more readable is to put a background layer behind the caption to set it apart from the visual below it. In essence, you are adding more artwork to your show to enhance the captions.

These background layers can easily be created using a photo editor. All they are is a solid-color layer with the right size and shape to contain the caption, as shown in Figure 6.25.

Image layer Caption Caption background image

Putting it together

Figure 6.25
The background layer behind the caption gives the caption a background, making it clearly readable.

For an even more polished effect, use your photo editor to alter the transparency of the solid color so that it's partially transparent, as shown in Figure 6.26. A transparency of 50 percent is a good amount for this depending on your tastes.

> **Note**
>
> ProShow Producer includes the ability to adjust the opacity of a layer so that the entire layer can appear partially transparent without the use of an external editor.

Image layer Caption Caption background image
edited to 50% opacity

Putting it together

Figure 6.26

The background layer being partially transparent subdues the visuals behind the caption but doesn't completely obscure them.

Moving right along, spend a little time with your photo editor to add some style to the partially transparent background. Instead of just a solid color, add an outline with a different transparency level and perhaps a highlight or some other artwork to make it look like something you'd see in a commercial. Figure 6.27 shows an example.

ON THE DVD

Example *Chapter 06-Number 34*: This example demonstrates different types of images used as a backdrop behind a caption to make the caption stand out.

Result

Caption background image
decoratively edited

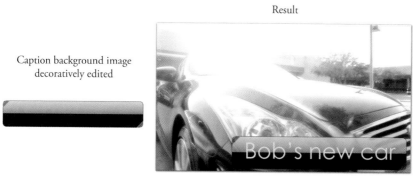

Bob's new car

Figure 6.27

Adding a little style to the layer behind a caption doesn't hurt as long as it isn't too distracting.

You can also use extra artwork created in a photo editor as a mask over your visuals that gives you a place for captions to rest. This kind of resting place for captions is sometimes called a *landing zone.* These do not have to be complicated (see Figure 6.28).

Landing zone
Simple shape - 75% opacity

Landing zone
Complex Shape

Result

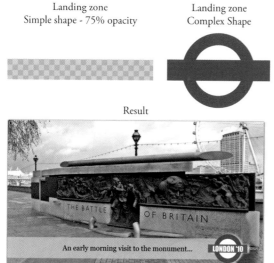

Figure 6.28

With a little more time spent with a photo editor, you can easily create fancy landing zones under your captions.

ProShow Gold can render captions to be included with or separate from the the transitions. When captions are not included with the transitions, they float above them and are not affected by them. When they are included with the transitions, they are part of the images that the transitions affect.

Including captions with the transitions changes how they appear as transitions happen. The effects can be quite pleasing and professional.

Example *Chapter 06-Number 35*: This example demonstrates the differences in caption appearance when captions are included with transitions compared to when they are not included. Note that ProShow Producer offers more control over when captions not included with transitions appear and disappear through caption keyframing.

Another way to complete your captions is to use fly-ins and fly-outs to change how the captions appear and disappear. In this example, the visual is cut by the transition, but the captions use a left-to-right fade to appear and disappear. This gives the audience more animation, but the duration of the animation isn't distracting enough to cause concern. Instead, it just makes the show appear more professionally produced.

Example *Chapter 06-Number 36*: This example demonstrates how even a simple fly-in and fly-out applied to each caption can add a lot of style to an otherwise unremarkable series of photos.

Another variation of this fly-in and fly-out technique is using a different fly-in and fly-out option called *Curling,* which fades and rotates individual letters. This creates a *morphing* effect when the captions change. The *Curling* caption effect is available as a fly-in and a fly-out and was designed to make this kind of effect easy to do.

Example *Chapter 06-Number 37*: This example shows how to morph captions using the Curling fly-in and fly-out caption effects.

Depending on the content of your visuals, you can polish your captions by using colors. When setting the colors of your captions, use the eyedropper in ProShow's color picker to choose colors from the visual, as shown in Figure 6.29. This guarantees that the colors will match something in the image perfectly. With a little experimentation, you can usually find very pleasing colors.

Example *Chapter 06-Number 38*: This example demonstrates the result of using the color picker to choose caption colors from photos in your show. Because the colors match precisely, they will always seem natural.

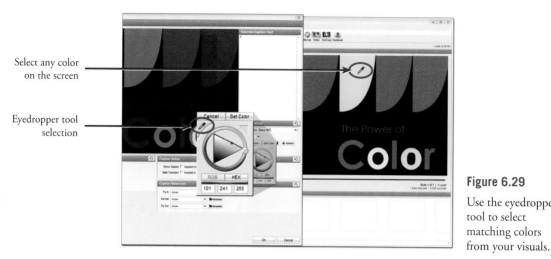

Select any color
on the screen

Eyedropper tool
selection

Figure 6.29

Use the eyedropper
tool to select
matching colors
from your visuals.

When working with bullet lists, it's sometimes best to have captions follow a voice-over narration such that each point first appears when it is talked about. You can do this easily by creating multiple slides and setting the timing of the slides such that the new captions appear when the voice-over mentions them.

ON THE DVD

Example *Chapter 06-Number 39*: This example demonstrates revealing bullet points as I talk about each point.

Note

ProShow Producer users can use keyframing to accomplish this same effect more easily, without the use of multiple slides.

When showing a bullet list with a voice-over when a highly topical image is used as part of the visual, using a photo is a nice touch. As the first caption appears, have the image zoom to one side and the captions appear opposite the image, as shown in Figure 6.30. This is an excellent way to control the audience's attention and thought process.

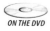
ON THE DVD

Example *Chapter 06-Number 40*: This example demonstrates the construction of a stylized bullet list with revealed captions as I talk about each point.

Figure 6.30
Splitting the slide into a photo and a caption list is a nice-looking way to present ideas.

A minor variation of this technique is to use a larger image and overlay a partially transparent layer over the photo but behind the captions. This tones down the part of the image that is less interesting and gives the captions a perfect background to rest on.

Example *Chapter 06-Number 41:* This example demonstrates the construction of a stylized bullet list over a full frame photo with a partially transparent background behind the revealed captions.

Animation Tricks

The simple motion that ProShow Gold supports is useful to produce some compelling types of animation. These examples show some common ways to create animation.

The Road Trip

A common trick used for travel shows is to show an airplane on a map moving to multiple destinations. This is often called a *road trip*. With ProShow Producer, you can easily do this using multiple keyframes. A more complex example is shown later in this book.

ProShow Gold does not support keyframes, so we again use the simple trick of having multiple slides in a row, each with its own start and end point.

For this example, you need a map image with enough resolution to look sharp even when zoomed in, and an image of the airplane that is transparent around the edges so the airplane looks proper as it moves across the map. The slides needed are shown in Figure 6.31.

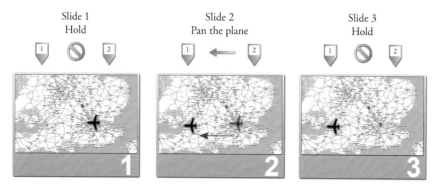

Figure 6.31

The "road trip." A small image of an airplane can be moved from point to point on a map.

Example *Chapter 06-Number 42*: This example demonstrates creating a road trip.

Highlighted Bullet Points

Business presentations often have bullet points and a narration track. I've shown how captions can appear as the narration track progresses.

This is a similar idea, but it instead changes the style of each point as the narration progresses. It's easy to imagine different ways to do this, and I've included a couple of examples for you. Once again, this technique uses multiple slides to cause the smooth changes as the narration progresses.

Example *Chapter 06-Number 43*: This example demonstrates changing the style of captions following a narration track instead of revealing them sequentially.

Using a Pointer

Sometimes when a show describes something in detail, it's useful to have a pointer on the screen—perhaps an arrow—that moves around to show the audience what's being referred to in captions or a narration. This technique does just that. This is done with multiple slides, just as in earlier examples.

Example *Chapter 06-Number 44*: This example shows how to use multiple slides to use the positioning of an arrow graphic as a visual aid.

Using a Highlight Image

You can control attention in various ways. Just as the preceding example with the pointer, try using something other than an arrow for a graphics effect. This example uses the same idea, but instead of an arrow, I use a partially transparent image with a fully transparent hole in it. I change the size of the mask image and move it around to control how large the hole appears to be in the frame.

The image itself is created in a photo editor and is only partially transparent in the darkened area around the transparent hole. The result is something like a spotlight over a darkened image.

ON THE DVD Example *Chapter 06-Number 45*: This example shows the use of a partially transparent image with a hole in it to guide the attention of the audience through the show.

Animated GIFs

For family and fun shows, animated GIFs can spice things up a bit. Be careful using animated GIF images for anything important because the audience might consider the effect cheesy.

The Internet has many sources for animated GIF images. A search for "animated gif" should yield thousands of sites where you can download animated GIF files.

ON THE DVD Example *Chapter 06-Number 46*: This example shows the use of an animated GIF image as an embellishment to a slide sequence.

Audio

ProShow plays background audio tracks one after the other by default. Playing two songs back to back is common. At the end of a song, there's often a long fade-out. To eliminate this "dead time" in the music track, you need to overlap audio tracks. This causes the next song to start playing before the previous song has completely faded out. Doing this is easy.

ProShow lets you specify the start time for each track in terms of when it would start if the tracks were played one after the other. This is called the *offset* in the program, as shown in Figure 6.32.

6-second gap of time before second track begins

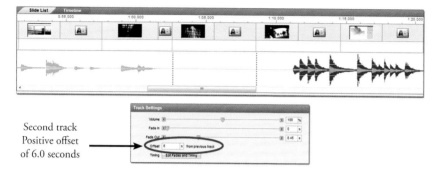

Second track
Positive offset
of 6.0 seconds

Figure 6.32
Audio tracks can be offset from the previous track by any number of seconds, both forward and backward in time.

When this starting offset is 0, as it is by default, the audio track plays immediately when the previous track is complete. This number controls how many seconds to wait before starting the next music track. Initially, this wouldn't seem to help us because we want the opposite of a starting delay. We want to move the start of the audio track backward in time—not forward.

To overlap music tracks, set the offset of the second track to a negative number, as shown in Figure 6.33. That's right—use a *negative delay.* This tells ProShow to start the audio track some number of seconds *before* the end of the previous track.

Two crossfaded tracks

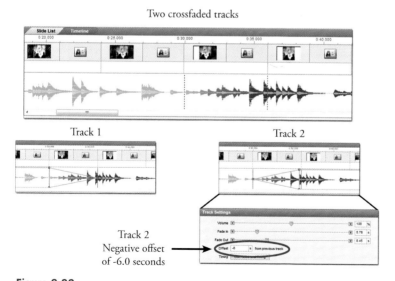

Track 1 Track 2

Track 2
Negative offset
of -6.0 seconds

Figure 6.33
Use a negative offset to start a track any number of seconds before the previous track ends.

Use the Tab key in the main ProShow interface, or click on the Timeline tab, to toggle between the slide view and the timeline view. The timeline view lets you visually edit the start times, fade times, and volume of each track. Even if you only use the timeline view for this kind of audio track tweaking, it's well worth knowing how to get to and from the timeline view.

Another problem people run into is how to have multiple audio tracks used as slide sounds. A slide sound is not in the background soundtrack, but attached to a slide. ProShow supports one slide sound per slide, so attaching more than one sound cannot be done. Well, not really…

As the principal designer and person responsible for all technical development at Photodex, I think of myself as being able to fully visualize usage patterns and techniques well in advance of most people, and by the time a new feature in ProShow is released, I've been thinking about all sorts of ways it can be useful for years ahead of time. We have seen users do all sorts of things with ProShow, and almost nothing has surprised me.

This technique is the result of one of the rare times when I knew there was a limitation, although minor, and a user surprised me. He found a way to trick ProShow into essentially appearing to support any number of slide sounds in a single slide. This technique is not obvious, but it's so amazing that I'm including it here. As demonstrated in Figure 6.34, proper credit goes to Jean Pierre Druffin—nicknamed "Jeep."

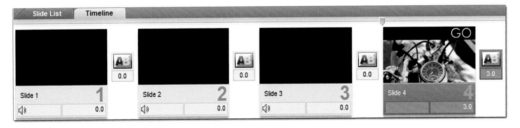

Figure 6.34

Congratulations to Mr. Jean Pierre Druffin for finding ways to do things that seemed beyond the capabilities of the software.

ProShow allows you to specify a slide time of 0.0 seconds and a transition of 0.0 seconds. When the software encounters a slide occupying 0.0 seconds total, it mostly ignores the slide because a slide with no duration cannot cause visual change. None of the images in the slide will be loaded, and none of the effects actually happen. However, the part of the program that mixes audio tracks has to look forward and backward in time because any slide can have a slide sound that can be offset forward or backward in time by any amount, and any slide can have

slide sounds that continue beyond the end of the slide. Technically, this is a difficult problem because it's easy to make a show that has to mix many audio tracks simultaneously, and at arbitrary points in time. We thought about this problem when we created the feature set and were careful to make ProShow capable of this.

Jeep brilliantly uses this observation to add a slide with a 0.0 second slide time and a 0.0 second transition just before the slide in question. Just add a slide sound to that slide. If you do this repeatedly, you can have any number of slide sounds start at the same time, as shown in Figure 6.35. Use the start offset parameters for each slide's sound, and you can slide them forward and backward in time. Because Mr. Druffin is French, I think the term *Voilà!* is appropriate here!

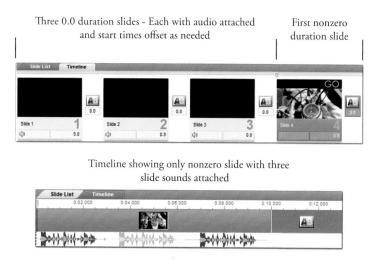

Figure 6.35

Use zero-second slides as containers for as many slide sounds as you like.

You can also add 0.0 second duration slides anywhere in the show. Just remember that the start time offsets are relative to what point in time they appear in the show. This is why I suggest adding these blank slides just before the slide in question instead, because that time is the same time as the first slide that has any nonzero duration.

Common Mistakes

One of the more common mistakes we see in slide shows created with ProShow Gold is what I call the *transition double image* problem. Many of the motion techniques discussed in this book involve using multiple slides to have a photo move from point A to point B, and then to point C, and so on.

The problem happens when the transition between the points is set to the default of a crossfade and the transition time is not set to 0.0 seconds—usually the default transition time, as shown in Figure 6.36. The user has matched the start and end positions of the photos in the slides and expects to see one photo—not two. However, because there is a transition that takes time, the motion of the photo overlaps with the transition and causes two copies of the photo to appear in the slide. This is not what the user intends, but most people do not intuitively understand what happens.

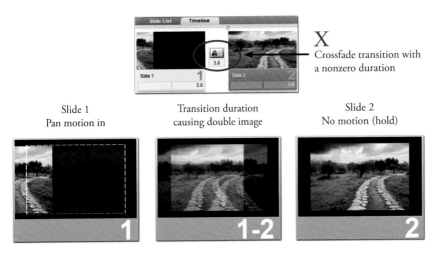

Figure 6.36
When matching layer motion from slide to slide, the transition time should be zero.
Look for a nonzero transition time if you see unexpected doubling of images between slides.

Avoid this problem by setting the transition time to 0.0 whenever you're using more than one slide to move the same photo around, as shown in Figure 6.37.

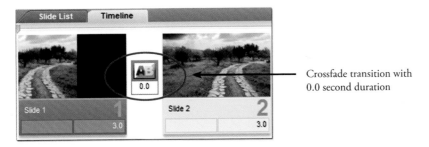

Figure 6.37
Make sure to use 0.0 seconds when matching layers between slides.

Explaining what this looks like is more difficult than looking at the show included on the DVD. Review this DVD example, which shows what happens with a nonzero transition time compared to a transition time of 0.0. Once you have seen what this looks like, you'll remember that correcting this problem is as simple as changing the transition time to 0.0 seconds.

ON THE DVD

Example *Chapter 06-Number 47*: This example shows a glaring example of what happens when you try to match the positions of layers between slides but do not set the transition between slides to 0.0 seconds. It also shows the same sequence with a 0.0 second transition.

Review

This chapter should have given you a good set of basic skills to get your mind thinking about putting effects together and how the tools of any slide show authoring tool can be used together to create basic slide shows. In the remaining chapters, I'll step it up a notch and describe how to do more sophisticated effects using more complex features. Fasten your seat belts!

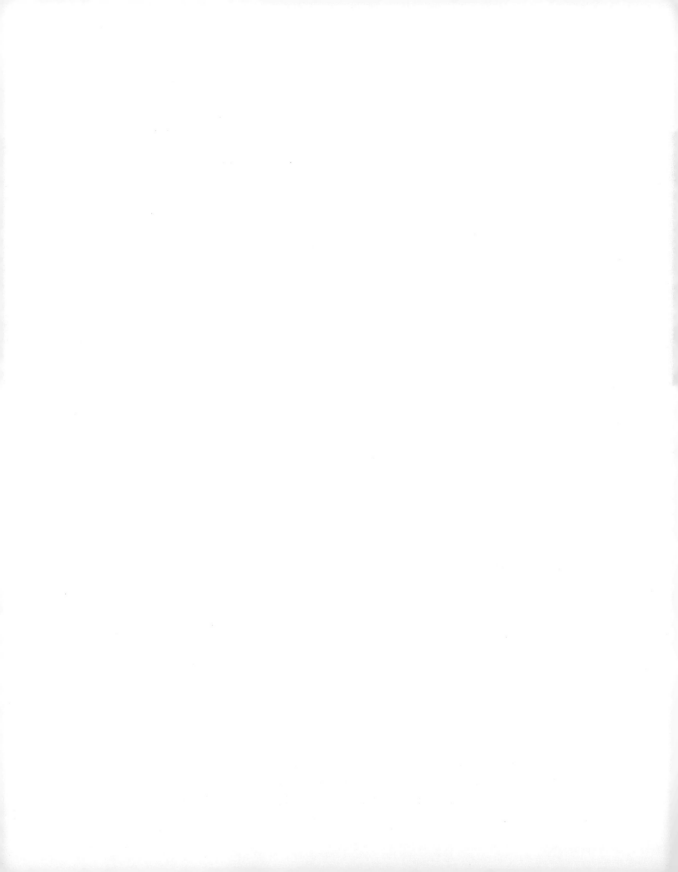

7

Better Content, Better Results

Creating amazing slide shows has a lot to do with what you do before you even sit down to build one. All the material you include can cause limitations. Mediocre photography is a limitation. Content that is difficult to arrange in visually pleasing ways is a limitation. Obvious quality and sizing issues aren't the only limits, though. Knowing some simple tricks and thinking ahead can radically change your results.

This chapter is about techniques to maximize the usefulness of the material for your slide shows before the slide show is even started.

Photography Tips

This section isn't about the mechanics of taking photographs. Instead, it's about some uncommon photography tips that can radically change what you have to work with when you make a show.

This section is specifically about how and what to photograph with slide shows in mind. Some simple changes to the ways you think about and shoot your photos help remove limits and make shows more interesting.

Shoot Horizontal Only

It's tempting to shoot certain photos as portrait images, and many of us have been taught to do just that. That's because historically, the only thing you could do with a photo was to print it. Some like the feel of their fancy SLR cameras when they

crank them around 90 degrees and shoot photos looking like a runway model photographer. But I prefer the results more than what I look like when I take the photo.

The reality is that today's high-megapixel cameras give you enough resolution to take every picture as a landscape image even if you're going to crop it into a portrait image later. You never know when you'll need a certain picture to be wider than tall, and always shooting landscape can save you a lot of heartache when making a slide show. It's easy to crop a horizontal photo into a portrait when necessary, but it's much more difficult to make a portrait photo work in a show, as shown in Figure 7.1.

Original horizontal image Cropped to portrait

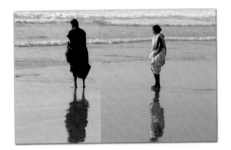

Figure 7.1

It is easy to crop a horizontal photo into a portrait when necessary, but it's much more difficult to make a portrait photo work in a show.

Digital displays are almost always horizontal, and televisions are always horizontal. Why make things difficult with vertical photos? Even if the background to each side of the subject is disinteresting or distracting, it's useful to have the background there to work with in most slide shows. Avoid the problem of having to fit portrait images into a horizontal slide show by always shooting horizontal photos.

After years of shooting portraits, it isn't necessarily easy to train yourself to shoot everything horizontally. I started shooting horizontal-only around 2003, and I found myself wanting to take portrait images all the time. Sometimes I'd realize I'd done it after it was too late. Even though I knew the reasons why, I somehow felt I could get a better photo shooting portraits. The reality today is that it is always easier to shoot horizontally.

Shoot More Than the Whole Picture

Cropping is one of the easiest things you can do with a mediocre photo to turn it into a masterpiece. It's one of the biggest secrets for making photos "pop."

Depending on the photo, a good crop can turn a bad photo into a thing of beauty. It can also change the feeling of the photo because cropping can remove things that would have been prominent, as shown in Figure 7.2. Many poor photos have an excellent photo hiding within them with the right cropping.

Original image Image zoomed in to crop out unwanted areas

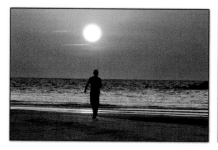

Figure 7.2
Cropping this photo changes its feeling. The cropping makes the person larger while eliminating the sun and the rocks to the right, which distracted from the person.

With this in mind, zoom out a little bit when you frame your shots. Understand before you take each photo that you can always crop it later. Keep in mind that when you use a photo in a slide show, it can be zoomed in or out, and that requires more imagery around the edges. Being able to zoom out a little further or start a little further out when you start a zoom in is useful when you're composing a slide show.

Training yourself to do this takes practice. When I first did this, I felt I would get a better photo if I zoomed in and framed each photo tightly within the viewfinder. Now that I no longer do this, I have better source material for my slide shows and more flexibility in cropping after my photos are taken.

Move Around

I've seen more than my share of amateur video clips. The single biggest videography trick I'd suggest for events is to realize that the video camera doesn't have to stay stationary even though the subject usually is.

To add variety, try slowly moving around a subject. The keyword here is *slowly*. If you move too fast, you're likely to jostle the camera around, and that makes the motion look clumsy. This is similar to what directors in motion pictures do when they use a dolly or a crane to slowly move the camera while a scene unfolds. The camera points at the same subject, and the motion gives the scene depth.

Even the smallest sideways shift will look good as long as you hold the camera smoothly on the subject, pointing it so it stays consistently framed on the subject. The idea is shown in Figure 7.3.

Figure 7.3

By moving slowly around the subject, you create a sense of depth as the action takes place.

This takes a little practice to build your confidence. Try it when you have a chance so you know what to expect.

Modern camcorders are so light that it's actually harder to keep the camera steady than it used to be. Their petite stature makes them unstable, and the lightest shock can show up in your video as an annoying jerking motion. You can correct for this with a little practice. Imagine that the camera weighs a ton and takes an enormous amount of effort to move it even the slightest bit. When you do move it, the imaginary weight keeps it moving in the same way until you exert enormous effort to change the motion. Choose a practice object and move the camera around while it points steadily at the same subject.

If you're willing to spend a little extra money, look into buying a video camera stabilizer. Stabilizers are simple and relatively cheap, and the results are more profound than most people would think. The first time I used one, I couldn't believe how easy it was to take amazingly smooth video sequences, even when running.

It is always a good idea to be on the lookout for scenes, themes, and textures that might be good to use as backgrounds behind images or perhaps for the background of a show menu. For example, if there's enough of a crowd milling around between important scenes, try walking through the crowd and videotaping nobody in particular. This gives you great footage to use as a background under photos or behind an interactive menu on a DVD or Blu-ray disc.

Try Different Angles

Sometimes the oddest angles work wonders to spice up a slide show. Here are a few ideas.

Change of Elevation

How far will a great photographer go to get a breathtaking shot? Mark Ridout risked much to climb a water tower hundreds of feet in the air at a farm for a series of groomsmen photos in a neighboring wheat field. He said the most difficult part was trying to communicate with the groomsmen because he was so far away that they couldn't hear him screaming out what to do. Although this is the oddest angle I've heard of to date, the photos that he created are nothing short of miraculous, explaining Mark's exceptional reputation. Don't be afraid to take photos from offbeat vantage points. Go ahead—try shooting from a balcony or stairway. You might be surprised at what you get.

Odd Personal Interviews

I saw an interesting trick a few years ago, and I've experimented with it since. A videographer I knew was doing candid interviews at an industry trade show and held his camcorder in front of him at about belly-button level while he was interviewing people. He'd talk to each subject while holding the camera in front of him, and it enabled him to hold his arms comfortably at his sides. This gave the interviewee a more comfortable environment to speak in. I call this the "underneath" angle, as shown in Figure 7.4. As he continued, he would move the camera to the side at eye level so it pointed at both of them and he continued asking questions. Because he controlled the questions, he could pause while he switched positions.

Figure 7.4

You wouldn't think that a video of a person being shot from this "underneath" angle would look good, but it does.

The videographer started with the camera in front of him so the person he was interviewing could start off as comfortable as possible. The interviewees didn't seem to worry about the camera. He would only switch when the interviewee was already into the interview. The resulting footage is strangely personal and casual. Because he was changing between the "underneath" angle and the side angle, he could edit the video later to remove the sections where he was changing views. He could change the point of view during the interview as he changed questions. He'd ask all sorts of questions, some of which were things he knew he would edit out. He did this to distract the interviewee from the fact that he was moving the camera. It kept them talking and personal with him, and not paying attention to the camera.

Feet Are a Good Filler

Similar to the crowd idea in the earlier section, consider videotaping an angle that captures people's legs and feet walking by. This creates an anonymous background video that can be used to embellish other visual elements in the foreground.

Another interesting background shot is to videotape your feet as you walk, but remember to watch where you're going!

Shoot Related Subjects

Let's say you're going to attend a birthday party at a restaurant. You're a guest, but you brought your camera and you want to take pictures of the event for your friend who is having the birthday. How can you get photos that make it easier to make a slide show of the event?

Think about the things that would make anyone attending the event remember it. Of course, photos of the event itself work, but other things might as well. How about photos of the front of the restaurant? Are there good scenes or identifying landmarks visible from the location? If there's a flag, take a picture of that.

Taking photos is now almost free, and if you don't use them, you can always delete them. Take more photos, not less. If you're always taking horizontal photos and zooming out to include more of the scene, they can be taken more quickly.

How about the inside of the restaurant? What about while you're waiting for everyone to arrive or to be taken to the table? Once you get to the table, what's there? Are there gifts? Does the menu or table setting look memorable?

These kinds of ideas work with just about any location or event. People remember many different things about events, and strange details about locations and surroundings can evoke powerful memories. To each person attending the event, the event isn't just the event itself; it includes everything happening around the event as well.

If you have a chance, look for photo subjects at events that have nice, regular patterns or would make a great background for other information. Photo backgrounds that are relevant to the surroundings make excellent artwork material for visuals. Just lighten them up and drop them behind other photos for a more professional feel.

In Figure 7.5, the photo on the left isn't the type of photo a person would normally take at an event. However, snapping a few photos like this as backgrounds for other photos can help make your slide show pop by giving you more interesting backgrounds that are specific to the event.

A dull image on its own Used as an interesting background

Figure 7.5

These photos have little relation on their own, but when combined, they create a stylish composition.

If you're shooting video, take a couple of long, still clips for 30–60 seconds of something that moves, like a flag or the street near an event. In these segments, you can often find a nice segment that can be used as a background behind other things, like credits. Simple and unexpected subjects can make effective backgrounds for credits at the end of a show, like dogs playing in the grass at the event. To make this kind of video use effective, though, you have to have a long enough video segment to last for the length of the credits. That could be anywhere from 30 seconds to several minutes, so consider this before you shoot, and make sure you get enough.

One brilliant trick I've seen several times is to use a familiar theme to offer something of a "topical anchor" for stories. For example, I've seen a vacation slide show where the vacationer took pictures of chairs wherever he went, along with other photos, and then he talked about the chairs he saw during his trip. I still find it amazing that photos of chairs changed the character of the resulting slide show. Without the chairs, the vacation slide show wouldn't have been memorable. Instead, it gave the audience an "anchor" to associate that trip and show with.

Another way to do this same kind of thing is to use a pet or stuffed animal as a point of view for a slide show. Imagine if your dog were the narrator and you'd taken some photos from the "dog's eye view" on your trip. What kinds of things would your dog see at different destinations? This opens up all sorts of possibilities for captions and ways to say things more interestingly in your show.

Why Use an SLR Camera?

Point-and-shoot cameras are affordable and easy to use. They take great pictures. In fact, in some ways, the pictures they take are too good because the focus is too sharp. Let me explain.

Single Lens Reflex (SLR) cameras are known for being well made and designed using replaceable lenses. However, the biggest reason most people like SLR cameras is the look of depth that the larger lenses produce.

Figure 7.6 shows the depth of field attained by an SLR camera. The photo on the left was taken with a point-and-shoot camera, and the photo on the right was taken with an SLR camera. Notice the obvious blurring of the background because of the shorter depth of field in the SLR camera. This effect gives a sense of professionalism to photography that cannot be obtained with a point-and-shoot camera. Point-and-shoot cameras have smaller lenses that are designed to keep more of the image in focus.

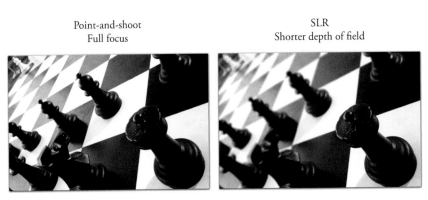

Point-and-shoot
Full focus

SLR
Shorter depth of field

Figure 7.6
Depth of field creates a professional look that cannot be easily attained with a point-and-shoot camera.

You could say that SLR cameras have the disadvantage of not being able to have everything in a photo in focus at different depths. Instead, you can think of this as an opportunity to use this *selective focus* to your advantage.

Note

These multiphoto SLR techniques don't have much value with still photography because still photos alone cannot show change over time. Showing time is only possible with mediums like video and slide shows. Until recent years, these techniques were only used by the motion picture industry, and even then they were done with motion picture film or video rather than still images. In many ways, these techniques are brand new. Many of these techniques are new because of the advent of the modern still photo slide show.

One way to take advantage of the selective depth of field in SLR cameras is to intentionally shoot multiple pictures with the focus set at different depths. When these photos are shown later, the natural effect is for the audience to shift its attention to the things that are in focus. I call this technique *selective focus*.

Figure 7.7 shows an example of selective focus. These three photos are almost the same and were taken at about the same time. The photographer focused once, took the first photo, focused again, and so on. You can use the photos in sequence to create a unique effect that cannot be obtained easily without planning ahead. Taking photographs like this is easy once you know to look for this type of opportunity.

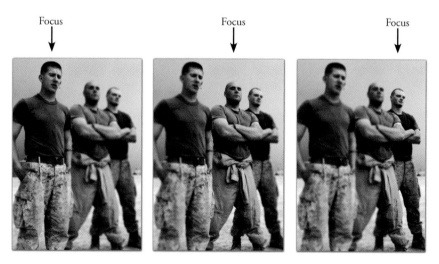

Figure 7.7
Changing slides with different subjects in focus is a great way to add style to a show.

Look at the following DVD example of how to use this technique to add style to a slide show. There's no way to get this kind of effect to look good without photos taken with this technique in mind.

ON THE DVD
Example *Chapter 07-Number 01*: This example demonstrates selective focus between similar shots to guide the audience's attention.

Rapid-Fire Shots

Our memory operates using snapshots. We think of memories as a point in time or a short gesture of movement in an otherwise still scene. Slide shows lend themselves to being organized this way, transitioning from still scene to still scene. These scenes do not have to be completely different from one another—they can be closely related to guide the viewer through a sequence of motion, even with still images.

All these techniques are closely related and use the idea of photos taken in sequence to create interesting effects in time.

Bride and Groom Walking the Aisle

Imagine a bride and groom, just married, walking from the altar toward the camera. Instead of snapping one or two photos to capture the moment, you take a series of photographs, each at even intervals. For still photography, you would only do this to make sure you got the best photo to print. You can still choose the best photo for printing, but now you have another use for these images. Use this sequence of photos to create a dreamy progression in your slide show.

Arrange your photos in order, transitioning between each photo with a fairly short crossfade transition. The audience will see the sequence as a normal progression, but the look will feel like a memory. It has almost a mystical quality to it. With the right music, this technique is very powerful.

Figure 7.8 shows the points at which several photos are taken of the bride and groom as they leave the altar and walk down the aisle. Make sure to take each photo at even intervals, and use a tripod if possible to keep the camera still. If you cannot use a tripod, keep in mind that the point of view of the camera should either remain in the same place for each photo or move at a consistent pace between each photo.

ON THE DVD
Example *Chapter 07-Number 02*: This example demonstrates a progression of images taken in sequence. It conveys movement but only in a way that also has a certain nostalgic quality of still photography.

Walking the aisle
Short crossfade transitions

Figure 7.8

Sequence of images taken to show a progression.

Sunrise, Sunset

Set up a tripod and take several photos of a sunrise or sunset at a regular interval. Snap a photo every 5 to 10 minutes; 5 to 15 photos should be enough. Technically, this is called *time-lapse photography*. Don't let that scare you, because this trick doesn't have to be automated, and you don't need many photos. However, you do need the camera to be still for this to work, so I recommend using a tripod.

Use relatively short crossfades between each photo. The results are a great stylized sequence that will be interesting for others to watch, as shown in Figure 7.9.

Sunrise effect
0.0 second slide durations with short crossfade transitions

Figure 7.9

A sequence of slides showing the time-lapse sunrise technique.

ON THE DVD Example *Chapter 07-Number 03*: This example demonstrates the use of sequential time-lapse photos to show the movement of the sun.

Post-Processing Photos

Spend time touching up your photos. This can be as simple as adjusting the colors or rotation to keep a photo's horizon aligned. If you've scanned photos from paper or film, there's bound to be some dust on the photos. Take the time and effort to conceal dust and remove blemishes from people's faces. Your slide show can only be as good as the material you put in it.

People are distracted by dust, blemishes, and misaligned horizon lines. If you remove these distractions, they'll focus more on the rest of your show. Figure 7.10 shows an example of the difference in quality gained by removing imperfections from photos.

Original image
Lots of dust/scratches and damage,
particularly on the left-hand side

Edited image
After removing some of the smaller
imperfections, and cropping
out the large tear on the left

Figure 7.10

Take the time to remove
imperfections from
your photos.

Review

Even the best slide show software can only go so far to make your photos pop. The best way to ensure a great result is to start with great material. Spend a little time thinking about which photos to take and how to take them, and then clean them up before using them for your slide show. The results are always better when the source material is as good as it can be.

8

Tricks with Source Material

ProShow provides a variety of tools to create impressive output. It is important to understand that as powerful as these features are, the core purpose of ProShow is to present audio-visual information, not to edit it. Features that manipulate or enhance the source material are only a convenience and are not intended to replace a separate photo editor.

Think of slide show software as the last stop before actual output is created. You can produce a much wider assortment of effects if you use external image and video tools to enhance your source material before you use it with ProShow.

Many of the techniques suggested in this chapter involve doing something outside of ProShow to enhance or create source material before using it in ProShow. This gives you even more ways to create impressive results.

Because you may be using any number of photo-editing applications, explaining how to use your photo editor is beyond the scope of this book. Refer to the documentation for your photo editor for instructions on how to accomplish the editing work described here. There are many books on using photo editors and an incredible range of things you can do to enhance your photos. This chapter describes some common tasks that you can do easily, but by no means does it try to be exhaustive about the possibilities. If you feel comfortable with your photo editor, feel free to experiment with many more ways to enhance your source material.

Cropping and Adjustment

I mention cropping in this book repeatedly because it is useful to control the audience's perception. Simply put, what the audience *can't* see forces them to pay attention to only what they *can* see. Figure 8.1 shows examples of photos that benefit from cropping.

Original images

Cropped for better composition Cropped to reduce background space

Figure 8.1
The photos on the top are not bad photos, but they clearly benefit from cropping.

Go through the photos you use in a show and think about the composition of each one. Crop and adjust them using either a photo editor or the built-in cropping tool in ProShow to simplify what the audience will see. Doing this makes your show easier to watch.

Borders

Picture frames add a finishing touch to artwork because they enclose it in a border that sets it apart from its surroundings. The same holds true of any kind of border placed around a slide show visual.

Simple Photo Border

The simplest of borders is a solid rectangular border around a photo. It's an easy add-in with ProShow. You can use any color you want, but people recognize a solid-white border as being similar to a border around an old photograph. The simplicity of this effect is elegant and is hard to beat for many uses. Figure 8.2 shows some simple borders.

No border Thin black border Thick white border

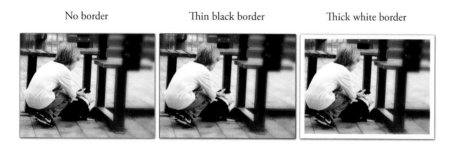

Figure 8.2

These photos show a thin black border as created by ProShow Gold, and a white rectangular vignette border added with ProShow Producer.

Producer users can take borders a step further by using the vignette tool to create a thick white border around photos, as shown in Figure 8.3. Simply click on the Vignette button, choose Solid Color for Type, and click the check box next to Fill Corners and Solid Borders. You can select any color, but white seems to produce the best effect. ProShow Gold users who want to use a similar type of thick white border can easily create this type of border in a photo editor and bring in the border as the top layer on their slide. We'll go into more detail on vignettes later on in this chapter.

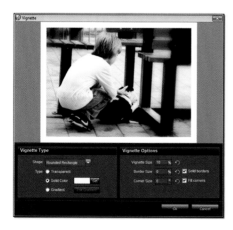

Figure 8.3

ProShow Producer's Vignette dialog.

Polaroid Border

Taking the simple border one step further, the bottom border can be taller than the other three sides. This is shown in Figure 8.4. If you get the proportions right, everyone will associate this border effect with the now-obsolete but popular Polaroid film look. I've also provided this border for you on the accompanying DVD, so feel free to use it in your slide shows.

ON THE DVD Example *Chapter 08-Number 01*: This example contains a popular border used with a photo.

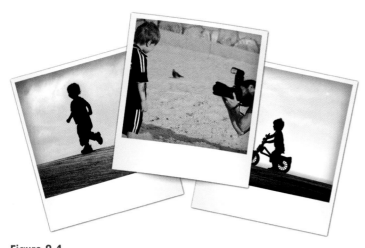

Figure 8.4

By making the bottom of a white border taller than the other sides using a photo editor, you can create the look of a Polaroid snapshot.

Picture Frames

Many photo-editing applications come with built-in features for adding photographic-quality picture frames to photos. Use these time-saving features when possible.

You can create a photographic picture frame around a digital photo using photographs of wooden molding. First, take a photo of a piece of molding, making sure the photo is taken at as straight of an angle as possible so there is no perspective distortion in the photo. The pieces are shown in Figure 8.5. Load it into your photo editor, and make sure it is rotated to be perfectly horizontal. Next, overlay strips around the outside of your photo in different layers. Finally, cut the ends of the strips at 45-degree angles so they all line up. Much like picture frames are made in real life, you can create picture frames in a photo editor.

Original wood panel After 45° cuts

Result

Figure 8.5

You can easily chop up a photo of a piece of molding and assemble it around a photo to create a nice frame.

Sometimes the molding photo strips are not long enough to fit all the way around your photos. You can stretch many types of moldings to make them longer without the viewer noticing they've been stretched. Remember, the audience won't be looking for this kind of subtle imperfection. Instead, they'll be looking at the photo in the frame.

If you really want to wow people with an impressive border, use a molding with a decorative edge—an edge that is not straight, as shown in Figure 8.6. This requires more care with the photo editor because cutting out the pieces of the molding is not as easy when the edge is not straight. It takes a lot of careful selecting and cutting to finish this kind of effect.

In the following DVD example, I show how this kind of source image looks moving on a background so you can see the compelling results of this technique.

Figure 8.6

The background behind the molding has been replaced by transparency. Removing edges like this takes practice.

ON THE DVD

Example *Chapter 08-Number 02*: This example demonstrates the use of a decorative border that has been edited in a photo editor to create transparency around the edges.

Reusable Picture Frames

The previous technique showed various ways to use a photo of a molding to create a border around a photo. A simple change to this technique yields a powerful procedure to make your own frames that you can use over and over again.

The idea is simple: instead of adding the pieces of the frames to a photo in a photo editor, add them as layers with a transparent center in ProShow.

As shown in Figure 8.7, the diagram on the left shows a photo frame with a transparent center. The diagram on the right shows how to arrange the photo frame in ProShow so the photo layer actually fits behind the photo frame layer. As long as the photo frame layer and the photo layer move the same way, the audience cannot tell that the photo and the photo frame are not the same piece of artwork. Sometimes it's nice to add motion only to the underlying photo to make it look like it's slowly moving under the picture frame. It's a subtle effect that requires just a little motion but makes a big difference in the overall feel of your show.

ON THE DVD

Example *Chapter 08-Number 03*: This example shows the use of separate layers for a photo and photo frame. As long as the motion is identical, the composition of the two layers appears to be one image.

Image in a reusable frame

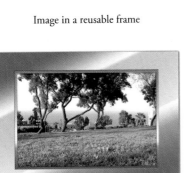

Frame image with transparent cutout

Slide background

Image layer

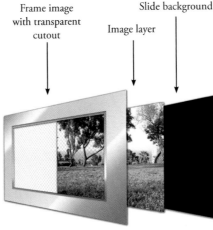

Figure 8.7

Constructing a framed photo using layers.

Photo Stacks

A popular technique with vacation and family slide shows is the *photo stack*. The idea is to show a stack of photos, presumably with photo frames, such that the photo on the top of the stack moves away to reveal the photos below.

Accomplishing this technique in ProShow Gold is relatively simple using multiple slides, as shown in Figure 8.8. Start with a slide containing all the photos as a separate layer, and arrange them so they look good. Set the slide time to 2.0 seconds or so and the transition time to 0.0 seconds.

Next, copy this initial slide over and over so you end up with twice as many slides as the number of photos you will be revealing. You'll need twice as many slides because the first of each pair of slides will be still, and the next will move the top layer away. So, if you have five photos in the stack, you will need 10 slides.

Starting with the second pair of slides, remove the top layer. Each pair should have one less layer in it than the pair before it.

Now go back to the second slide in each pair and drag the ending position in ProShow so that the top photo's ending position is completely outside the visible area of the slide.

Adjust the timing for the first and second slides in each pair so that the stack is still for the right amount of the time and the photos move at the right speed during the slides where the top layer is being moved out of view.

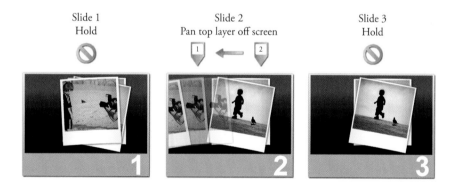

Figure 8.8

The photo stack technique uses pairs of slides to move each layer away.

Study the example on the DVD to see how the pairs of slides work together to give the impression of a stack of photos revealing themselves.

Example *Chapter 08-Number 04*: This example demonstrates the use of a stack of layers, each moving away in sequence.

> **Note**
>
> ProShow Producer's keyframing produces this motion using a separate keyframed motion for each layer. This entire effect is more easily done in Producer without the need for many slides, as seen in Figure 8.9.

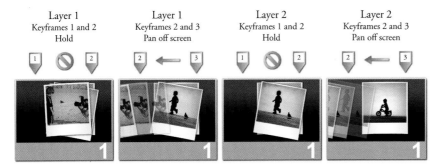

Figure 8.9

The photo stack technique is done in one slide in ProShow Producer with two layers and keyframes.

ON THE DVD Example *Chapter 08-Number 05*: This ProShow Producer example demonstrates the use of a stack of layers, each moving away in sequence. This example is accomplished in a single slide using keyframes.

Caption Motion

You can use captions as powerful messages that stylize a slide show. ProShow Gold has no way to move captions by itself because it does not have keyframes. Here are ways to trick ProShow Gold into creating a couple of slick-looking caption effects without using keyframing.

These effects work because a graphics image doesn't have to be a photo. Instead, it can be an image you create in a photo editor that looks just like a caption. In effect, it *is* a caption. It is just a caption shown as a graphics file instead of a caption the program creates on its own. This works well as long as the caption moves around as one large piece, without each glyph in the caption needing to move separately.

Caption Graphic with Transparent Background

In your photo editor, create a new image that is completely transparent and add text to it. Figure 8.10 shows how this might look in Photoshop. You can save these files as a *.PNG or *.PSD image so the transparency will be preserved in ProShow.

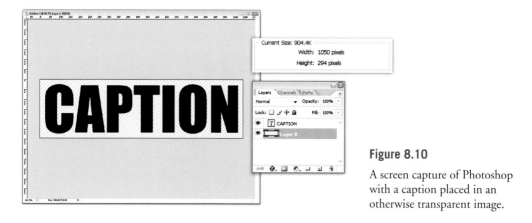

Figure 8.10

A screen capture of Photoshop with a caption placed in an otherwise transparent image.

When you use this caption graphics file in ProShow, you can manipulate it just as you would any other graphics file. You can scale it, move it, rotate it, and so on. You can even add a drop shadow.

Be careful to use a pixel resolution for your graphics file that is not too small or too big. If the pixel dimensions are too small, scaling your caption graphic up makes the caption look blurry. If the caption graphic is more resolute than it needs to be, you'll be wasting unnecessary resources. A good metric to use is to not make your caption graphics more than 2.5 times the pixel dimensions they will ever be displayed at.

With this technique, you can add slides together to create effects like captions that change size during slides, pan slowly, and so on. Study the DVD example to see some different caption effects that you can easily create with this technique.

ON THE DVD

Example *Chapter 08-Number 06*: This example shows various creative ways to use image files as if they were captions. This is an example you may want to study in ProShow to see how each effect was constructed.

Big Panning Caption Effect

Using the caption graphic technique described in the previous section, you can scale and move the caption graphics in ways you may not initially consider when you think of captions. This can create some fancy embellishments for a show.

Create a wide caption graphic that is about the pixel height of your show. When you add the text to the image, use your photo editor so that the caption text is partially transparent—perhaps 80 percent transparent, which is 20 percent opaque. The technique for doing this with your photo editor varies depending on which photo editor you are using. See Figure 8.11 for an example.

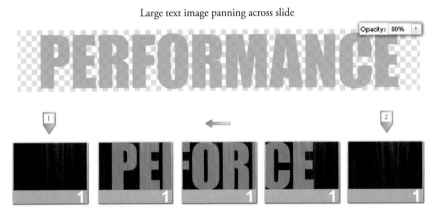

Figure 8.11

The caption graphic slides across the visual area so only part of the caption is visible at any one time.

When you first use this graphic, ProShow defaults to scaling it to fit within the frame. Increase the zoom of this caption graphic so that it is wider than the visible area of the slide and the height of the caption fits nicely to fill the vertical height of the slide.

Set the starting position of the caption graphic so it is to the right of the slide but none of it is visible. Set the ending position so it is to the left of the slide but none of it is visible. Finally, set the pan style for the caption graphic layer to "Linear." This gives the audience a nice message to follow, which adds to the visuals in a way that a normal caption cannot do.

This technique results in a smoothly moving, partially transparent caption that slides across the surface of your show, adding a message to the visuals underneath. The speed of the motion for the caption is controlled in ProShow Gold by the length of the slide it appears in. Longer slide times create slower motion, and shorter times create faster motion. Adjust the slide duration until the audience can easily read the caption. You may need to adjust the transparency and color of the text in your original caption graphics file once you see the results to tune the way it looks in your final show. Adjust the transparency, color, speed, and zoom until things look the way you want.

Example *Chapter 08-Number 07*: This example demonstrates the use of a big panning caption.

You can also create this big panning caption effect in ProShow Producer without the need for an external photo editor, as is shown in Figure 8.12. Simply create a caption and choose a large font size; you can play around with the exact size, but each letter needs to nearly fill the screen. Next, go to the Effects tab and set up your keyframes so that the caption moves from the right to the left for the duration of your slide. Like the instructions for ProShow Gold earlier, you can lengthen the slide time to make the caption move slower or shorten the slide time to make the caption move faster.

ProShow Producer - Caption Effects window

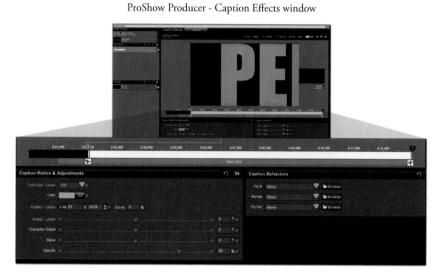

Figure 8.12

Use keyframes in ProShow Producer to pan a large caption.

Example *Chapter 08-Number 08*: This example demonstrates the use of a big panning caption created using the caption capabilities of ProShow Producer. The results are smoother and easier to accomplish than the previous example using ProShow Gold.

Vignettes

When we think of a border around an image, we usually think about something like a picture frame. These borders are usually opaque.

A *vignette* is really a fancy way of describing a border that includes transparency as its defining attribute.

Adding a Vignette to a Photo

An effective way to stylize a photo border uses transparency to change the shape or sharpness of the edges. An oval matte in a picture frame is kind of a vignette that can be thought of as cropping the photo to an oval shape. In a photo editor, create a similar effect by cutting out the area around a shape so that it becomes completely transparent. For more production value, blur the edges of the photo so that it fades from fully opaque to fully transparent.

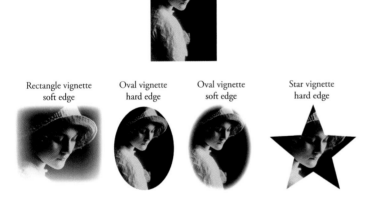

Figure 8.13

The original photo is modified to add transparency around the perimeter, called a *vignette*. Different styles create different feelings.

In Figure 8.13, I included a star shape on the right to demonstrate that you can use any shape for this effect. When you must find ways to compose a slide, remember that you are free to change the shape of photos this way to make them fit with other visual elements. Sometimes an irregular shape gives you something that will visually fit together with other things in the slide, much like a puzzle. Be careful to keep similar vignettes consistent in proportions throughout your show to avoid distracting the audience.

The basic idea of fuzzy vignettes is that you're putting transparency around the outside of the photo. This by itself doesn't do much for the photo until you use the photo over something else, as shown in Figure 8.14. This is why the transparency is so important—it allows the background to show through. Perhaps you use another photo as a background. Using a photo with a vignette on a black background certainly looks better than other backgrounds, but much of the potential is lost.

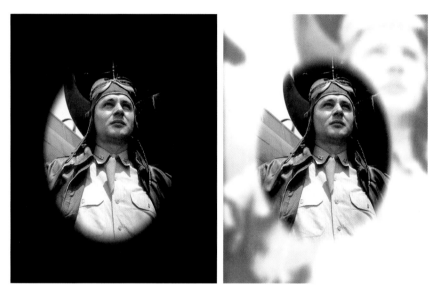

Figure 8.14

The power of using vignettes is in the way the foreground and background interact.

ProShow Gold supports alpha channels for several image file types including Photoshop files, *.PNG images, and *.TIFF files. Once you've modified your photos in your photo editor, the transparency around the perimeter of these files is preserved and combined with the visuals in layers underneath your vignetted photos.

Note

ProShow Producer has basic vignetting built in for rectangular and oval vignettes as shown in Figure 8.15. There is no need to use an external photo editor for the most common vignettes with ProShow Producer. It also allows control of the fuzziness of the border to save time.

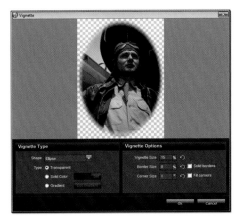

Figure 8.15

ProShow Producer provides
built-in image vignetting.

Using Multiple Images with Fuzzy Borders

Consistency is the biggest issue when using multiple vignetted photos. If the relative size of a soft-edge border around one image doesn't match other photos, the audience becomes distracted. Getting the exact amount of soft edge around photos with different resolutions can be tricky. If you start with multiple images with different pixel resolutions, you need to do some simple arithmetic to figure out exactly how many pixels to blur the edges of each photo. Remember that this is all about proportions—the same percentage of the border must be blurred for each photo. When your photos are to be displayed at different sizes, you must multiply by the size difference to end up with the same proportion in the final result. See Figure 8.16 for an example of what happens when you don't take different image proportions into account. Take special note that the fuzzy edge of the upper-left image appears to be almost sharp because of the difference in pixel sizes of the photos.

Image 1 - Resolution: 300 ppi Image 2 - Resolution: 75 ppi
 20px vignette 20px vignette

Image 1 - Resolution: 300 ppi Image 2 - Resolution: 75 ppi
 80px vignette 20px vignette

Figure 8.16

Vignette proportions should not be judged
by pixels alone. Instead, they should be
viewed as a percentage of the overall size.

The sum of all the details in a show can make the difference between a well-made show and a shoddy one. These details may seem overwhelming, but as you practice and run into these problems, they become easier and easier to anticipate and manage. Stylization without consistency can easily become a distraction.

Image Stylization—Canned Effects

Most modern photo editors come with an arsenal of easily applied stylization effects. Be careful with these "canned" effects because they do not necessarily add much to your show. Anyone can click a button in a photo editor and make a photo look like a Picasso, as shown in Figure 8.17.

People's usual first reaction when introduced to the power of photo editors is to show off all the special effects they can. The best thing to remember is that most people who will watch your show have probably seen these kinds of canned effects and will most likely be immediately bored by them rather than impressed.

Watercolor filter

Original image

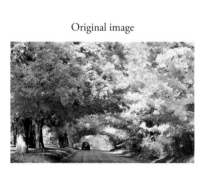

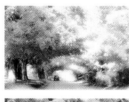
Diffuse Glow filter

Crosshatch filter

Figure 8.17

Modern photo editors come with many ways to instantly stylize photos.

There are some circumstances where canned effects have genuine value in a slide show. The first is as backgrounds: to reduce distraction and increase production value. A common way to improve the look of a slide is to use a stylized version of the foreground photo as a background. Canned effects are great for this.

Stylizing a background image using the same foreground image is a quick and effective way to improve the production value of a slide, as shown in Figure 8.18. Note how I've increased the black point of the background image to lighten the background. This lightening increases the audience's focus on the foreground photo because the background initially appears to be washed out.

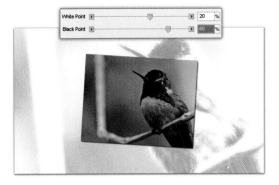

Figure 8.18

Using the same image washed out and enlarged for a background is an effective style trick.

The second way canned effects have value is when used as a way to stylize a transition to or from another photo, as shown in Figure 8.19. Be consistent with this type of effect, and use it mainly as a theme where you do this almost all the time in a show. If you only do this once or twice or if you constantly change the type of canned effect being used, the effects can be distracting.

Figure 8.19

A canned effect can be an effective visual cue to help transition from one visual to another.

ON THE DVD

Example *Chapter 08-Number 09*: This example demonstrates some simple uses of common canned effects found in popular photo editors to stylize photos.

Fake Masks

Shortly after ProShow Producer was released, ProShow Gold was updated to support multiple image layers and transparency. Although these aren't true masks, they can act similarly. I call layers with transparent parts that are used to reveal things below them *fake masks*.

A *masking layer* is a layer that only controls the visibility of a series of layers contained within it. Masking layers allow the contained layers to move about and appear only where the masking layer allows. Anywhere the mask layer does not reveal the layers contained within, it leaves the rest of the show surface untouched.

There are many powerful advantages to masking layers that cannot be realized without them.

In contrast, a fake mask must conceal the layers below it using opaque pixels. We can think of this like a wall with a window in it. The audience members see the layers beyond it through the window, but the only reason they cannot see more of the obscured layers is because the wall is in the way. There are problems with this. A good example I call the *two-window problem* is shown in Figure 8.20.

A fake mask with two windows is used to frame moving photos behind each window. As each photo zooms in, one of the photos incorrectly appears in the wrong window because the fake mask cannot constrain the visibility of each photo separately.

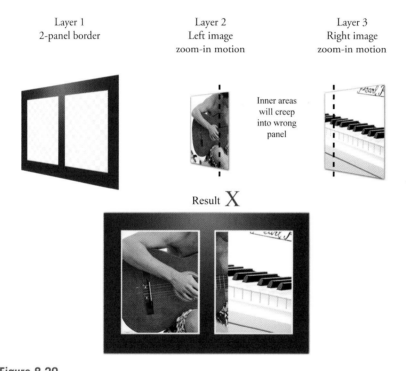

Figure 8.20

Fake masks do not actually limit the display of the layers they frame completely, so be careful when zooming or panning.

Example *Chapter 08-Number 10*: This ProShow Gold example shows that without masking found in ProShow Producer, certain types of motion with layers having multiple windows are not possible.

With masking layers, the two-window problem cannot exist, as shown in Figure 8.21. Within each mask, none of the contained layers can appear anywhere except within each mask layer's area. Using ProShow Producer with real masking layers eliminates the two-window problem.

Figure 8.21
ProShow Producer's mask layers eliminate the two-window problem and make a vast set of visual effects possible.

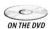
ON THE DVD

Example *Chapter 08-Number 11*: This example demonstrates the use of masking to solve the two-window problem. ProShow Gold users can view this example using the included executable (*.EXE) file.

Fake masks are powerful despite their limitations. Depending on the problem at hand, they can be the perfect solution. The key is understanding when and how to use them.

Employing Holes and Windows

An easy way to use a fake mask is to make a layer that is exactly like a matte in a picture frame. It is simply a large rectangle with a border in it, and the rectangle inside the border is cut out with a photo editor to contain only fully transparent pixels.

This kind of matte image is easy to make with any photo editor and results in the same effect as a picture frame, except you can move the photo behind it to add motion to your show. You can see an example of a matte layer in Figure 8.22.

Figure 8.22
A rectangle with a hole in the middle can act exactly like a matte in a picture frame.

Note

A simple trick is to take high-quality photographs of some matte cardboard of varying textures. Experiment with different textures. If you have a picture frame handy on your wall, you can even take a photo of it on the wall if you are careful and the lighting is right. Once you bring these photos into your photo editor, you can easily add a rectangle in the center and chop out a transparent hole. Use these images in your shows as photorealistic mattes over other photos. They will look exactly like real photo frame mattes—because they are!

If your goal is to show a scene with a window in it, a photo of a wall with a window that has had the glass cut out to be fully transparent is an obvious trick. I've seen this used effectively to show scenery passing by on a train trip as viewed from inside the train car.

Create the illusion of clouds moving across a sky by applying a low level of transparency to the sky part of a photo and then moving another layer of clouds behind it.

ON THE DVD

Example *Chapter 08-Number 12*: This example demonstrates the use of partial transparency in a photo with a layer of clouds moving behind it. To fully understand this, examine the foreground layers and notice which parts of the foreground layers are partially transparent. These are the parts the cloud layer will show through.

A similar effect requires applying a low level of transparency to the windows of an office building. By moving a photo of clouds behind the frame mask office building photo, the partially visible clouds appear to be a reflection in the windows. This takes some careful editing, but the results can be impressive.

ON THE DVD

Example *Chapter 08-Number 13*: This example demonstrates a compelling cloud reflection on the side of a glass building. The effect is very compelling even though the reflected clouds are moving in the wrong direction!

Creating Layered Depth

A technique common in cartoons is to use multiple layers that move proportionately to create the illusion of depth. This can be done with photos to create the same illusion. It does require some careful editing and can be time consuming. However, as seen in the DVD example, the results are worth it. The structure of a multilayer scene is shown in Figure 8.23.

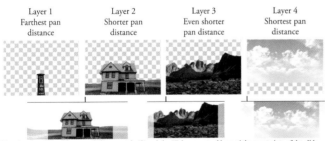

Note that the width of the ground (2), mountain (3) and sky (4) layers extend beyond the constraints of the slide. This is critical to allow the scrolling motions to occur without reaching the image edge.

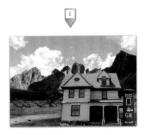
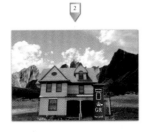

Figure 8.23

Using four layers moving at different speeds, you can create the illusion of depth.

 Example *Chapter 08-Number 14*: This example shows the use of four layers to create the illusion of depth.

Controlling Attention

Sometimes it is important for the audience to follow along with a narration track and avoid distraction. These are usually situations in which there is more information on the screen than necessary at any given point in time and you really need the audience to focus. A fake mask can be a perfect way to guide the audience to ignore most of the visual.

The spotlight mask is just a large, partially transparent black rectangle with a completely transparent hole in it, preferably with edges that are a little blurred just to make it look nicer. See Figure 8.24 for an example of a spotlight layer. You can move around and scale the mask layer to change where the hole appears. The dark area of the mask is partially transparent black, so most of the visual underneath it shows through as if it were darkened.

Figure 8.24
The spotlight mask is simply a rectangle with a hole in it.

Set up your slides to follow the narration, and move the hole in the mask from one subject to another as appropriate. You can pan and zoom the mask. You can include slides that hold the mask in one spot during the duration before moving onto the next location.

 Example *Chapter 08-Number 15*: This example demonstrates the use of a partially transparent layer with a fully transparent hole in it to guide the audience's attention to various coins.

Chopping Up Photos

Starting with a photo, you can use your photo editor as a tool to change the material you use in your show. Often, the background of a photo takes attention away from the subject. Depending on the photo, you may be able to remove the background with your photo editor to increase the impact of the main subject and avoid distraction. Figure 8.25 shows an example of using a flower with a different background. With some effort, you can replace some or all of a photo with transparency to guide the audience to focus on exactly what you want. Remember, what the audience members cannot see cannot distract them.

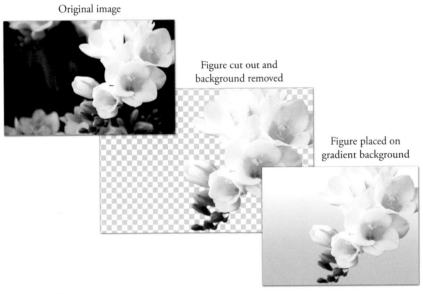

Original image

Figure cut out and background removed

Figure placed on gradient background

Figure 8.25

Modern photo editors have tools to selectively remove parts of a photo.

One detail can make or break this technique, as shown in Figure 8.26. Be careful about the outlines of what you crop out and the contrast in the edges. It is easy to make minor errors in the edges of a cropped image; high-contrast pixels that are sometimes difficult to see in the photo editor you are using are often left behind. Consider the colors of the background you'll be using the photo against, and try to remove pixels that would cause a high-contrast border around your images.

Figure cut out and
background removed

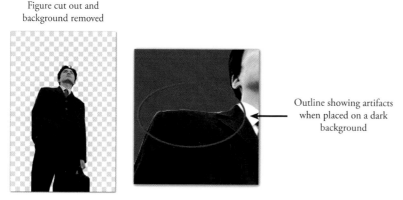

Outline showing artifacts
when placed on a dark
background

Figure 8.26
Part of the background removal can leave visual artifacts around the edges if you're not careful.

Changing Backgrounds

Once you've removed the background around the subject of a photo, you can create some interesting effects by placing the subject on different backgrounds from other photos. This can easily lead to a surreal look because the placement looks unnatural. See an example in Figure 8.27. Notice how the choice of background significantly impacts the perception of the image. Surprisingly, this often works to your advantage depending on the purpose of the visual, especially if you add a small amount of motion.

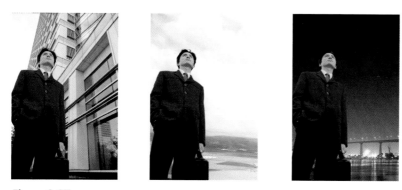

Figure 8.27
The same subject of a photo chopped out and placed on three different backgrounds.

Keep in mind that you do not have to place the image on the background in the photo editor. Instead, leave the background transparent and use it as a layer positioned over the background image in ProShow. This enables you to apply motion to the subject photo or the background in the slides they are used in.

Using Pieces of Photos

The television show *Home Improvement* popularized an effect using pieces of images that flew together or fell apart during transitions in the show. Figure 8.28 shows how a photo can be cut apart similarly into different layers that can each be moved separately. Slide show software allows you to make the pieces follow their own paths that either start out or end up together to appear as one seamless image.

Original image Image broken apart

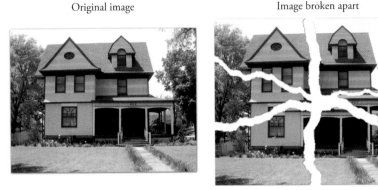

Figure 8.28

Breaking a photo into multiple pieces is a great way to add a stylish transition to a show.

This trick is often used to make puzzle effects in ProShow. Each piece is usually a full-sized image with transparency everywhere except for the individual piece the layer represents. This uses many layers but makes it easy to align all the pieces. It is possible to crop each image and avoid all the blank transparent space, but aligning the pieces is much more difficult this way and creates more work to get it right.

There is always more room for more transitions. Figure 8.29 shows how to make a photo appear to be a sheet of glass breaking and falling away to reveal the next photo underneath.

There are three tricks in this example that help the effect work. The first trick is that the pieces of the photo that represent the glass should be partially transparent. When the slide with the glass pieces occurs with a cut transition, the original photo appears to instantly reveal the underlying photo, but only partially. This gives the slide the psychological effect of the glass breaking all at once. Your mind sees it as if it were a sharp event that broke the glass.

The second trick is to set the motion type for each of the glass pieces to *accelerate* so they start slowly and move faster and faster as they go. All the pieces will be moving downward, so this will make it look like they are falling because of gravity.

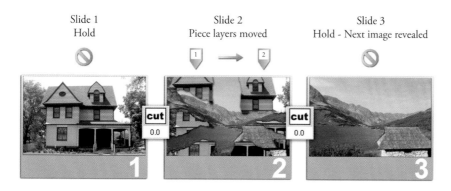

Slide 1
Hold

Slide 2
Piece layers moved

Slide 3
Hold - Next image revealed

Figure 8.29

The pieces of the image look like the photo is broken. In the slide, the pieces fall away to reveal the photo underneath.

The third trick is something that I will cover only partially here because I will cover it in more detail later. The idea is that the sound effect has an offset of 0.1 second. This means that the crash sound actually happens *just after* the glass breaks. Because the "crash" sound is unexpected, the audience members need to hear it about one-tenth of a second *after* they see the event occur. If this offset isn't there, people will think the sound isn't properly synchronized. For more information about this oddity of human audio/visual perception, see Chapter 9, "Audio and Synchronization."

ON THE DVD

Example *Chapter 08-Number 16*: This example demonstrates using multiple pieces of an image to simulate the image being broken and falling downward.

Tricking ProShow Gold with Video Output+Input

ProShow Gold supports video layers. This opens up a lot of possibilities to do things that cannot be done with ProShow's features alone. Anything that you can do with ProShow or any other tool that outputs video can be dropped into ProShow as a video layer.

Creating Moving Backgrounds

An easy way to create interesting moving backgrounds is to set up a show with a single slide with a 0.0 second transition. In the slide, insert several layers with varying levels of transparency. Using linear movement, rotate the layers in different directions such that at the end of the slide, they end up at the same rotation they started at. Figure 8.30 shows an example of the setup for a moving background with rotation settings.

A simple setup for a moving background

In order to ensure the final video loops properly, any moving layer must end at the same point it began.

In this example, the light burst layer rotating 360 degrees ensures there will be a seamless looping motion.

The light burst is transparent, overlaid on top of a simple gradient layer.

Figure 8.30 •

Setting up a moving background isn't terribly difficult once you understand a few simple tricks.

If you export this single slide show to a video file, you can use this video as a layer. When you loop the video, it appears to be continuous because the end of the video is identical to the beginning and the motion is linear. The audience does not see a change between when the video loops.

You can use as a background anything you can create with ProShow. Just create a show that does an effect and export a video file. Use that video file as a layer in another show.

Morphing Images

ProShow Gold doesn't support varying the transparency of layers or keyframes. How can we trick ProShow Gold into transforming one image into another while it is moving? The answer is to create a video to help you.

Make a short show of two slides transitioning from one to the other. Export this as a video file, and bring the video file into ProShow as a layer in a new show. The video shows the photos changing from one to the other; you can move the video around just as you would a still photo.

Example *Chapter 08-Number 17*: This example is a short show that is designed to be output as a video file for the next DVD example (Chapter 08-Number 18).

Example *Chapter 08-Number 18*: This example uses the video created using the previous DVD example (Chapter 08-Number 17) as a layer included in a slide for stylistic effect.

Cheating with Animated Caption Layers

Sometimes you really need to have captions move below other layers. You can accomplish this easily the same way. Just create a video of the caption effects, and bring them into ProShow as a video layer.

People are sensitive to the quality of text on the screen. Make sure you use a video resolution high enough to satisfy the resolution requirements of your final show, or your captions will appear soft or blurry. Also, do not use an interlaced video format if you can avoid it. Caption motion with interlaced video can cause various types of motion artifacts. Noninterlaced video formats do not have this problem.

Review

Although there are many ways to use ProShow to create a fantastic slide show, don't forget about the myriad ways you can use other tools to create content that will increase your options within ProShow. Some techniques require you to think about your visuals in ways that at first are not obvious. Others require using facilities in ways that aren't the usual ways you'd normally think to use them.

Creative manipulation and refinement of your source material always results in better productions. The saying goes, "Better material in, better slide show out!"

9

Audio and Synchronization

A show's audio is more important than most think. An obvious audio problem is more destructive than an obvious visual problem. As humans, we naturally hear continuous sound because there are few things that can interrupt our hearing in our natural environment. In contrast, when you hear something obviously different, your instinctive reaction is fast and furious. Imagine your reaction when you suddenly hear a bug flying right next to your ear.

We react to visuals differently than sound and are naturally tolerant of visual imperfections. We constantly change what we look at as we scan what we see. We regularly blink our eyes to keep them from drying out. Passing objects temporarily get in our way. Other objects move in our peripheral vision, and we naturally ignore these distractions. It makes sense that audio is more important than visuals once you think about how much visual stimulus we ignore.

Importance of Audio

A show with good audio and mediocre visuals will almost always be appreciated more than a show with good visuals and mediocre audio. Time spent to get better audio is almost always time well spent.

Perhaps surprisingly, good audio can hide a fairly severe visual problem, especially if the visual problem is short. A bad glitch in a video for a few frames will go almost unnoticed by the audience if the audio sounds normal throughout the visual glitch.

ON THE DVD

Example *Chapter 09-Number 01*: This example demonstrates the same show with small audio and visual glitches. The show with the visual glitch only feels more finished than the show with the audio glitch only.

Just as good audio can make a mediocre slide show watchable, bad audio can make a show almost unwatchable. The most common problems with audio are inconsistent volume and pops and clicks.

Changing the volume of audio clips is easy and can be done on a track-by-track basis or for each sound you include with a slide. In ProShow, you switch between the slide list view and the timeline view with the Tab key, as shown in Figure 9.1. In most slide show software, reducing the volume of a track below 100 percent won't cause problems, but increasing the volume of a track above 100 percent can cause a common problem called clipping. *Clipping* happens when the extremes of the audio waveform are amplified beyond the available range and the software has no choice but to limit the waveform to a flat line wherever it would go out of range. This causes abrupt, high-speed clicking and is highly annoying. Audio tracks are often recorded at low volume and are so quiet that they can be amplified quite a bit without causing clipping. Feel free to increase the volume of a soft audio track, but be careful that your volume increase doesn't cause clipping. In ProShow, you can see the audio waveform in the timeline view, as shown in Figure 9.2.

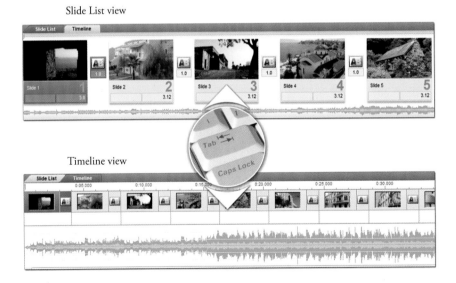

Figure 9.1

Use the Tab key to switch between the slide list view and the timeline view in ProShow.

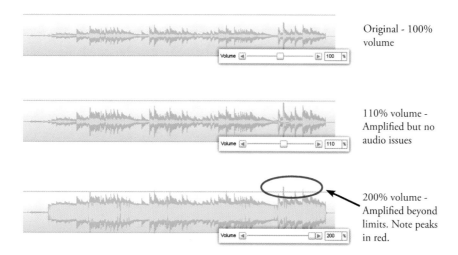

Original - 100% volume

110% volume - Amplified but no audio issues

200% volume - Amplified beyond limits. Note peaks in red.

Figure 9.2

Clipping occurs when volume levels are increased beyond the maximum range and the tops and bottoms of audio waveforms are clipped.

To equalize the volumes of tracks, it is safest to reduce the volume of tracks that are too loud rather than to try to increase the volume of tracks that are too soft, except when you know a soft track can be safely amplified beyond 100 percent without causing clipping. If you increase the volume of an audio track, make sure to listen to the result closely to see if you can hear clipping.

To edit audio clips with glitches in them, you need a separate audio editor. Find the glitches and smooth them out by either silencing pops and clicks or, even better, replacing the pops and clicks with chunks of audio taken from adjacent audio data.

ON THE DVD

Example *Chapter 09-Number 02*: This example demonstrates the difference between good and bad audio.

Audio as a Reinforcement of Emotions

Have you ever noticed how dramatic movies have emotional music during periods when emotional things are happening? This kind of musical accompaniment reinforces the emotional feelings the audience perceives and amplifies the audience's acceptance of the feeling. This works for many emotions but is most easily understood with deep emotions such as sadness or love.

Select Music for Emotion

For any given show sequence, you will most likely have an idea of the kind of feeling you want to create. What kinds of music remind you of this feeling? Listen to different tracks and imagine your finished sequence playing in your mind. It often helps to close your eyes to concentrate on your visualization of the results.

Be mindful of the lyrics and how prominent they are in the music. If the lyrics in your music tell a different story from the visuals in your show, the audience could become confused.

Use Music as a Background

Unless the whole point of your show is to promote music, the music you choose should not demand the audience's attention. Instead, it should effortlessly sit "behind" the visuals in such a way that the audience doesn't think much about it. Even when you choose a piece of music because of a prominent lyric that precisely matches the message of your show, the audience should only notice the lyric in passing and get back to focusing on the point of your show.

Avoid using music that is overly distracting or difficult to listen to. You'll do much more for the show if you allow the visuals to capture more of the audience's attention than the music does.

Match the Music to Your Visuals

What happens when the tone of the visuals in a show doesn't match well with the music? Surprisingly, the results aren't necessarily as horrible as you might think. However, the results aren't as powerful as when the visuals and music are well matched.

The example I've provided on the DVD shows some matched and mismatched sequences for happy, sad, and business sequences. Watching and "feeling" the results is the best way to get an idea of how the matching of music to your show makes a difference.

ON THE DVD Example *Chapter 09-Number 03*: This example shows different variations of matched and mismatched music.

Amplify Emotion with Musical Events

In an emotional story line, new information is revealed that tells the story. As the audience sees each piece of information, the emotional feeling of the show can be amplified by immediately following each event with a swell of emotional music.

One way to do this is to change the music and increase the volume a little bit, or even temporarily increase the volume to cause a "swell" in the music. This technique works well when the swell is also aligned in time such that the swell matches the structure of the music.

In theatrical scores, these changes and swells are written into the music by composers scoring and recording the music. For less formal productions, you can do this by changing songs just after these events or, using an audio editor, increasing the volume temporarily after each event. Make sure to reduce the volume relatively quickly or you'll find the volume level of your show increasing as it goes on.

Be Wary of Music Legalities

Many people don't realize that purchasing a music CD does not mean that you own the music. Ownership would imply vast rights that are not available with commercially distributed music. Instead, when you buy a music CD, you are buying a plastic disc, which comes with a license to listen to the music contained on it for your own personal purposes. Strictly speaking, you are not licensed to play it for others, charge money for access to play it, or do anything other than listen to it. In reality, the interpretation of copyright law and music industry case law is difficult for the average person to understand.

Caution

Nothing in this book is intended to be legal advice. Legal issues concerning music can be confusing. It's best to consult an attorney if you have legal questions.

Some consumer protection and fair use laws enable owners of music CDs to do a little more than listen, but it doesn't amount to anything very surprising. For example, in the United States of America, you can make backup copies of music CDs, although even allowing this was fought against heavily in the courts by the music publishers before the courts finally allowed it.

What happens when you combine music with other nonaudio elements (like visuals or a dance routine)? This process is called *synchronization*. Synchronization licenses (commonly called *sync licenses*) are common in the music and related industries. Every time you hear a well-known song in a Hollywood movie, you can be sure that licensing fees have been paid and an attorney has acquired a sync license for that song to be used in that particular film. A slide show with music is a synchronization of the music and other forms of media. If your slide show is for any kind of business or organization, you most likely need a sync license for music

you use in your show. Sync licenses for popular music are not cheap and are usually time consuming and confusing to acquire. Consult a competent attorney for legal advice.

Sync Licensing Revealed

Based on the work I've done with sync licensing, I can offer some helpful insight for those who are serious about spending time and money to obtain proper sync licenses. Keep in mind that the music industry is changing quickly, so read these thoughts with that in mind. You may be able to find a deal better than what I describe here.

Music publishers typically are not very interested in sync licensing because the price for each license involves a lot of variables, is negotiable, and necessary legal work makes the process expensive for them. Few people ask for sync licenses, and the details of sync licensing are complex. Most people asking about sync licensing are not willing to pay enough to make sync transactions profitable. Imagine being offered $1 to deliver something you know costs you $100.

Sync licenses are expensive for music publishers to finalize because of the legal work that needs to be done for each license. There are many types of artist contracts that can affect sync license details between the publisher and the artist; those agreements can dictate the publisher's ability or inability to grant you rights. An attorney must research all the details. Some of these agreements may not exist yet and may be necessary for the publisher to acquire from the artist before they have rights to grant you anything at all. Mainstream music publishers aren't likely to talk to you seriously about sync licensing unless you're ready to pay at least $3,000 for a single song in a single show with broad but limited distribution. The final price depends largely on the value of the result. The price is usually negotiable based on how it is to be distributed, how many people will see it, how long it will be distributed, what song you want, and how you intend to use it. If the song you're after is popular, expect to pay more.

The best way to start with a proper sync license is to tell the publisher as soon as possible that you understand that it'll cost an appropriate amount of money to obtain the license. This assures them that you already know that you'll be paying for their time and effort to make it happen.

Whether you intend to make money on a slide show doesn't necessarily have anything to do with whether you are allowed to use commercially produced music in the slide show. Even if your customer provides the music for you, you may not be able to synchronize such music with visuals legally without acquiring a sync license. Again, if you have any questions, get advice from a competent attorney.

Royalty-free music is a popular categorization talked about a lot by industry organizations and user groups on the Internet. By itself, the term *royalty free* doesn't necessarily mean what most people think. There are plenty of royalty-free tracks offered by publishers that charge royalties for their music depending on how it is

distributed. They call it royalty free because there are ways the music can be used that they do not charge royalties for. One common misconception is that royalty-free music can always be used on the Internet. Some publishers producing royalty-free music do not allow use on the Internet because such use would constitute *broadcasting*, which they define in their licensing agreements as including distribution on the Internet in any form. Some publishers make a clear distinction between anonymous broadcasting and limited access broadcasting. Be careful.

Regardless of whether an organization says its music or other content is royalty free, read the licensing agreements carefully and consult a competent attorney for legal advice.

Here's a list of sources we often turn to for royalty-free audio:

- www.triplescoopmusic.com
- www.shockwave-sound.com
- www.themusicbed.com
- www.vimeo.com/musicstore

You may be able to obtain music by contacting and developing relationships with local musicians. An easy way to do this is to contact music teachers, such as piano or guitar teachers. Ask them if they have any recordings they would be willing to offer or license for use with your slide shows or if they know anyone who might be interested. Music stores are central hubs for active musicians in the area, and the people working there are often very familiar with others who might have exactly what you're looking for. Local musicians may be much happier to work directly with you and understand what you're after. Because you're both local, they're often easier to deal with than someone far away. In exchange for music credit in your show, they may be willing to offer you the rights to use their music at no charge. Obtain something in writing that shows you have the right to use someone else's work before doing so.

Beat Synchronization

Synchronizing visual elements to the beat of the music can be a powerful tool to get the audience to follow along and absorb more energy from the show. Especially in an introduction or major transition between two substantially different parts of a show, major captions cut to the beat of music quickly set the tone.

Don't overdo it, though. It is tempting to synchronize the entire show, but doing so rarely works well. Instead, it is usually best to let the beat of the music and the visuals go in their own directions.

Cut to the Beat

ProShow's timeline view is designed for working with audio synchronization, but it is not the default view because the slide view is easier to work with for most purposes. To switch back and forth between the timeline view and the slide view, press the Tab key in the main user interface. Use the timeline view in ProShow to work with audio and timing as shown in Figure 9.3.

Unsynchronized slide timing -
Slide transitions are not aligned with the beats in the audio

Figure 9.3

Use the timeline view for working with audio synchronization.

In the default slide view, slides are shown from left to right regardless of the timing for each slide and transition. The timeline view differs by showing time linearly from left to right. You can drag the vertical boundaries of slides and transitions left and right to change the timing of slides and transitions.

Use the mouse wheel to increase and decrease the time scale. Zooming in so the time scale is small helps point out the beats in the music. When you begin the edges of slides and transitions will not be aligned with the music. Once you've aligned the beats, you should see something more like the timeline shown in Figure 9.4.

Synchronized slide timing -
Slide timing has been adjusted to align transitions with the beats in the audio

Figure 9.4

Use the mouse wheel to zoom in so the time scale in the timeline view is small enough to see the beats in the music.

To synchronize beats, it is almost always best to use a cut transition, especially if you are synchronizing to sounds that are sharp, like a drum beat. The cut transition instantly switches to the destination slide at the beginning of the transition, so any transition duration is meaningless. For this reason, it is best to use a transition time of 0.0 seconds. For simplicity sake, I strongly suggest just setting your transition times to 0.0 seconds. Any transition whose duration is set to 0.0 seconds effectively converts it into a cut because there is no time to do any other kind of transition.

With a softer sound, such as a *swoosh* sound, you can use transitions that take longer, like crossfades or wipes. You can still use a cut transition and it will look fine, but the softer transition may work depending on the look you're after. Using softer transitions takes a little more work to get the look just right.

Grab the edges of slides and transitions and drag them so they are aligned with the beats in the music, as shown in Figure 9.5. When you synchronize visual changes to the beat of the music, you give up the freedom to set the timing of each slide to anything you want. After all, the changes have to match the beat. Remember that captions still have to be readable to make them effective. For example, if you only have a short amount of time for information to be visible on the screen between two cuts, you may have to simplify the captions to make them understandable to the audience.

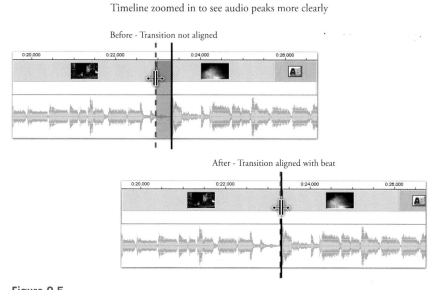

Figure 9.5

Drag the transition boundaries to align the cut transitions with beats in the music.

Load Example Shows

I've included a couple of sample shows on the DVD to demonstrate some simple types of audio and beat synchronization. I've also included some simple tricks using multiple slides for each cut to spice up the effects. Feel free to load the show file into ProShow and examine how these are put together in the timeline view to understand exactly how these are done.

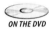

ON THE DVD Example *Chapter 09-Number 04*: This example demonstrates simple variations of synchronized effects you can use to stylize your show with the music.

Voice-Over Tips

When recording voice-overs, the first thing to accept is that nobody likes how their voice sounds. Listening to a recording of yourself is bound to be one of the most horribly embarrassing things you can do, and I highly encourage everyone to do it. If for no other reason, it is a great way to get more comfortable with the idea of being uncomfortable.

Chances are, others won't think you sound all that bad. Only when you've gotten past the notion that you sound horrible can you start to work on ways to make yourself sound better. Ask others what they think, and always ask them to be brutally honest, *especially* if they think something about the way you sound is bad. Be ready for their critical feedback and take it positively, even if they tell you that you should never go near a microphone again. After all, you want to know the facts in this case.

If you are working on family shows or shows for fun, unprofessional voice-overs can actually help the production. Speech imperfections add a sense of reality that professional voice-overs do not. You may hate some attribute of your speech, but others may find it charming. Try to see it from the audience's eyes and leave your insecurities behind. After all, you're doing this for the audience, right?

Once you've recorded your voice-over, it's time to integrate it with the rest of your slide show. ProShow allows you to have a soundtrack playing at the same time as a slide sound. A slide sound can be anything you want—a voice-over or a sound effect.

Just click the Slide Sound tab in the Slide Options dialog to add a slide sound to your show. You'll find settings that adjust the volume of your soundtrack while your voice-over plays. ProShow has default settings that do this for you, but you can always override this level to suit a particular voice-over if necessary, as shown in Figure 9.6. The result is a nice, smooth transition from soundtrack to voice-over and back.

Slide Sounds window

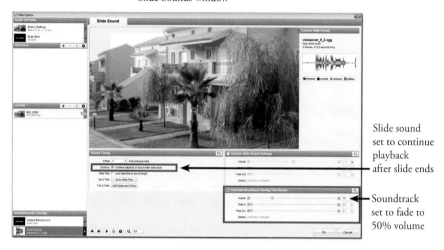

Slide sound
set to continue
playback
after slide ends

Soundtrack
set to fade to
50% volume

Figure 9.6

The Slides Sound tab of the Slide Options dialog. Override the soundtrack volume adjustment if necessary.

Don't Be an Announcer

One of the biggest mistakes people make recording voice-overs is attempting to sound like they think an announcer should sound. This invariably ends badly. Unless you have a good background in vocal training, you should not try to do this. Relax and speak naturally. Imagine you're speaking to a good friend in front of you; talk to your imaginary friend just as you would talk to her in real life.

One way I explain this is to forget about your voice and focus on what you're saying, how fast you're saying it, and how you're enunciating certain things.

Relax, Slow Down, and Enunciate

The biggest thing to overcome is tension. If you are nervous, you will sound nervous. Relax. Think about your shoulders, and make sure they are completely relaxed. Make sure you can breathe deeply and slowly and that you are completely at rest before you begin.

Slide shows are a little different from communicating in person. When you speak to someone in person, you normally do so face to face and at a rate that works for both of you. This is an intuitive thing that we learn as we communicate with people over the courses of our lives. Each of you usually watches the body language of the other as you speak, and everything you hear and see contributes to the communication.

Voice-overs in slide shows differ from face-to-face communication because the slide show visuals are different from the body language you normally see with face-to-face communication. The audience watches the visuals, which demand some of their attention. This reduces the amount of mental energy available for absorbing the information in the voice-over.

This means voice-overs should be spoken slower than face-to-face communication. Getting the right pace can take some practice. I strongly recommend practicing with a voice-over segment and recording it over and over and listening to it to see how fast feels comfortable for the show you're doing. Getting opinions of others really helps as well if you have the time to do it.

Enunciation is the act of pronouncing speech. In normal face-to-face conversation, people can get away with being lazy about enunciating certain sounds, especially Ts, Ds, Ns, and Ss. After you've gotten used to relaxing and slowing down, think about the sounds you're speaking, and spend a little extra effort enunciating these consonants so that the latter parts of the sounds are clear. A word like *sun* should have a little extra *nuh* at the end. Words ending with a T should have a little extra *tih* at the end. The word *past* should almost sound like *pastih*. Once again, this is subtle. If you literally say *pastih*, it will sound like you said *pasta*, which is a completely different word. You most likely don't want the sentence "In the past…" to sound like "In the pasta…"

Once you're familiar with these little enunciation tricks, listen to vocals in some popular songs. You'll notice that the singers are doing what I've described. They're adding a little bit of extra inflection to these syllables to make their words clearer than they would if they were speaking naturally.

As you do more voice-overs, you'll quickly get used to relaxing, slowing down, and enunciating. Like anything else, practice builds expertise.

Avoid Pops

Now that I've described how to add a little extra oomph to your consonants to enunciate your words more clearly, I need to tell you that sharp consonant enunciation is one of the biggest problems for recording voice-overs. Microphones operate on changes in air pressure—sound waves—and sharp consonant sounds cause sharp sound waves. These sharp sound waves cause pops and hissing in audio recording when you point your mouth directly at the microphone.

The easiest way to avoid most of the pops and clicks is to avoid speaking directly into the microphone and to instead speak *across* the microphone, as shown in Figure 9.7. This is almost at a right angle to your mouth, but not quite. You can think of this as speaking *across* the microphone.

Figure speaking directly into microphone Figure speaking across microphone

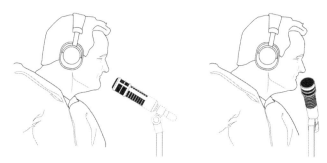

Figure 9.7

Instead of speaking directly into the microphone, speak *across* the microphone.

Essentially, you want to speak past the microphone, but not directly into it. The lower frequencies created by your voice will still be clearly recorded, but the sharp, high frequencies caused by S and T sounds will shoot past the microphone without causing the annoying pops and hissing typical of speaking directly into the microphone.

Use Better Equipment to Get Better Audio

For professional shows, a better microphone can make a huge difference compared to a cheap PC microphone. Keep in mind, though, that most of the quality gain you will get has to do with obtaining a professional microphone. Once you've spent $180 on a microphone, the results from a $2,000 microphone probably won't be enough to justify the additional cost. Only the most expensive studios should consider using the best equipment, and even then, the difference is negligible.

If you want a bigger difference for less money, consider spending the money on converting a closet into a cheap audio booth.

If you're interested in learning more about becoming a voice actor or you want more information about how to record better voice-overs, a well-done book on the subject is *The Voice Actor's Guide to Recording at Home and On the Road*, by Harlan Hogan and Jeffrey Fisher.

Create a Do-It-Yourself Audio Booth

The hardest thing to master in voice-over recording is background noise. In modern offices, air conditioning, loud fans in your computer, and road noise creep into the recording, and there isn't much you can do about it. I had this problem in my home studio and did something about it.

The bedroom I chose for my home studio had a large closet, which is one of the reasons I chose the room. I am a musician and am lucky enough to have a digital studio at home. Recording noise-free voice-overs and vocals for songs is a problem, though, because of air conditioning and the acoustics in the room. Fortunately, the closet is large enough to stand in comfortably. To eliminate any echoes in the closet, I hung blankets from the walls. The silence is deafening.

In some ways, I went overboard and replaced the original wooden door in this room with a glass door so the person doing vocals or voice-overs can see the recording engineer and vice versa. When I'm going to record vocals, I turn off the air conditioner. Summers in Austin get hot quickly, so I cannot do voice-overs for very long without having to take breaks to allow the vocal room to cool down.

The results are stunning. I'm sure they could be better with a huge investment, but with my budget consisting almost entirely of the cost of the door, some blankets, and the time to set it up, this yields results that even the best professional studios would be hard pressed to beat.

Because I hardly expect most people reading this book to go to the extents that I went to, here are some more reasonable tips to limit the noise in your recordings. Move your computer under your desk or as far away from the microphone as you can. Turn off your PC speakers and use headphones instead. Get a USB-compatible condenser microphone for your PC. If you're really worried about noise, you can always build a makeshift structure around your desk with hanging blankets to deaden the noise around you. It may look strange, but it works.

Sound Effects

Sound effects aren't a huge part of slide shows—at least not like they are in film and video production. The main thing I tell people is not to overdo sound effects. Just because you can use a trick doesn't mean you should. Sometimes sound effects can come in handy, but they can easily be distracting and unprofessional if they don't fit.

A common sound effect we see in slide shows is a camera shutter sound. This is the sound a typical camera makes when you've just snapped a photo. This sound effect can be quite powerful when synchronized with a photo popping onto the screen. You can even synchronize the sound with a flash effect by adding a short slide containing an all-white layer just before the new photo appears. Timing is important with this effect. Ideally, you want the flash to appear just *before* the click sound is at its peak. See the sidebar for a brief explanation.

Figure 9.8 shows how to set this up in ProShow. As talked about earlier in this chapter, use the timeline view to synchronize exactly where you want the camera shutter sound to start.

Sound Effect Synchronization

Did you know that your brain perceives sharp changes in sounds faster than sharp changes in visuals? As it turns out, this is a very useful thing to know when you're working with the synchronization of sound effects.

If you want perfectly synchronized sound effects, a sharp and unexpected sound effect should always occur about 0.1 seconds after the visual it is to be synchronized with. It takes your brain about 0.1 seconds longer to perceive an unexpected visual change than an unexpected audio change. Because your brain is faster with sounds than visuals, the visuals should appear first, giving your brain more time to realize there's a change.

0.1 seconds does not seem like it should make much of a difference, but it does. If the sounds are expected, as with the beat of music, this adjustment isn't critical. However, when a sound and visual are unexpected, as with a camera click with a flash, the click will seem to be in perfect sync with the flash only when the flash occurs about 0.1 seconds *before* the initial peak of the click. This is also true of explosions, gunshots, and any unexpected and sharp sound.

A detailed overview of the psychoacoustics of audio is beyond the scope of this book, but this trick is surprisingly useful. It is one of the big tricks usually known only by professional film and video editors.

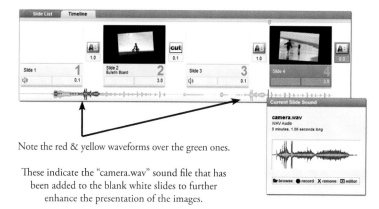

Note the red & yellow waveforms over the green ones.

These indicate the "camera.wav" sound file that has been added to the blank white slides to further enhance the presentation of the images.

Figure 9.8

A slide list view of two camera click effects.

Sometimes you need to create sound effects, or *foley effects* as they are sometimes called. Because you have control over the visuals separately from the sounds, the sounds you use don't always have to be what they seem. A favorite example of a common sound effect that is not what it appears to be is thunder, which can easily be created by recording the sound of hitting a large, flat cookie sheet or piece of thin sheet metal with something heavy, like a hammer. When the sound effect is combined with an image of lightning, nobody will even question that the sound heard is thunder, even though it might not sound very convincing when you listen to it with your eyes closed.

There are many sources for sound effect audio clips. I strongly recommend searching for *sound effects* on the Internet. As with just about anything, you get what you pay for. You can find some free sound effects, if you're willing to spend some time digging for them.

Segue Between Topics Using Audiovisual Gap

When talking about audio and techniques to use it, perhaps one of the most common uses for audio involves knowing when not to use it. Use a gap in audiovisual information to create a soft barrier when changing topics.

The idea is to slowly fade from one topic to a black or neutral background without distraction. Silence is powerful. Once the "nothingness" has set in, you're free to start with the new topic, almost as if the new topic is a new show.

There isn't anything particularly special about this technique because it is very simple. If all goes well, the audience members won't notice the effect, but the result will be a clean and natural segue from one topic to the next. Look at the example on the DVD, and remember this trick for whenever you need to switch cleanly between one scene and the next.

ON THE DVD

Example *Chapter 09-Number 05*: This example shows a clear gap between two distinctly different sequences. A clear audiovisual gap has been used to give the audience a clear separation between the two sequences.

Review

Audio is an important part of a well-produced slide show. It can be as simple as well-chosen music as a background or as complex as professionally recorded voice-overs and sound effects. I've tried to give a good overview of some of the most important factors in each of these things. Audio is one category of information that you can dive into much more deeply than I've decided to do in this book. The main thing to consider is how much value you can add by taking even just a few steps to improve your audio. You can realize most of the payback with audio with the simplest of techniques.

10

Multiple Images

With few exceptions, I've thus far focused on the basics of slide show composition with the general assumption of showing one primary image per slide. This chapter addresses creative techniques you can use when you want the audience to focus on more than one image in the same slide.

There are several reasons you may want to display more than one primary image, especially with group photos and collections of people who are related to each other in your story. Showing these people at the same time is the best way to reinforce their relation to your audience and can make narration flow smoothly.

Another reason you may want to show more than one primary image is as a stylistic technique: either as a way to add pizzazz to a show or to use the multi-image nature of slide show software to create interesting background effects that can be utilized in various ways, such as for animated backgrounds behind other visuals.

I need to remind you now that balance and consistency are very important throughout this chapter; I assume you know that at this point. Be careful to balance the sizes of your visuals and keep your effects, timing, and look and feel consistent. For more information about consistency and balance, please see Chapter 4, "Space and Simplicity."

I should also point out that the number of possible things you can do to present multiple images at once is huge, and I make no attempt to cover the full range of possibilities here. Instead, I'll give some simple solutions to common problems in the hopes that it sparks your understanding of the ideas and gives you a good starting point to imagine more ideas of your own.

Head Shots and Objects

The most obvious place to use multiple images to clarify your message is when presenting photographs of multiple people, especially when you need to talk about more than one of them at once. One reason for this is because people are taller than they are wide, which puts them in the portrait orientation. Because most displays are landscape, or wider than they are tall, fitting people in a landscape display begs the use of multiple images to complete the composition.

Very often, shows involving people use voice-overs or captions to give the audience more information than the photos alone portray. Overlays showing close-ups of people's faces give the audience a natural way to focus on a particular person and help the voice-over or captions "zero in" on the additional information.

Here are some ideas to help you find creative ways to present people in your show.

Single Subject Overlay

Very often, you start with a photo showing a subject's full body, a group of people, or a series of objects. One of these objects is the focus of your voice-overs or captions at any one time. The face of the person or object at issue isn't set apart from the overall photo to make it plainly obvious where the audience's attention should be. The level of detail may not be clear enough to give the audience a clear idea of what to pay attention to.

Help the audience know exactly what you're talking about by overlaying a close-up of the subject in the composition. There will be no confusion—the audience will naturally assume that the enlarged person or object is the topic of your voice-over or captions.

In Figure 10.1, it is easy to understand how this can be done by including the same image as a layer and cropping it. The enlarged face image is presented as a cropped close-up from the original photo. The audience intuitively understands that the enlarged person is the person being talked about. In the example on the right, it is clear which object is being talked about.

Be careful using thick vignettes with ProShow Producer when the layer has a drop shadow because the shadow and the fuzzy border appear to bleed together. Sometimes this looks fine, but it can also make certain images look muddy. Figure 10.2 shows a comparison between two compositions, with the only difference being the drop shadow.

Example *Chapter 10-Number 01*: This example shows how a single subject can be highlighted in a slide using a cropped overlay.

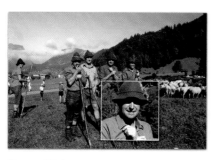

Figure 10.1

Two examples of overlaying an enlarged subject to highlight it.

Close-up with vignette Close-up with vignette and drop shadow
 causing muddier colors

Figure 10.2

As you can see, if the vignette's border is fuzzy enough, adding a drop shadow can make the resulting composition appear muddy.

Multiple Subject Overlays

Just as enlarging and overlaying one person or object clarifies the topic, multiple overlays can do the same thing. Very often, the important part of a show is the way people or objects in a photo relate to each other. You can easily apply the same logic as the last section by repeating the process and enlarging more than one subject, as Figure 10.3 illustrates. As you can see, you can even obscure unimportant people's faces with the enlarged layers of the subjects' faces.

ON THE DVD

Example *Chapter 10-Number 02*: This example demonstrates the same overlay technique used with multiple subjects.

Figure 10.3

The three people highlighted in this photo are the subject of the voice-over; the audience will intuitively ignore the remainder of the people in this photo.

Highlighting People and Objects

When you want something less obtrusive than overlays, you can achieve some nice-looking animated results.

Highlighting a Subject

The idea of this effect is to start with a group photo, highlight a subject, have that subject hold on the screen for a while, and finally return the subject to the original photo, as shown in Figure 10.4. The highlighted image is most easily created with an external editor such that the background is obscured, usually by editing it to make it look dimmer or washed out.

Slide 1 - Original image Slide 2 - Edited image Slide 3 - Original image

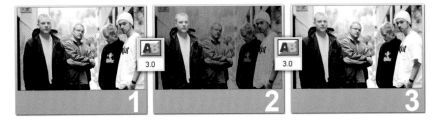

Figure 10.4

The logic for this show is simply to start with the overall image and transition to and from a modified image, which highlights the subject.

There are many ways to obscure the unimportant part of the photo for this effect; the one you choose depends on the style you want in your show. Depending on the color scheme and tone of the show, I tend to gravitate toward darkening the background to make the foreground image seem to be in a spotlight with a soft edge and brightening the background by raising the black level.

ON THE DVD Example *Chapter 10-Number 03*: This example demonstrates high-lighting a subject by subduing the background around the subject.

Enlarging a Subject

Building on the example of highlighting a subject, you can enlarge the subject or subjects of a photo to increase the audience's focus on them. This involves more work in an external editor to make the overlay image or images.

> **Note**
>
> If you have ProShow Producer, you can skip to the next subsection to learn how to do this trick quickly in one slide using keyframes and without external editing.

Figure 10.5 shows the logic for this effect. The idea here is to create two new images from your original image. The first image is the same as the original photo, but it's clearly obscured in such a way that the audience won't pay attention to it as much as the subject photo. The second image is completely transparent except for the subject. Figure 10.6 shows an original photo that has been used to create the two edited images for this effect.

This effect requires seven slides in ProShow Gold. The first slide introduces the scene. The second slide is necessary to fade from the original photo to the modi-fied photos, which clearly highlights the subject. The third slide zooms in on the subject. The fourth slide holds the subject still during the important part of the voice-over. The fifth slide zooms the subject back out. The sixth slide transitions back to the original slide. The seventh slide holds the original photo in the origi-nal position.

You can eliminate the last three steps if you don't need to show the original photo again. I've included these steps here mainly to show that including them can be useful if you want to chain these steps together to highlight multiple subjects separately.

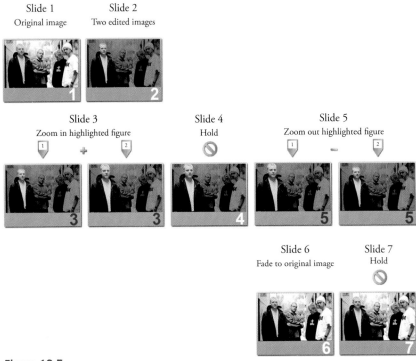

Figure 10.5

The logic for this show is much more complex than the previous highlighting example because of the change to the edited photos and animation steps.

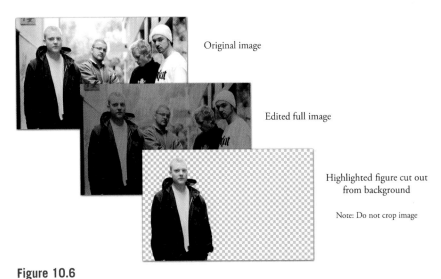

Figure 10.6

From left to right, an original photo, an edited version to create a subdued version, and the overlay image containing only the subject.

You can eliminate steps two and six if you don't mind the *ghosting* that occurs when you fade from one slide to another and move images at the same time. I try to avoid this because the results look more seamless to the audience. It may be a good idea if the show must move quickly and you just don't have enough time to do the steps separately and make them look good.

It is important to watch the transition times between each slide. When switching to and from the original photo and the edited photos, make sure there is no motion and you're using a crossfade transition. The other steps should use cut transitions, with a transition time of 0.0 seconds. Because the images are the same between the steps, you won't see a transition between the slides, which is exactly what you want here.

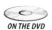

Example *Chapter 10-Number 04:* This example demonstrates enlarging the subject. This can be an effective visual aid during a voice-over.

You can use this technique with any number of subject overlays by adding them as layers above the original photo and positioning them separately.

Enlarging a Subject with ProShow Producer

This section describes the same technique as the previous subsection using ProShow Producer instead of ProShow Gold. Instead of using separate images created with an external editor, we use the editing capabilities of ProShow Producer and keyframing to accomplish the same thing but in much less time. This is shown in Figure 10.7.

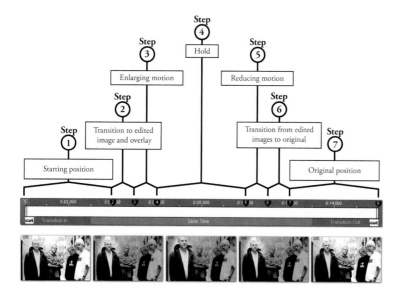

Figure 10.7

ProShow Producer's keyframing creates the motion and image appearance changes in a single slide.

To accomplish this effect, create a solid white layer with an oval vignette. This produces a round mask. This mask hides everything in the original photo except the subject because only the area made visible by the mask shows through the mask. By moving the mask and a separate copy of the original photo contained within the mask, you can move the subject around separately without an external editor. Figure 10.8 shows a diagram of the layers used to make this effect.

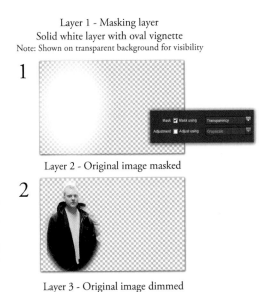

Figure 10.8

There are three layers in this example, two of which are the original photo. The mask layer is created using a solid white layer with an oval vignette.

The original photo at the bottom of the layer list never needs to move, but it does need to change to obscure it while the subject is highlighted. Do this by creating keyframes and changing image settings for each of them. I suggest adding this bottom layer first and setting it up before adding the mask layer to avoid confusion. Figure 10.9 shows the keyframe timeline with explanations of what happens at each keyframe.

The mask layer is a bit more confusing, especially for new users of ProShow Producer. Start by adding a solid color layer and setting the color to white. Don't set it to be a mask just yet or you may confuse yourself. The resolution of the layer isn't particularly important; you can make it smaller than the defaults, but don't make it too small or you'll cause *aliasing*—rough edges caused by stretching a small image to make a larger image—around the edges of the mask. You can always edit

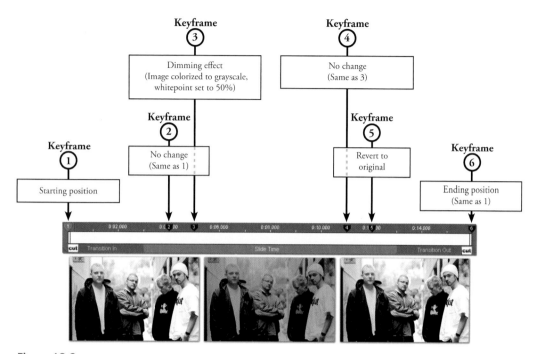

Figure 10.9

This is the keyframe timeline of the original photo.

the resolution of this layer, so feel free to experiment. The best way to set the resolution of this layer is such that the layer's shape is what you want to use as the mask rather than using the X and Y zooming to change the vignette. This keeps the fuzzy borders of the vignette symmetrical.

Go to the Adjustments tab in the Slide Options dialog box and click on the Vignette button. Select an oval vignette, and set the border width to something you think looks good. This will make a fuzzy oval out of the layer.

Once you've added the solid color layer, add the original photo as a new layer and position it just under the solid color layer. Select the solid white layer and check the Mask button under the Layer Settings tab. This includes the copy of the original photo you added by default, because all mask layers must include at least one layer within them.

Go ahead and preview the slide. While the background original photo changes, the original photo contained in the mask layer shows through as an unaltered image wherever the mask layer is.

The idea as shown in Figure 10.10 is to set up keyframes to position the mask layer so that it covers the subject first, then gets larger while the background layer becomes obscured, holds for a while and then returns to the original position.

After you've completed the keyframes for the mask layer, set up the keyframes for the original photo in the mask so it moves with the mask layer. The mask and the masked original photo don't have to be perfectly synchronized in movement, but the result will look more professional if you play with it and get the motion as close as possible.

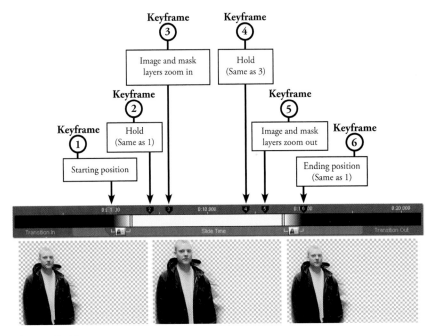

Figure 10.10

The keyframes for the mask layer and the original photo contained within the mask layer are nearly the same, but the positions vary.

For the masked layer to be distinguishable from the background when the background photo is normally displayed, the original photo contained within the mask layer must be at the same size and position as the background photo.

Note

An alternate way to avoid having to synchronize the positions of the original photo and the photo in the mask layer is to control the opacity of the mask layer so it really is invisible when the original photo is not obscured. When a mask layer is completely transparent, it reveals none of what it contains.

I've included a DVD example that you can watch and load to see how this effect is set up. Of course, there are many possibilities you can use with Producer to create different variations of this technique. Experiment with different options in Producer and see how you can enhance it.

Example *Chapter 10-Number 05*: This example demonstrates highlighting a subject using a masking layer and a fuzzy vignette.

Orientation

Using multiple images in a slide brings with it challenges that do not occur with single-image compositions. With multiple images come multiple subjects, and these subjects can fight each other depending on how they are positioned. Think about how the subjects of the images interact with each other visually as you view the slide as a whole. When possible, make sure subjects look into the center of the slide instead of away from it.

This competitive effect is common in sports shows. Imagine creating an intro slide for a football or softball team. Photograph each team's helmets, and in your slide show, add them as separate layers to one slide, facing each other. Put the game details below, and you have a compelling visual. Figure 10.11 gives an example of this type of competitive composition.

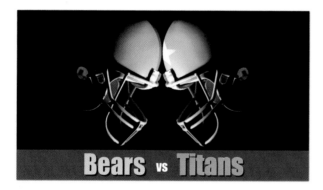

Figure 10.11

Having competitors directly facing each other amplifies the intensity of the competition.

Remember, when competitors or enemies are shown, the effect is often greater if they are back-to-back or appear to be staring directly at each other, as in a fight. To really amplify a conflict between subjects, use an obvious, sharp barrier between images. If you want a real conflict, add animation and a sharp sound effect so the two images appear to hit each other with a crash. Positioning and subject agreement are discussed in more detail in Chapter 4.

Horizontal Image Blending

When you don't need special effects to blend images, placing images next to each other in ProShow works just fine. Sometimes, though, you need an external editor to add production quality to the composition.

Multiple Image Composition

Especially with portrait images, fitting multiple images can be done by creating a single new image composed of the multiple images put together horizontally. Use sharp edges to keep the images distinctly separate, or blend the edges with a soft edge to show relation to each other.

Figure 10.12 shows four ways you can blend the same two images using an external editor. In the upper left, the photos are placed next to each other with no special editing. You can do this with ProShow and no external editor. In the upper right, an external editor blends the two images using a soft fade between the two. In the lower left, a solid bar has been added between the two images to show a clear separation. In the lower right, a special effect blends the two images with more style.

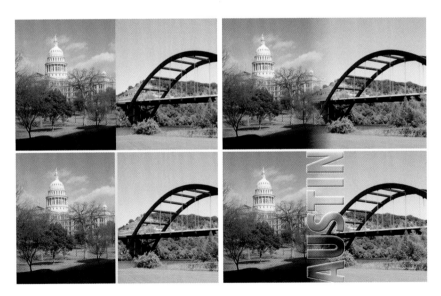

Figure 10.12
Four different types of dual-photo blending using an external editor.

Vignette Masks with ProShow Producer

The example in the upper right of Figure 10.12 is done quickly and without an external editor using ProShow Producer. It uses a solid white layer with a fuzzy rectangular vignette as a mask layer, as shown in Figure 10.13.

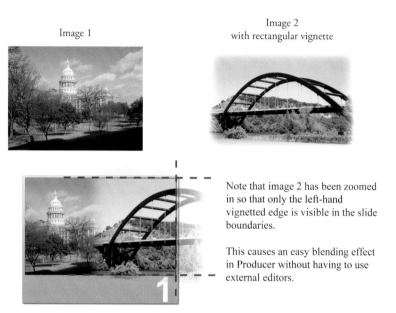

Image 1

Image 2
with rectangular vignette

Note that image 2 has been zoomed in so that only the left-hand vignetted edge is visible in the slide boundaries.

This causes an easy blending effect in Producer without having to use external editors.

Figure 10.13

The mask layer extends beyond the edge of the slide frame, so the audience notices only the left fuzzy edge of the mask.

This technique with Producer takes advantage of the fact that the audience cannot see outside of the slide. The solid white layer has a fuzzy rectangular vignette, so all of its edges are fuzzy. However, only the left edge of the vignette border is within the slide, so we position the mask layer so the top, the right, and the bottom of the layer are completely outside the slide. When the photo is positioned within the mask, only the left side appears to be blended. It does not matter if the right-hand photo matches the edges of the mask layer because the audience will never see the effects of the rest of the vignette mask layer. It is out of view.

As a variation of this masking technique, consider what happens with oval vignettes or when the masks are rotated at an angle. You can also use mask layers of arbitrary shapes created with an external editor, as shown in Figure 10.14. Consider what happens if you use this technique more than once as you add more masked layers to the right. The mask shapes can have a profound effect. The orientation of the masks can create style. Be careful about consistency whenever you use angles so the angles don't fight each other or the contents of the images you're showing.

Two images blended with
oval mask shapes

Four images blended with
rectangular mask shapes
rotated 20 degrees

Figure 10.14

The left example uses a heart-shaped vignette mask created using an external editor. The right example shows multiple vignetted photos.

ON THE DVD

Example *Chapter 10-Number 06*: This example shows a couple examples of using fuzzy vignettes to stylize photos.

Multiple Images Through Time

Regardless of whether you use an external editor or ProShow Producer's features to create multiple-image compositions, there are more techniques that can add style.

Don't think of a slide show as just a series of separate compositions. Instead, think of it as a composition whose surface area can change in different ways over time. From slide to slide, some things can remain the same. With two photos in a frame, you can change one photo and not the other. Changing one photo and then the other guides the audience to look back and forth almost like watching a tennis match in slow motion.

Changing one image on each slide doesn't have to be limited to slides with only two images. There can be any number of images per slide, and you can even change more than one image at a time. The idea is that not all the content in a slide needs to change from slide to slide; this notion can create pleasing results. Figure 10.15 shows an example using two images on the screen.

ON THE DVD

Example *Chapter 10-Number 07*: This example shows different ways multiple images can be changed over time to vary the presentation of many photographs.

Slide 2 Transition to slide 3 Slide 3
Original images Only left image changes New left-hand image. Right
 image will change on next slide.

A series of slides set up to show multiple images over time,
alternating left and right

Figure 10.15

With multiple images shown at once, you can change one image at a time using multiple slides.

Transparency Tricks

Most computer users are familiar with transparency in images. Transparency simply makes the stuff behind an image show through proportionately to the transparency of each pixel. What isn't obvious, perhaps, is that transparency has almost no value unless there is more than one image in a composition.

Background Transparency

Image transparency creates all sorts of creative possibilities when paired with motion. Imagine a foreground photo of a person with the background cut out and made 100 percent transparent. Now any image put behind the photo can move independently from the foreground photo. The image behind the person doesn't have to be realistic. In fact, it can be anything, including a photo, a video, a slide show, a computer-generated image, a gradient, a floral pattern, a picture of a table cloth, whatever.

As you can see in Figure 10.16, the tone of the composition can change greatly by modifying the background. Now imagine the background moving slowly throughout the duration of the slide. Slow movement adds depth and style that still images cannot convey.

Figure 10.16
A single photo can be made to feel different depending on what kind of background is present. Transparency can create the opportunity to set the tone of a composition in highly creative ways.

ON THE DVD

Example *Chapter 10-Number 08*: This example demonstrates using transparency and a completely different background to change the feeling of the overall composition.

Partial Transparency

You can also use transparency to add effects to a photo. The audience doesn't intuitively realize that there is a whole layer behind the foreground that is moving because all they see is the result, not how it is constructed.

Figure 10.17 shows an easy way to make a picture of a photo in a photo frame more interesting to view in a slide show.

The image to the left has been edited to make the glass area of the photo frame transparent. The middle image is a glass-like "sheen" image that will be partially seen wherever it is in the glass part of the photo. When put together with a photo underneath, the glass image can be moved separately.

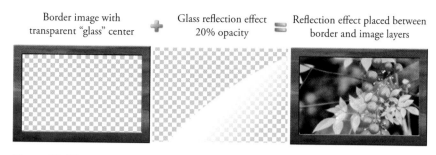

Border image with Glass reflection effect Reflection effect placed between
transparent "glass" center 20% opacity border and image layers

Figure 10.17

Use a separate glass sheen layer to add a sense of style to an otherwise still image.

At this point, you may be asking, "Why not just add the glass sheen layer in Figure 10.17 to the photo frame and be done with it?" The answer is that if the two layers are separate in the slide show, the glass image can be moved over time. This adds depth and a sense of motion, which gives the visual more style.

ON THE DVD

Example *Chapter 10-Number 09*: This example shows a separate glass sheen layer used to add a little more style to a photo frame.

ProShow Producer is capable of a more realistic version of this idea because of its masking capabilities. This is described in Chapter 11, "ProShow Producer Techniques." Because ProShow Gold does not have masking capabilities, the technique described here is the best that can be done with ProShow Gold.

Transparent Pieces

We first discussed the *Home Improvement* technique of making an illustration look like it is falling apart in Chapter 8, "Tricks with Source Material." It's easy to create this effect using an external editor and some careful editing.

As seen in Figure 10.18, start with a photo and chop it into pieces using an external editor. Leave each piece the same size as the original photo, with most of the surface area of each file as complete transparency, as shown in Figure 10.19. Notice how each piece is the same size as the original photo but consists mainly of transparent pixels. This is less efficient for the image-editing software, but it makes dealing with the alignment of the pieces much easier in ProShow and doesn't cause significant performance problems.

Once you bring all these layers into a slide in ProShow, they fit together as if they were one image provided you chopped them out properly without accidentally leaving gaps.

Original image Chopped into a series of pieces

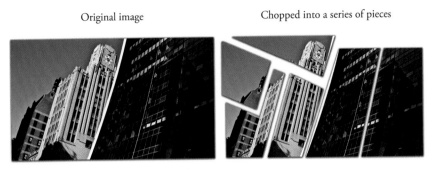

Figure 10.18

Original photo on the left and exploded view of separate pieces on the right.

Note how all the separate images remain the same size as the original

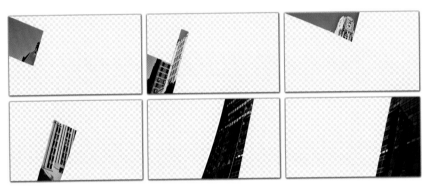

Figure 10.19

This is the series of pieces created by chopping individual pieces of the original photo and saving them as separate files.

Within the slide, drag the ending position of each piece randomly off the bottom of the slide and set the motion type to *accelerate*. The acceleration makes the motion look like the piece is falling because the piece starts moving slowly and increases in speed as time passes. Add the sound of breaking glass as a slide sound, and you have a good transition in the form of a slide!

Because this is a way to make a transition, you'll likely want to set up the preceding slide so it leaves the original photo exactly where the breaking up photos will be on the screen. You can also put a background behind the falling pieces that matches exactly with the subsequent slide to continue on with the next topic. On either side of this slide, the transition times should be set to 0.0 seconds so they match precisely.

ON THE DVD Example *Chapter 10-Number 10*: This example demonstrates how to create the illusion that a photograph is breaking into pieces.

Note

In the television show *Home Improvement*, the pieces often started moving at different times. This isn't possible with ProShow Gold because of the lack of keyframes to control them. ProShow Producer offers keyframing to control exactly how each piece moves and replicate the original effect precisely.

Tricks with Multiple Slides

This section offers a couple of interesting techniques. The first I've included mainly out of my amusement with just how useful it is to think about available tools and how they can be used in unexpected ways. The second is a more useful technique to highlight a series of photos in an interesting way.

The Impossible Fade

Early in the development of ProShow Gold, we decided that ProShow should not include keyframing because of the ease-of-use that would be lost. So the omission of keyframing is both a blessing and a limitation that matches the target markets for ProShow Gold very well.

This trade-off leaves several techniques impossible simply because the tools to achieve these techniques are unavailable. One of these things was to have an image fade into another image while it is moving.

Two years after the release of ProShow Gold, I realized it was possible to abuse the functionality of the crossfade transition to produce effects that seem intuitively impossible. The trick here is to remember that the crossfade transitions fade from one slide to another. This means that anything you can do in a slide can be faded with anything else you can do in the next slide. When the position of an object in the first slide appears to match the position of a different object in the next slide during the transition, the crossfade blends the two together, making one appear to change into the other. Normally, because we think of the slides as distinctly different, we think of everything in the slide as changing with the transition. However, if everything in the slide stays the same except the two objects in question, the audience cannot perceive a change in the rest of the slide. From the audience's point of view, the *only* thing changing is the moving object.

Most of this technique works because the motion in a slide starts at the beginning of the transition before the slide and ends at the end of the transition after the slide. What if the slide time is 0.0 seconds? Well, then the motion happens completely during the transition between slides.

We tend to think about the slide time and the transition times as totally separate and often forget that slides with transitions always overlap in time. This overlap is where this technique happens.

The example shown in Figure 10.20 has two slides, and both slides have 0.0 second slide times. The second slide has a transition time of 0.0 seconds. This means the entire duration of this example show happens completely within the transition between the two slides.

Slides 1 and 2 feature 0.0 second durations and the same pan motion effect.
The 6.0 second transition, where all the action takes place, produces
the "impossible fade."

Figure 10.20
Both slides should have layer movement that is identical.

There are a few requirements to make this work: the backgrounds in the slides must be identical, the positions and sizes of the moving object in each slide must match each other, and the size of the two objects must match. Any deviation, and it will be obvious to the audience what is going on. However, when all these attributes match, the audience is convinced that you have transformed one moving image into another in one slide.

> **Note**
>
> Creating this effect is much easier with ProShow Producer, where you have tools available that are designed to do exactly this kind of thing without abusing features to do it.

For the value of this effect alone, I would not have included it in this book. However, I decided to include it because of the thought process that led to its discovery. I want to teach slide show creators to think differently about how their compositions are constructed and train them to use the tools to their fullest extents, regardless of each tool's apparent intent. Instead of learning just what a tool does, I want you to think about what it *can* do, even if that means abusing it. This is the essence of this technique.

As the principal designer of the ProShow product line, I am aware of everything the software is required to do. I'm aware of the practical limits of its features more than anyone outside of Photodex. I take pride in being able to thoroughly anticipate the needs and usage patterns of ProShow users. Even so, it was two years after the public release of ProShow 2.0 before I realized this effect was even possible. I have watched thousands of user-created slide shows created with ProShow Gold. I have never seen any show outside of Photodex that does this.

I hope this example helps you understand that creative thinking can clearly be the most important part of creating a slide show. Don't let anything stop you from coming up with new ways to make magic happen. How many ways can you find to do things you've never seen before?

Symmetrical Montages

Vacation, travel, and photography exhibition shows focus mainly on a collection of images to document a story or present a collection of photos with a similar theme. Finding ways of showing images without boring the audience is always a challenge. One way to keep the audience anticipating the next image in a sequence like this is to use an array of images, or more technically described, a symmetrical montage. Two examples are shown in Figure 10.21.

A 3x3 montage

A 4x4 montage

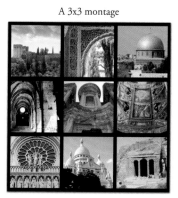 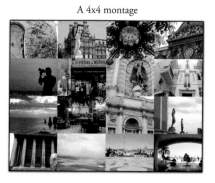

Figure 10.21

The first montage shows 9 images, and the second shows 16 images, each symmetrically sized and spaced in an array.

The idea with the montage is that the audience initially sees all the images but does not have enough time to absorb much detail. As the show progresses, each image zooms in so the audience can see it in detail. When the next image is to be displayed, the previous image zooms back out or fades out to reveal the original montage between images. This repeated appearance of the montage image ties the images together in the audience's mind and gives them a sense that the entire group is a distinct section of the show. The audience perceives this group of images as more interesting because of the montage's constant reappearance as the show progresses.

Before you begin, size your images so they are all the same aspect ratio you need. The aspect ratio is important; otherwise, the images will not fit together precisely when they are reduced in the montage. You can find the aspect ratio you'll need by multiplying the show aspect ratio values by the numbers of images across and down, respectively. For example, if you want three images across and three images down in a 4:3 show, you'll need images with an aspect ratio of 12:9, which, when reduced to their least common denominator is 4:3. However, if you have three images across and four images down in a 4:3 show, you'll need images with an aspect ratio of 12:12, which, when reduced is 1:1, or square. You can use ProShow to crop the images to these aspect ratios using the cropping function in ProShow's layer editing tools.

To make the show easy to construct, start with a slide containing all the images for the montage. You will copy this slide four times for each photo in the montage. ProShow's workspace uses coordinates from –50.0 on the left and top edges of the display to 50.0 on the right and bottom edges of the display. This creates a workspace that is 100 units by 100 units. Do some simple math to figure out what coordinates to use as is shown in Figure 10.22. Don't rely on positioning the layers with the mouse because the placement of the images will most likely not be precise. If you have 4 images across, divide the workspace by 4, which means each photo will occupy 25 units. Because objects are placed from the center, divide this value by 2 to get 12.5 units. So, the first object will be at –37.5 and the next object will be 25 units away, or –12.5. The next object will be 25 away, or 12.5, and so on. Repeat these steps for each image across and down, and the positioning of your layers will be perfect.

Figure 10.23 shows the slides you'll need to zoom each photo in and out. Repeat the last three of these four slides for each photo in the montage. You don't need the first slide shown here for every photo because you don't need hold time between one photo zooming out and the next photo zooming in.

Before and after the montage slides as described earlier, you'll want to add slides with the montage not changing to introduce and hold the montage without motion or focus on any particular photo.

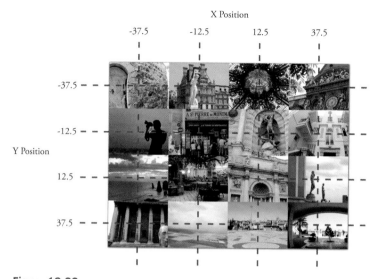

Figure 10.22

This is an example of coordinates for a 4×4 montage. The dotted lines show the center lines for placement.

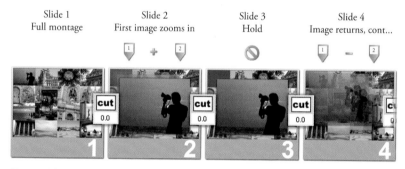

Figure 10.23

Four slides are zoomed in, held, and zoomed out.

 Example *Chapter 10-Number 11*: This example demonstrates zooming into each photo in a symmetrical montage.

There are many ways to enhance this kind of montage technique. One simple technique is to colorize the photos to grayscale or sepia whenever they are not the image being moved or zoomed in. Change each photo to full color just before it zooms in and just after it zooms out by adding two more slides to the sequence for each photo.

> **Note**
>
> This technique is described here for ProShow Gold using separate slides. ProShow Producer provides keyframing, which is a better fit for this kind of motion and can be done all in one slide. Enhancements like colorization in ProShow Producer are easily performed arbitrarily at any keyframe, so multiple changes to effects can happen simultaneously with ProShow Producer without having to add more slides.

Creating Looping Video Backgrounds

A common trick used by videographers to add polish to slides is using a video background with nice-looking visuals that are designed not to grab your attention away from whatever is in the foreground. You can purchase these kinds of background videos from a variety of vendors on the Internet; some sites even have them for free.

Professionals creating such backgrounds use various video-editing tools. The techniques to create looping backgrounds for sale are mostly beyond the scope of this book. However, a couple of simple tricks can get you on your way to creating looping backgrounds that can add a little flair.

Looping backgrounds should be abstract and usually should have no high-contrast edges. Instead, stick to things that are blurry or have only smooth fading edges. You can create shapes and patterns in an image-editing program to use in a looping video. Gradient tools are a great way to get nice smooth fades in an image. Also, you can look around on the Internet for royalty-free images that have an abstract shape or pattern. Remember, you want things that don't really look like anything recognizable.

The idea for a looping video is that the video you create must look the same at the last frame of the video as it does in the first frame. Doing this takes planning and attention to detail. If you don't get the starting and ending correct, your video appears to jump when it loops. At Photodex, we call this a *pop*.

To perfectly avoid jumping, you also should pay special attention to the exact duration of the show. Each video format you can output to will have an exact frame rate, and if the end of your show does not line up exactly with an even frame time, there will be a slight pop when the video loops. For example, if you are using 720p at 24 frames per second, each frame of video will occur every 0.0417 seconds. Of course, this isn't quite correct because the actual value of 1/24 of a second is slightly less than 0.0417 seconds because the actual value is something like 0.4166666

with 6s that repeat forever. Instead of trying to figure out your duration by first dividing to get the number of frames per second and then multiplying by the number of frames, figure out how long you want the show to be and then calculate where the closest frame time will end up by multiplying by the frame time and removing the remainder. Because 24 divides nicely into even seconds, you can use any number of even seconds for your show length.

NTSC video uses 29.97 frames per second, which makes things more difficult to calculate. You cannot just use even numbers of seconds. The closest number of frames for a 5-second show is 149.85 frames. If your show is 5 seconds long, the timing will be just a bit off, and you may see a slight pop when it loops. Calculate a total length that ends close to an exact frame time instead. You can do this by using 149 frames at 29.97 frames per second, which results in a total show duration of 4.9716383 seconds. ProShow allows a precision of 1/1000 of a second, so round up to the nearest thousandth of a second. If you make your show length 4.972 seconds, your video will only be off by 0.0003617 seconds instead of 0.005 seconds. This is more than 10 times the accuracy and will further avoid any perceptible pop.

Based on the potential for confusion in the previous paragraph, I suggest using video formats that run at an even number of frames per second. If math isn't your strong suit, definitely stay away from formats that do not use even numbers of frames per second, and always make your loops even numbers of seconds long!

If you're making a looping video for the first time, I suggest trying a simple example first. Use a single photo as a layer in a single slide and have it rotate 360 degrees from the start of the slide to the end. Make sure to set the motion style to linear so it doesn't accelerate or decelerate. When you watch the show, make sure the transition time is set to 0.0 seconds. Render the slide to a video file.

Create a new show, use the video you've created as a layer, and set the video to loop. Make the slide duration quite a bit longer than the video you've created and watch the show play. If all is well, the photo spins seamlessly when it loops. Now that you've created a test video that loops, do something creative to make a looping background that will spice up your shows.

The key to making polished background loops is to use multiple layers with partial opacity. You can apply this opacity in ProShow across the whole image, or you can use images with transparency built in, such as *.PSD files or *.PNG files. It is easiest to just alter the opacity in ProShow, but this also limits the creative possibilities. I suggest trying layers with different levels of opacity and moving and rotating them to see what you think looks best. Remember, slow is best for backgrounds that are not supposed to distract the viewer from the information in the foreground.

ON THE DVD Example *Chapter 10-Number 12*: This example shows various uses of looping videos as backgrounds to slides.

Review

Composing slides using multiple images is challenging and touches on a full-fledged career in graphic arts. Composition can be further complicated by movement over time. With a few simple techniques, you can find ways to mix images that not only work well but look good, too. Creativity is perhaps the most important part of composition, and attention to details about sizing and symmetry will help you keep your slide compositions pleasing. Remember, if the audience notices your composition, it usually means there is something that can be worked on to make it better.

11

ProShow Producer Techniques

This chapter is for ProShow Producer users who want to learn how to use its features. If you do not have ProShow Producer, this chapter will help you explore more about what you could expect were you to upgrade to it.

How Is ProShow Producer Different?

Some say that ProShow Gold can do almost as much as ProShow Producer; for everything Producer does, there is a *work-around* for ProShow Gold. This is not even close to the truth. ProShow Producer is significantly more powerful than ProShow Gold and provides a litany of useful techniques that are impossible with ProShow Gold. In this section, I point out techniques that make ProShow Producer a bargain, depending on your needs. There are good reasons for the differences between ProShow Gold and ProShow Producer, and the reasons may not be obvious.

ProShow Producer is designed for those who are serious about making professionally produced slide shows and works of multimedia. Often these people are professionals using ProShow Producer as a tool to make money or serious hobbyists who take the art of slide show creation seriously. The price of ProShow Producer is trivial when you consider how much ProShow Producer enables profit and amazing results. These serious users are motivated by their businesses and are understandably willing to learn more skills to use the added power. As they learn, their workflow takes less time and their results improve.

Advanced quality and speed are why they use ProShow Producer. Stated another way, ProShow Producer users need to know they have all the best tools, so they are not limited.

In contrast, ProShow Gold is designed for those who want or need to make slide shows but are primarily motivated by ease-of-use. These users typically do not need to be experts. ProShow Gold users are highly motivated to get their shows completed quickly, and they don't want to have to learn much to do it. If you look at the features included in ProShow Gold, you'll notice that Photodex included the core features necessary for most consumers to make a compelling slide show. Their results may not be the fanciest possible, but they have the basic components their audiences expect. Photodex simplified or skipped the more complicated and often difficult-to-understand features to make ProShow Gold much easier to use than anything else in its class. Even so, ProShow Gold is still one of the world's leading consumer slide show software applications.

The main features that set ProShow Producer apart from ProShow Gold are keyframing, masking, adjustment layers, blurring, modifiers, chroma keying, and advanced styles. There are many more, but these are the major ones. Take special note about my mention of styles here. ProShow Gold includes styles, and they work the same as Producer's styles. Why would styles be different in ProShow Producer? ProShow Producer's styles are not different in function, but in results. They can use Producer's features mentioned earlier that are not present in ProShow Gold. As a result, the average ProShow Producer style is many times more complex and compelling than the average ProShow Gold style. With easily attainable styles, ProShow Producer is more expandable than ProShow Gold. You may have noticed how there are many more styles available for ProShow Producer than ProShow Gold. This is simply because there are more effects that can be done with ProShow Producer styles.

As you read on, keep in mind that every one of the included examples is impossible in ProShow Gold simply because one of ProShow Producer's features is not present in ProShow Gold.

Should you upgrade to ProShow Producer if you have ProShow Gold? Only you can decide. If you are serious about the best production value possible, you will most likely not regret the upgrade. If you cannot justify the expense, you should probably not upgrade. After all, if the expense is a larger factor than the results, that should drive your decision. If the capabilities you see from ProShow Producer are worth more than the difference, your question is answered.

I don't mind at all when people say they chose to stay with ProShow Gold instead of upgrading to ProShow Producer. After all, this is why Photodex publishes more than one version of ProShow.

Producer Techniques

This section contains some examples of things that ProShow Producer's rich feature set offers. Remember that this is just a small exhibition of ProShow Producer's capabilities. There are a seemingly infinite number of ways you can combine the features. By the time this book goes to press, users around the world will have come up with many more complex examples. The creative uses of ProShow are constantly evolving. I've tried to come up with a good set to illustrate the most common ways you might use the features to achieve common goals.

Get your creative mindset working, and read on. Your own imagination is what unlocks your ideas, so use what you see here to invent new ideas of your own. Pick and choose different pieces of these techniques and put them together into new techniques. The rest of this chapter requires that you follow along with the accompanying DVD. You'll see example shows of each technique that you open and explore to see how to create each technique.

Big Panning Caption

As simple as this example is, it is included here because ProShow Producer supports caption keyframing. This means you can move a caption during the duration of a slide. What happens when you use a caption that is much larger than usual? Well, you get an easy way to introduce *style!* This technique uses the fact that captions do not need to fit on the screen completely to be functional. A large caption is made to scroll across the screen such that only part of it is visible at any one time, as shown in Figure 11.1.

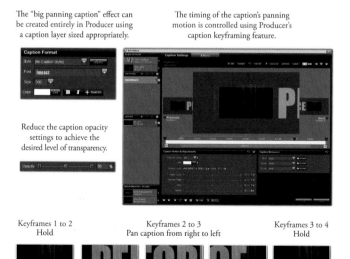

The "big panning caption" effect can be created entirely in Producer using a caption layer sized appropriately.

The timing of the caption's panning motion is controlled using Producer's caption keyframing feature.

Reduce the caption opacity settings to achieve the desired level of transparency.

Keyframes 1 to 2
Hold

Keyframes 2 to 3
Pan caption from right to left

Keyframes 3 to 4
Hold

Figure 11.1

The big panning caption technique.

To be fair, you can do this in ProShow Gold, but it requires that you go to the extra effort of creating a large caption graphic with partial transparency instead of using a caption layer. Producer does this in one step without leaving the program or using a graphic for the caption.

Example *Chapter 11-Number 01*: This example demonstrates the big panning caption effect.

Background Image Blur

In Chapter 6, "Basic Techniques," I showed how to "blow out" an enlarged background using the black point and white point controls to create a stylized background. This technique is similar, but it uses ProShow Producer's blurring to make the background less attention grabbing and more stylized, as shown in Figure 11.2. The results look polished in comparison.

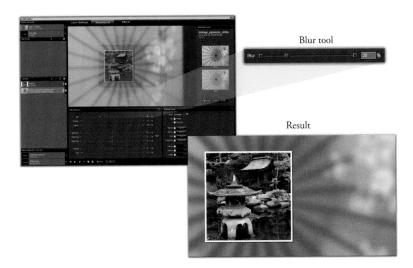

Figure 11.2

Use Producer's blur adjustment to blur background images.

This background image blurring is one of the most common stylistic techniques that professional slide show creators use. We use this technique at Photodex for many of our slide styles, and you can, too.

Example *Chapter 11-Number 02*: This example shows several slides that have been enhanced greatly by using a blurred background image, which is based on the same photo as each of the foreground images.

Collapsible Curtain

In Chapter 6, I showed how to make a theatre curtain effect using layers for the left and right curtains. ProShow Producer includes the ability to unlock the horizontal and vertical zoom values for each layer. This lets you squash or stretch layers visually.

In this technique, the idea is the same as the curtain technique in Chapter 6 except instead of simply sliding the curtain images left and right, we squash them to make them look more like real curtains.

ON THE DVD Example *Chapter 11-Number 03*: This example shows a use of collapsible curtains.

Photo Frame Glass

As mentioned in Chapter 10, "Multiple Images," this example shows how to create a better implementation of an animated glass sheen in a photo frame. It requires two layers for the photo frame, and the glass sheen image is actually a mask in ProShow Producer that allows a solid white layer to show through only where the glass mask image appears.

This technique is better suited for ProShow Producer because it does not require a change to the photo behind the photo frame. It is a subtle difference, but the results are very good. The photo can move separately from the glass overlay. The advantage to using a style with this technique is that the original image doesn't need to be modified to get the glass sheen effect to work.

ON THE DVD Example *Chapter 11-Number 04*: This example shows a reflection sheen added to a picture frame to stylize the composition.

Soft Focus

For decades, photographers have used Vaseline or a similar clear gelatin smeared on a lens filter to create *soft focus*. This effect, which you may have seen used in family portraits, gives photos a dreamy look even though the edges of important parts of the image are still in sharp focus, as shown in Figure 11.3.

Soft focus is created with a computer by superimposing a blurred version of a photo over the original photo. The intensity and transparency of the blur alter the results. In general, you want to use a pretty large amount of blur for this type of effect.

Figure 11.3

An example of soft focus created with ProShow Producer.

The best way to find the exact effect you want is to play with the blurring amount and opacity in ProShow Producer's user interface while watching the preview.

Remember that if you move the photo, you need the blurred photo to move exactly the same way the original photo is. If they move differently, the audience immediately see that they're looking at two separate layers.

ON THE DVD Example *Chapter 11-Number 05*: This example shows samples of soft focus created completely within ProShow Producer.

Radial Soft Focus

This technique uses the same idea as the soft focus in the previous section, but with a stylistic twist, as shown in Figure 11.4. Soft focus uses transparency value of the blurred photo to adjust how much the soft focus layer is visible. With a mask, you can easily create a radial soft focus mask using a radial gradient and use it to further change the opacity of the blurred image. The result is that the center of the image is untouched and the soft focus gets stronger toward the outside of the image.

To do this, you must put the blurred photo inside a radial gradient mask. The mask should look like a huge blurry black blob on a white background. The whiter the mask is, the more of the blurred photo will show. I suggest making the gradient layer the same resolution as the photo you are using so the edges of the mask will be perfectly aligned with the edges of the photo.

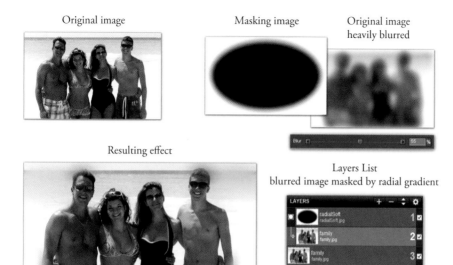

Figure 11.4
Radial soft focus with ProShow Producer.

Remember that if you move the photo, you need to move not only the original photo and the blurred photo, but also the mask layer the same way. The one caveat is that you can move the mask layer slightly to vary the soft focus. If you do this, I suggest zooming in on it over time.

ON THE DVD

Example *Chapter 11-Number 06*: This example demonstrates radial soft focus created entirely within ProShow Producer.

Sliced Masks

Mask layers work by converting white levels or transparency levels into a transparency value that controls the visibility of whatever layers they contain. People usually think of a mask as being the same size and at the same position as layers they contain, but this does not have to be the case. When a mask is in a position that does not reveal anything it contains, the mask has no effect on the slide. When a mask only allows part of the layers it contains to show, nothing outside of the mask is affected.

You can use rectangular masks shaped like strips to stylishly reveal parts of photos over time in a way that you've likely seen in television commercials. When you saw these effects, you probably didn't think about them at all because they are normally used quickly as stylistic effects.

In this example, the original photo is at the bottom of the layer stack, as shown in Figure 11.5. I've used several vertical mask strips that each contain the same photo in the same position as the original photo. Each of the masked photos has been altered with adjustment effects so the masked part of the photo that shows through is obviously different from the original photo background. Keyframing makes the masks dance across the photo.

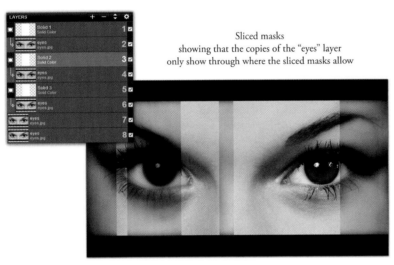

Sliced masks
showing that the copies of the "eyes" layer
only show through where the sliced masks allow

Figure 11.5

Multiple masked copies of the same photo create the sliced mask technique.

Example *Chapter 11-Number 07*: This example shows the results of using this sliced masks technique.

You can use this same idea with different photos in each mask layer. This next example uses a different photo inside each masked layer to create an effect that teases you by showing you only slices of different photos over time.

Example *Chapter 11-Number 08*: This example shows the use of sliced masks to transition to a different photo.

Sliced Adjustment Layers

Adjustment layers apply creative adjustments to everything below themselves and in proportion to the brightness or transparency level of the pixels in the adjustment layer. You can think of this like a mask, except instead of just showing what is in the mask, it adjusts whatever would be on those pixels by the adjustments associated with the adjustment layer.

Similarly to the example in the previous section, I use vertical strips here to highlight only the difference between the masking approach and the adjustment layer approach. The idea is the same, except instead of revealing a photo contained within each mask layer, each adjustment layer simply modifies whatever it appears above.

 Example *Chapter 11-Number 09*: This example demonstrates using
ON THE DVD sliced adjustment layers to stylize a photo.

One thing to be careful of with adjustment layers is that they are cumulative; they affect any adjustments made by other adjustment layers below themselves. If you use two adjustment layers to brighten and they overlap, the regions where they overlap are brightened twice. This is different from the way masks work, because masks cover anything under what they reveal.

Image Reflections

Reflections are created by including an original photograph adjacent to another copy of itself and flipping it either horizontally or vertically. You can add more realism by using masks and blurring. The results are fairly predictable, as shown at the left in Figure 11.6.

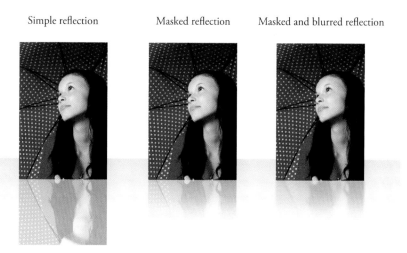

Simple reflection Masked reflection Masked and blurred reflection

Figure 11.6

A simple reflection, a masked reflection, and a masked and blurred reflection.

The example in the center of Figure 11.6 shows the effect created when putting the reflected image inside of a mask created using a gradient. This enables the reflected image to become more and more transparent depending on how far away from the original photo it appears. The example on the right adds a blurred version of the reflection to create a soft focus effect with the same masking as the middle example.

The example show on the DVD contains three slides corresponding to Figure 11.6 so that you can look at the construction of each of these variations.

ON THE DVD Example *Chapter 11-Number 10*: This example demonstrates simple, masked, and blurred reflections.

Quick Image Morph

To quickly change one image into another, I like to use a technique I call the *quick image morph*. The idea is to change from one image to another, but instead of a slow change, I use a change that happens in one-half of a second, and sometimes less. You can actually do this trick in as little as one-quarter of a second depending on the energy level of your show.

Because this effect happens so quickly, the audience doesn't have time to study the change long enough to see how it is happening. Instead, they see one image quickly blurring and changing into another photo. This works best with photos that are the same size, or photos of objects that are about the same size and have been cut out with a photo editor and have transparency all around them. A great example of this is with products in a promotional show that talk about different models of similar products. As the show continues, the current product suddenly morphs into the next product, and so on.

The idea is to use keyframing to increase the blur amount for the original object and decrease its opacity at the same time. While this is happening, the opposite is happening in the same place with a new object. The new object's opacity is increasing while its blurriness is decreasing.

In the DVD example, I've changed the objects back and forth a few times so you can study the effect more easily without restarting the show.

ON THE DVD Example *Chapter 11-Number 11*: This example demonstrates the quick image morphing technique to switch subjects.

Just to add a little pizzazz, change the background behind the objects with a fade just as the objects morph. In this example, I'm using different background colors to make the change obvious. The result is obvious but not shocking.

This is a great example of combining one effect with another. When the effects are combined, the audience doesn't have time to study what is happening. Instead, they are just dazzled by the show. Always remember, though, that the effects should never distract from the message.

Example *Chapter 11-Number 12*: This example demonstrates the same technique with changing background colors.

As one last example, I wanted to show that, depending on the structure of your shows, you can use the crossfade transition to fade the objects instead of using the transparency in each frame. If you are using this effect a lot with similar slide construction, doing it this way can be a real time saver because you can copy the slides and replace the content in each without changing much else about each slide. Structuring your show construction such that you avoid having to do a lot of changing is a great time saver.

Example *Chapter 11-Number 13*: This example demonstrates the use of separate slides to reduce workflow with this technique.

Object Wipe

This technique demonstrates some of the power of masks and what happens when a mask's contents aren't revealed because of the position of the mask. The idea is to move an object across another object, seemingly changing the underlying object as the top object passes. In reality, there is no change happening—only two photos being partially visible at any one time. Instead, behind the moving object, masks are being moved so they selectively conceal and reveal two different photo layers that are in the layer list the whole time.

To get a better feel for how this works, load the DVD example show into ProShow Producer and hide the foreground object. Preview the show to study what happens with the mask layers. You'll see the original object disappear because its mask moves away and the new object appear because its mask moves into view.

Example *Chapter 11-Number 14*: This example shows the use of the object wipe technique to transition between two photos.

Combining Adjustments with Transitions

You can easily use Producer's keyframing to arbitrarily add adjustments as effects. In a slide, you can add a new keyframe at the end of the slide that enables you to increase an effect during the transition. In the next slide, do the reverse at the beginning. The result is a transition in which the two photos appear to be changing at the same time as transitioning, which can be a very pleasing effect.

In the DVD example, I've included several variations of different effects, including blur, white point, saturation, hue, and colorization.

ON THE DVD Example *Chapter 11-Number 15*: This example shows some ways you can combine adjustment effects with the crossfade transition to further stylize the transitions.

Adjusting Part of a Photo

Sometimes you want to highlight part of an image or draw attention to something, but in a way that isn't just a spotlight. Adding chaotic motion to such an adjustment is a great way to stylize a show.

In general, I have found that this kind of adjustment ends up working best as an adjustment of everything except the highlighted part. For example, a spotlight is done by darkening everything except where the spotlight is. This is especially true for adjustments like blurring or color saturation. You wouldn't want to blur the point of interest, and you probably wouldn't want to desaturate it either. Instead, you want to blur everything else or desaturate everything else.

To do this kind of reverse adjustment, use an adjustment layer that is larger than the layer you're adjusting that has a hole in it. An example is shown in Figure 11.7.

I've added a little bit of motion to the adjustment layer mask to emphasize that motion is a powerful addition to these kinds of effects. There is no easy way to simulate this kind of adjustment with simpler tools.

ON THE DVD Example *Chapter 11-Number 16*: This example shows the use of selective adjustment.

Image that will be used as the
adjustment mask

Resulting effect:
Everything has been blurred but the
specific masked object

Original Image

Figure 11.7
The adjustment layer on the right is used to adjust everything but the subject, shown on the left.

Adjustment layers adjust everything under themselves. Sometimes you need to adjust a photo using an adjustment layer, but you don't want the adjustment to happen to the background. This is especially true when your adjustment layer needs to move around and may go off the edge of a photo. You can do this by putting the adjustment layer and the layers to be adjusted in a mask. Adjustment layers contained in a mask do not affect layers outside the mask.

Falling Pieces Using Keyframing

In Chapter 10, I showed how you can chop up a photo of a house into pieces and make it fall. This example can be improved significantly using keyframing.

The idea is to have the different pieces of the house start moving at different times. This is easily accomplished by setting up keyframes to control when the pieces fall.

ON THE DVD

Example *Chapter 11-Number 17*: This example shows the creation of a transition using pieces of a photo that fall away to reveal the underlying imagery.

Slow Motion Video

ProShow Producer offers the ability to control the playback speed of videos. Instead of having your video play back at full speed, you can slow it down.

Add a video and set the video playback speed to 25 percent rather than the default of 100 percent. The options for this are shown in Figure 11.8.

ProShow Producer's Video Clip Settings:
The video playback speed has been reduced from the
default 100%, resulting in a slow motion video effect.

Figure 11.8

Set the speed of video to something less than 100 percent to create a slow motion video.

Example *Chapter 11-Number 18*: This example shows a stylized slide using a background video that has been slowed down.

To add more polish to your video, you can use the Soft Focus technique described earlier in this chapter to give it a more dreamy effect. The video is included twice, just as a photo would be included to produce the soft focus effect.

Example *Chapter 11-Number 19*: This example shows a background video further stylized with the soft focus technique.

Travel Path Animation

The "Road Trip" example given in Chapter 6 shows an airplane moving from point to point. Using keyframing and masking, we can improve this example by adding a path to the plane's movement—a dotted line that the plane appears to leave behind as it travels from one destination to the next.

The lines are revealed using masking in the same way that the "Object Wipe" section discussed earlier in this chapter. The idea is to use the movement of a rectangular mask object to reveal the line as the plane moves.

For each path, there is a separate image containing only the dotted line for one segment of the trip, as shown in Figure 11.9. The rest of each dotted line's image is transparent. Position the dotted line images so they all line up between the points the plane travels.

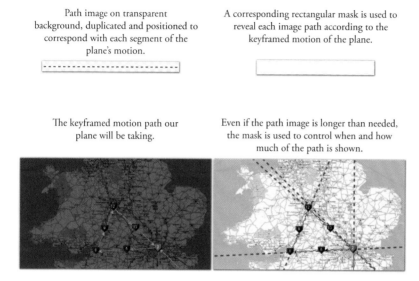

Path image on transparent background, duplicated and positioned to correspond with each segment of the plane's motion.

A corresponding rectangular mask is used to reveal each image path according to the keyframed motion of the plane.

The keyframed motion path our plane will be taking.

Even if the path image is longer than needed, the mask is used to control when and how much of the path is shown.

Figure 11.9

The travel path technique.

Create white rectangular mask layers and add one for each of the dotted lines. Position them so they are rotated and set up to move with the plane, so they reveal each line as the plane moves. In your layer list, you should see a mask layer followed by a dotted line layer followed by the next mask layer, and so on. I've created a DVD example with false rectangular layers to show what the mask images are doing at each stage of the keyframed movement.

ON THE DVD

Example *Chapter 11-Number 20*: This example uses solid white layers instead of dotted lines to make it easier to see what the mask layers are actually doing to reveal each dotted line.

Once you convert these rectangular layers into masks, the dotted line segments should be contained by their own mask layer. The motion of the mask layer is such that at the start of the slide, each mask layer reveals nothing because it is not over any part of the dotted-line image it contains. As time passes, each mask layer starts moving at the right moment and revealing the dotted line. Once the line has been completely revealed, the mask layer stops moving.

 Example *Chapter 11-Number 21*: This example is the same as the previous example but with the dotted lines used instead of the white layers.

Now we add the airplane. Some adjustment may be necessary to get the airplane to move exactly with the edge of each mask. If everything is synchronized properly, the audience should not be able to see the edge of the dotted line being revealed, because it should be covered by the plane.

 Example *Chapter 11-Number 22*: This example adds the plane to coincide with the dotted line.

And now, to make things just a tad fancier, we add a shadow of the airplane to the slide. This shadow object is simply a copy of the airplane graphic that is only partially transparent and moves from the same starting and ending points at the same time. However, between the plane's starts and stops, our shadow airplane moves in a slightly different curved path to make it look like the airplane is rising above the surface of the map while it moves. Compare the keyframes for the airplane and the shadow airplane to see exactly how to do this.

 Example *Chapter 11-Number 23*: This example adds a shadow to the plane to give the finished result more realism.

Modifier Examples

Modifiers are one of the most powerful features in Producer, but they should be used infrequently, or at least only in specific circumstances. Modifiers provide a certain level of automated control and can make certain difficult things easier. There is nothing that modifiers can do that cannot be done manually, although the amount of work necessary to do it without a modifier might well be so great as to be nearly impossible.

Think of modifiers as a way to modify any slide options setting using a waveform or some other reference value in a slide. All modifiers do is set values for layers from values from something else. What they use as values is configurable and can be derived from constant values, other layer settings, and handy built-in waveforms. For a more complete explanation of modifiers, please refer to the ProShow Producer User's Guide.

This section attempts to show you some real-life examples of how modifiers can be useful. Load the DVD example shows into ProShow Producer to study the settings

of the modifiers in this section. Note that when a modifier is present, a small red triangle appears in the upper-right of a value's text cell in the ProShow Producer user interface. You can find the Modifier dialog box by right-clicking on the zoom values in the Effects dialog box. Figure 11.10 shows an example of a right-click menu with the option to add a modifier to a value.

To access the Modifier tool, right-click on the relevant setting you want to modify.

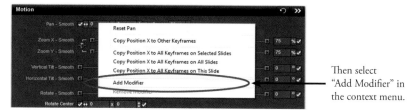

Then select "Add Modifier" in the context menu.

Figure 11.10
Add modifiers using the right-click menus for each value to be modified.

Shaking

Have you ever needed to make something shake? A modifier with a random number offset for the pan positions and rotation settings makes a convincing shake, as shown in Figure 11.11.

Modifiers - Shaking

Here we see the adjustments made to the X-axis pan value. A similar modifier was set on the layer's Y-axis pan value as well.

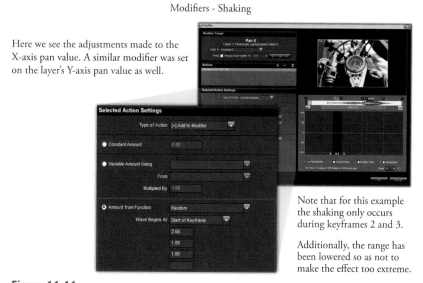

Note that for this example the shaking only occurs during keyframes 2 and 3.

Additionally, the range has been lowered so as not to make the effect too extreme.

Figure 11.11
Setting up the modifier to create a shaking effect.

Example *Chapter 11-Number 24*: This example demonstrates the use of a modifier to create chaotic motion and give the audience a feeling of a motorcycle starting.

Bobbing

Imagine something floating in water. It bobs up and down and gently leans from side to side as the waves guide it. The bobbing up and down is faster than the leaning. How can this be done?

For side-to-side leaning, we use a sine wave modifier to change the rotation value. For the bobbing up and down, we use a sine wave offset for the vertical pan position. The waveforms for the rotation and vertical offset have different frequencies, so the leaning and the vertical motion happen at different speeds.

Example *Chapter 11-Number 25*: This example uses modifiers to move a photo as if it were bobbing in water.

Pendulum

Just as we modified the rotation in the bobbing example, we can modify the rotation of a pendulum to make a more realistic clock. Serious physics enthusiasts may notice that using a sine wave isn't 100 percent accurate in this example because it isn't a parabolic curve, but the motion is close enough to work well.

Example *Chapter 11-Number 26*: This example uses a modifier to rotation to simulate the motion of a clock pendulum.

Adjustment Oscillation

Sometimes it is useful to make a layer's adjustments oscillate, like a warning light. You can easily do this using a waveform modifier with an adjustment effect. This example modifies the color saturation of a small image superimposed over a light to make it look like the light is getting brighter and darker.

Example *Chapter 11-Number 27*: This example shows a light that has been adjusted with modifiers to oscillate.

Rolling Wheels

Rotating a layer is done using a sawtooth wave. A *sawtooth* wave is a wave that starts at 0.0 and moves linearly toward its maximum value of 1.0. When it reaches the top-most value of 1.0, it pops back to the starting position of 0.0 and does the same thing all over again.

Applied to rotation, you can think of this happening from 0–360 degrees instead of 0.0–1.0. At the beginning of the wave, the rotation is at 0 degrees. As the wave moves up, the object rotates around. At the exact point the rotation would hit 360 degrees, the wave pops back to the starting point of 0 degrees, just as rotation would, to continue indefinitely. The scaling from 1.0–360 degrees is a simple multiplier in the configuration of the modifier.

If you apply a modifier to wheels of a car, as shown in Figure 11.12, the wheels rotate indefinitely.

Modifiers - Rolling Wheels

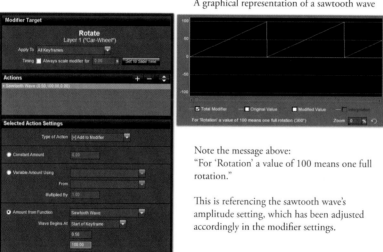

A graphical representation of a sawtooth wave

Note the message above:
"For 'Rotation' a value of 100 means one full rotation."

This is referencing the sawtooth wave's amplitude setting, which has been adjusted accordingly in the modifier settings.

Figure 11.12

Setting up the modifiers for the rolling wheels effect.

ON THE DVD

Example *Chapter 11-Number 28*: This example shows simple rotation of wheels using a sawtooth wave on the rotation values.

What if the car needs to move? If it does, you'd have to position the wheels exactly right each time the car moves. This is a painful task, so you can use modifiers here, too. Add the position of the car to the position of the wheels and position them so they're in the right place. Now as the car moves, the wheels move with the car precisely.

Example *Chapter 11-Number 29*: This example moves the car to show that the wheels appear to be rolling on the surface when they're rotated at the right speed.

Let's get fancier. Let's say you want the car to roll from the left to the right and have the wheels rotate as if they were really rolling between the car and the imaginary surface. Instead of using a waveform to make the wheels rotate, use the horizontal position of the car as the input for the rotation of the wheels. You need to experiment with the scaling factor for the rotation to make the wheels rotate at a speed that matches the size of the wheels.

Example *Chapter 11-Number 30*: This example shows the wheels rotating with the car using the horizontal position of the car as the reference point for the rotation.

Now the wheels change rotation based on the position of the car, so even if the car speeds up and slows down, the rotation of the wheels is always correct. In this example, I've added more keyframes to the car's movement to demonstrate that even with complex movement, the wheels dutifully roll just as you expect them to.

Example *Chapter 11-Number 31*: This example shows what happens when the car is moved forward and backward. I've added some body tilt to the car just to increase the realism of the finished example.

ProShow Producer is being used to do many otherwise messy calculations in this example. It would be difficult for even an experienced ProShow Producer guru to reproduce this last example without modifiers. If anything, it would take a massive amount of effort and a huge amount of time to accomplish it. With modifiers, this task becomes relatively easy. This is a perfect example of how modifiers can be extremely powerful with certain solutions.

Circular and Elliptical Movement

A circle is an ellipse that has an equal diameter in all axes. If you are a math whiz, you may know that a circle or ellipse can be described using a sine wave in one axis and a cosine wave in the other axis. This simple rule makes circular and elliptical motion possible using modifiers because modifiers support both sine waves and cosine waves.

To move an object in an elliptical path, simply use modifiers as shown in Figure 11.13 to offset the object's pan positions. Use a cosine wave for the horizontal pan position and a sine wave for the vertical pan position.

Modifiers - Circular and Elliptical Movement

Note the X value has been modified with a sine wave, while the Y value is using a cosine wave.

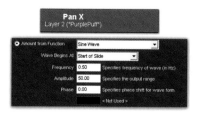

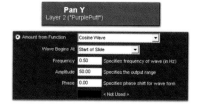

Figure 11.13

Create circular or elliptical movement using sine and cosine wave modifiers.

ProShow uses coordinates ranging from −50.0 to 50.0 in each axis for layers. Sine and cosine waves naturally go from −1.0 to 1.0, so you need a multiplier to see any obvious motion. This brings up another detail: if you multiply both the sine and the cosine by the same values, you usually get elliptical instead of circular motion because the aspect ratio of the show is almost never square. Put another way, your show is usually wider than it is tall, which means that equal offsets make the ellipse wider than it is tall. To get a circle, you need to adjust your multiplier by the aspect ratio of the show, which you can do by multiplying by the ratio of the width over the height. For a 4:3 show, multiply the vertical offset by 4/3, or 1.333333. Once you do this, the layer follows a perfectly circular path.

ON THE DVD

Example *Chapter 11-Number 32*: This example demonstrates a photo being moved around in a circular path.

Just to spice this up a bit, I've added a sawtooth wave to adjust the rotation of the object moving around.

ON THE DVD

Example *Chapter 11-Number 33*: This example uses a sawtooth wave to adjust the rotation of the photo.

Feats of Complexity and Amazement

This section focuses on combining some of the more powerful features of ProShow Producer in creative ways that might surprise even advanced users. My goal here is to produce results that most people would look at and have no idea how they were accomplished. Don't feel bad if you don't absorb these techniques immediately. They're easy to understand once it clicks and you *get it*, but figuring out how they work can be challenging at first.

Invisible Control Layer for Position

Because modifiers include the ability to modify any value in any layer with the value of any other setting from any other layer, it is possible to create a layer that is invisible to the user but controls other aspects of the show. Essentially, this is a way to use the keyframing ability in Producer to drive more than just the parameter that is being keyframed.

I like to create layers outside the show area that move left and right within a certain range of motion to control things like brightness, blur, and rotation. In this example, I've controlled the settings of several layers using a layer that isn't visible in the show. The hidden layer is actually above the show area; you can see it by using the zoom slider at the bottom of the Slide Options dialog to expand the size of the Preview canvas area.

By expanding the canvas size, you can change the scale of the preview to see more of the area outside the visible show area. The controls for this are shown in Figure 11.14.

Modifiers - Invisible control layer

Below is the Precision Preview zoomed out so we can see well beyond the slide edges. The red circle indicates the off-screen location of the actual control layer.

The red box indicates the actual slide edges.

Figure 11.14

Scale down the preview so you can see the area outside the visible show.

In this example, I've controlled the positions, size, and rotation of several layers at once by making their horizontal and vertical pan positions, zoom values, and rotation all modified with the values from the single layer outside of the normal view. When dealing with a group of layers that have to do the same thing, it is difficult not to appreciate modifiers.

ON THE DVD

Example *Chapter 11-Number 34*: This example demonstrates using an invisible control layer to control pan positions, zoom values, and rotation.

Invisible Control Layer for Brightness

You can apply the hidden control layer idea in a lot of different situations and for different reasons. In this example, I've created the effect of lightning using a number of different layers. There is no layer that shows the lightning, but all the layers' black and white point adjustments have been tied to one layer that controls them all. Each layer has a different multiplier, so the effect of the lightning appears to be more realistic.

Without modifiers to tie all these changes together, synchronizing all the keyframes for these changes would be time consuming and frustrating.

ON THE DVD

Example *Chapter 11-Number 35*: This example demonstrates using an invisible control layer for brightness to create a lightning effect.

Multilayer False Perspective

In Chapter 6, I showed the example of false perspective with several layers moving at different speeds. In this example, I show the use of multiplied offsets of one of the layers to control the position of the other layers automatically. The result is that by moving one layer arbitrarily, the other layers automatically move perfectly. I've included some simple motion and more complex motion to demonstrate that the modifiers do all the work for you.

ON THE DVD

Example *Chapter 11-Number 36*: This example shows a simple example followed by a more complex one. The complex example demonstrates that all the panning and zooming values are adjusted by the control layer, so even complex movement is trivial.

Rotating Target Masking

This example uses multiple masks that collectively form a target pattern to slice an image into consecutive two-dimensional torus shapes. (A *two-dimensional torus* is a circle with a hole in the middle, like a flat donut.) Figure 11.15 shows the mask layers and the way the layers are configured. Each mask contains the same photo. The rotation of the center photo is used as a reference rotation for the other masked layers but is multiplied so the different parts of the target shape rotate at different speeds.

The idea is to create a transition from one photo to another in the slide. During the transition, a second photo in each mask is faded in. This second photo is rotated at the same speeds as the first photo, so the rotation of each masked shape seems to coincide. At the end of the transition period, the second photo becomes the only one visible because it covers the first photo completely.

ON THE DVD Example *Chapter 11-Number 37*: This example shows the use of masked target images to create a unique transition effect.

Modifiers - Rotating target masks

The five images below are our masks.

On the left we see the effect in mid-rotation.

Each masked copy of the original image is modified to rotate, but at different speeds due to differences between the Multiplied By number (shown below).

Figure 11.15

Each of the different masked layers has a different rotation multiplier.

Nested Target Depth

Using the same target masks as the previous example, instead of rotating the images, we zoom them in and out using a modifier, which derives its zoom value based on a sine wave. All the layers use the same sine wave, but the sine wave modifier's phase value has been changed to cause all the layers to be a little bit out of phase. You can see this if you look at the phase value in the configuration for the sine wave in each zoom value's modifier.

Example *Chapter 11-Number 38*: This example shows the use of nested target-shaped masks to create a unique transition effect.

Checkerboard Mask Depth

This technique uses the same idea as the previous techniques, but with completely different masks. Instead of a target shape, we use checkerboard masks. Other than the mask shape difference, the effects are identical.

Example *Chapter 11-Number 39*: This example uses checkerboard mask images instead of the target images used in the previous example.

Chroma Keyed Video as Self-Adjustment

This example uses a chroma keyed video to adjust itself, as shown in Figure 11.16. The results can be artful or abstract depending on the video, because the chroma keying process constrains the effect to only the part of the video that the chroma keying process does not remove. The chroma keyed video layer is an adjustment layer that adjusts only on the part of the video that is not removed, or vice versa if the adjustment layer is inverted.

Example *Chapter 11-Number 40*: This example demonstrates the use of a video being adjusted by a chroma keyed version of itself.

The Chroma Key settings chosen have removed any black pixels, leaving them transparent.

Result of chroma keyed video adjusting original color.

Figure 11.16

Using chroma keying to create this unique effect.

Text Exploded by Upward Panning Image

This technique uses the *explode* caption fly-out effect in combination with a moving layer to make it look like the layer is causing the captions to explode upon impact as the layer hits each caption. You can see this in Figure 11.17. The result is something like a bulldozing effect and can be effective when used in the right context. The goal for this effect is that it is unexpected. If you were to use this effect over and over again, the audience would quickly find it tiring.

The effect starts with a screen full of captions, and the show needs to transition to the next topic. Instead of just transitioning, you can use a layer panning up as a transition. Your captions must be one line of text only, and the image panning up should kick off your next topic, so you need to put some thought into this.

At the exact moment the layer panning up touches each caption, the caption starts its fly-out effect, which is to *explode*. Once you adjust the speed of the panning layer and the timing of the start of each explode effect, this effect looks great.

ON THE DVD

Example *Chapter 11-Number 41*: This example shows captions being exploded when hit by another layer.

Exploding text

Each caption has been set to begin "exploding" at the point where
the layer meets it, as indicated by the arrow below.

Figure 11.17

Setting up the exploding caption text technique.

Clever Scrolling Credits Trick

Sometimes it is desirable to have rolling credits with different colors and font weights. You can use this trick with different font sizes, but take care to set the line spacing for both captions to the same amount so they line up properly. Depending on what you're doing, it might be easier to use an external editor to create a large caption image with all your credits in them.

The idea is to have two captions that move together and appear to be one caption, as shown in Figure 11.18. One caption has bolded headings in one color, and the other has the normal weight headings in a different color. Using alternating blank lines of text in each caption, you can interlace the caption lines to make the result look like there are multiple font styles in one caption. When both captions appear together and move upward identically, the result appears to be one single caption. Take special care to make sure the differences between the start and end vertical pan positions are identical, or the captions will not move at the same speed.

ON THE DVD Example *Chapter 11-Number 42*: This example demonstrates the use of two captions that are in sync to appear to be one scrolling credits caption.

I suggest studying the DVD example before attempting to use this last technique. Although it can save you a lot of time and reduce the download size, it can also become confusing if you lose track of what you're doing.

Caption 1 Caption 2

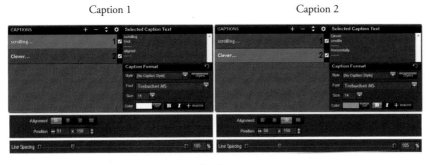

Result

Note that it is
important to ensure
both captions have
the same line spacing
and Y-axis values.

Figure 11.18

Two captions are superimposed to create the illusion of two font styles.

Review

ProShow Producer is more powerful than ProShow Gold in many ways. Mastering the full potential of ProShow Producer is an ambitious endeavor. The powerful features can be used together in so many different ways as to at first seem overwhelming. Instead of considering mastery in terms of learning all the features completely, realize that ProShow Producer's power lies mostly in your ability to use features together in creative ways. Start slowly and learn one feature at a time. Then learn to combine them in different ways. As you use more and more features together, the possibilities expand easily. Before you realize it, you'll likely be doing things you never thought you could, and your shows will benefit quickly.

12

Delivering Your Show

The goal of any effective show is having someone see it. There are many ways for audiences to see shows. This chapter covers the most common ways to deliver your shows.

There is no *best format* to deliver all shows. There are simply different formats that solve different problems better or worse in certain circumstances.

Video Versus Real-Time Playback

There are two general types of output: those based on video and those based on real-time playback. Both are stored in files and displayed with software designed to view those types of files. Video formats require video players, and more specialized formats, such as Microsoft PowerPoint files or the Photodex Presenter file format, require specialized players to play them. Although there are many differences between these two types of output, an easy way to describe a key difference between the two is that video output does most of the work when you create the output, whereas real-time output does most of the work when you play back the show. There are advantages and disadvantages to both of these methods, which is why ProShow offers you many choices for publishing your show.

Video Playback

Video playback has become widely supported both in the consumer electronics and the personal computer industry and includes many output methods you may already be familiar with. Video playback includes not only video files you create, but formats that are based on video in one form or another. It has become common in the living room, where Digital Versatile Disc (DVD) and Blu-ray players are used to play movies, and it is becoming more common on the Internet with sites like YouTube. Regardless of how it is delivered, video data is a stream of separate images, encoded and decoded in a way that reduces the amount of data needed.

When you create video output, your show is put through a video *encoding* process that drastically reduces the amount of data the video stream requires. Your show is rendered into thousands of individual still images, and these images are encoded into compressed video as part of the output process. This work is done when the video is created, potentially reducing the amount of work that must be done during playback. This comes with a price, because the video is now created at a fixed size and quality level.

Video compression is *lossy*, meaning that it reduces the amount of necessary data by making usually small sacrifices in quality. There are many ways this is done, but the details of video compression are beyond the scope of this book. All this clever compression results in subtle and sometimes obvious loss of quality. The lower the data size of the resulting video is, the more quality loss you'll see in the video. Figure 12.1 shows an example of quality loss caused by video compression.

Original video clip Video clip after compression to FLV

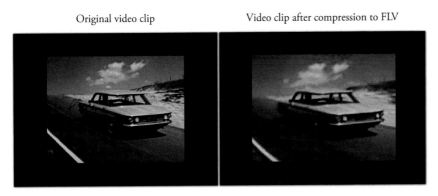

Figure 12.1
Quality loss caused by lossy video compression.

Rendering and encoding the video stream take most of the time when creating a video. Depending on how the video data will be stored and delivered, the video data may be written to an optical disc, stored in a file on the computer, or uploaded to

a website automatically. Writing an optical disc, like a DVD, usually doesn't take all too long compared to encoding the video, but uploading to a website such as YouTube can take a long time if you have a slow connection.

Both hardware and software video players are designed for the same thing: playing standardized video formats. Video formats are convenient in that they are widely supported and the players are widely available, at least for common formats. Be aware that not every video format is well supported, and no video format is universally supported.

Video formats are frustrating because they require you to balance difficult decisions that affect quality and data size. You can't have both. Reducing the amount of video data means lowering quality. For example, trying to make a video file play back with high quality on the Internet can be challenging because most users on the Internet cannot receive data fast enough to avoid delays in transmission. The result is that most video on the Internet is of poor quality. In the future, the Internet may offer high enough transmission speeds to ease these problems. The industry has promised great Internet video for more than a decade, yet it remains a problem. With that in mind, I do not expect this problem to go away quickly.

Real-Time Playback

Unlike video formats, which perform the rendering when you create the output, real-time formats are rendered when you play the show back. Some of these formats are files that require dedicated playback software, such as the *.PX format discussed next, whereas others are completely self-contained, like ProShow's executable (*.EXE) output, which acts as its own playback software. What makes these formats different from video is their ability to adapt during playback. These specialized formats can offer superior quality because they are not fixed to a specific resolution, compression level, or frame rate like video files are.

Formats designed for a specific purpose can outperform video in several ways. These formats require a more specialized player that may not come with most people's computers. I often refer to these formats as *PC Playback formats*, because they are primarily designed to play back shows on a computer. Photodex's format is called the *.PX format*—this is the format that Photodex Presenter uses to play back shows created with ProShow. The Photodex Presenter is available as a free download from the Photodex website at www.photodex.com. Other somewhat similar formats you may have heard of are the Microsoft PowerPoint presentation format and Adobe SWF format. Both of these specific formats require a special nonvideo player to be played.

Because the *.PX format is fairly specific to the construction of a show in terms of still images with motion, it can store its data in terms of objects and actions rather than one stream of image data. This results in tiny file sizes compared to video.

The *.PX format also delivers vastly superior image quality—there is often no quality loss at all. This makes PC playback desirable for photographers and others whose primary interest is quality. And the tiny data size makes the *.PX format attractive for websites that must serve shows to users with limited Internet bandwidth.

PC playback is also almost always better than video in that it usually delivers frame rates far above video formats. On most modern computers, Photodex Presenter achieves 60 frames per second, which provides incredibly smooth motion. Even Blu-ray video is usually limited to 24 frames per second at 1080p, which is less than 40 percent of the motion smoothness of Presenter. A higher frame rate is something most people notice but few understand.

PC playback formats require a plug-in on the viewer's computer. Some companies employ policies that forbid users from installing plug-ins, making it difficult for some to see shows on work computers. Many people are also wary of installing plug-ins on their computer at home unless it is for some vitally important reason. But this understandable fear ends up pitting the importance of a show against people's fear of problems with a machine.

PC playback formats also depend on the speed of the viewer's computer to play the show well. Slower computers result in slower or jerky playback, although that's not very common with modern machines. Both PC playback formats and video suffer on slower machines, although video usually has a more consistent type of jerkiness compared to PC playback formats. Balance this against the opposing fact that PC playback formats always outperform video on an adequate machine.

My experience from Photodex is that, on most computers, Presenter does a much better job with slide show playback than any video playback solution, including the most modern HD video formats. The one unfortunate reality is that the viewer must install Presenter. Everything else is an advantage.

Photodex has been publishing Presenter since 2005, and it contains no viruses, malware, adware, or anything else malicious. It also has no known vulnerabilities to hacking—it is quite safe. Every instance of the Presenter plug-in installed automatically through a web page is digitally signed and is downloaded directly from Photodex.

Both Is Better

I've been amazed by the struggle to find the single slide show format that solves all playback problems. The people I see struggling the most are simply unwilling to give up anything. Their struggle is rooted in not asking the right question. They ask, "What single format will solve all of my problems?" Instead, they should ask,

"What format(s) will solve all of my problems?" The best answer isn't one format or another; it is *both!* There is no need to lose sleep over which format to use if you've covered all your bases by supplying an option making everyone happy.

Hypothetically, let's say you're a photographer and you have a website to promote your photography business. You want to provide the highest-quality shows with the smallest data size, making sure that you have the best solution for all users. Not surprisingly, this is what everyone wants. Unfortunately, no single format delivers it.

Instead, provide two options side-by-side and cover both bases. Provide two links for each show—a link to a video version and a PC playback version. For those who can install Presenter, amazing quality and tiny data size are achieved. For those who don't install Presenter, the lower-quality video is the next best option and works on 95 percent or more machines out there. I even suggest putting the video option first with a gentle reminder that the plug-in delivers better quality. This way you deliver compatibility first, which is the best way to get new acquaintances to like you more. Once your viewers get used to you, they'll trust you more and try the higher-quality option. They'll be pleasantly surprised when they find that it works well. Figure 12.2 shows how we've done this with the Photodex website.

Providing your audience multiple options to watch your video is often the best solution.

Figure 12.2

Providing video and Photodex Presenter formats gives your audience both solutions.

When you give people a choice, you don't have to be shy about telling them about the pros and cons. Default to the safer option (for example, Flash video), but recommend the high-quality option (Photodex Presenter). That way you've put the quality decision in their hands. People always have the option to watch the lower-quality video, and many will take it, especially early on. But once they do try Presenter, they won't go back to video on your site.

Discs: CDs, DVDs, and BDs

Delivering a show on a physical disc is often necessary. Wedding shows are almost always delivered on DVD or Blu-ray discs (BDs) even if they are also available on the Internet. Many photographers give a link to an online version of a ProShow for free and charge the bridal party for DVDs and Blu-ray discs. Figure 12.3 shows various types of discs with some different types of packaging.

An assortment of media and packaging options

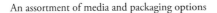

Figure 12.3

You can package and deliver CDs, DVDs, and BDs in various ways.

Physical discs have advantages and disadvantages. DVDs are easily playable by almost anyone in the Westernized world because of the success of the DVD format delivering Hollywood movies. The audience doesn't need a certain kind of computer—they just need a television and a DVD player. Most people already have both. If your situation provides physical contact with your audience, physical discs are an obvious, affordable choice.

The disadvantage of physical discs is that they cannot be easily downloaded. You have to physically get the disc to your audience. This can be expensive because of cost in both time and money. If your audience is not standing in front of you, you have to transport the disc.

One huge tip I'd like to offer is to always use rewritable media when you're testing your shows. Don't waste DVD-R, DVD+R, or BD-R discs unless you're sure you're done. If you're just testing to see what it is going to look like, use DVD-RW, DVD+RW, or BD-RE discs. Sure, they cost more than a write-once disc, but you only have to buy one and you can use it over and over again. Each time you burn a new disc, you replace whatever was on it before.

PC Playback Discs

PC playback discs are simply discs with an executable (*.EXE) file that the audience can execute on a compatible computer. These discs may or may not also be formatted to be playable in a DVD, Blu-ray, or other video player. When combined with a video format, the executable file is usually just a standard file in the directory structure of a disc formatted to be compatible with a hardware video player.

PC playback discs deliver all the advantages of real-time playback, but with the physical distribution characteristics of a physical disc. In addition, they can be combined with other video formats so a disc can be playable not only on a PC, but with a standardized player. It is very common to include a PC executable file on a DVD or Blu-ray disc using ProShow.

One pitfall of playing an executable file directly from a disc is that good show playback depends on the computer having a drive that reads the disc data fast enough to play the show without stuttering. If you research the specs of the available drives, you'd conclude that this isn't a problem. The reason is not obvious. There are software configurations out there that use a tremendous amount of CPU power to read from CDs and DVDs. This isn't apparent when you're only using the drives for data because you're usually waiting for data to copy anyway and you don't realize that the CPU is being overused for the task. The reason this usually happens has to do with the way Windows deals with disk controller errors. The Windows operating system can periodically become confused about Integrated Drive Electronics (IDE) controllers and stop using Direct Memory Access (DMA) because it thinks the IDE controller is faulty. This causes all data transfer to or from the drive to use enormous amounts of CPU time. The result is that, on some machines, playback will be terrible because reading from the disc leaves little CPU power to actually play the show. The only good workaround other than fixing the controller configuration problem is to copy the *.EXE file to the hard drive before playing it. Even then, if the hard disk has had the same problem, show playback can still suffer. If you distribute PC playback discs, you may run into this kind of problem once in a while. The only comforting news in these unfortunate situations is that no software for show playback will work well on such a machine because the machine's software configuration makes it unusable for show playback.

DVDs

DVDs are currently the most popular disc format for distributing video. This section gives you some history and information about them. Figure 12.4 shows a DVD in standard DVD packaging.

Figure 12.4
A DVD in standard DVD packaging.

DVD History

In the 1990s, the DVD format was introduced as a lower-cost and higher-quality alternative to VHS videotape. DVD was wildly successful in its first decade, and almost all the support for DVD formats went to professionally produced discs. DVD writers for PCs were prohibitively expensive for years after the video industry successfully standardized on the DVD format for retail movie distribution. Years after DVD had already become the standard for video distribution, the computer industry finally caught up, and DVD writers became affordable enough to be common. DVD writers are now so common that it is difficult to find a CD writer that is not also a DVD writer. Figure 12.5 shows a DVD writer for a personal computer.

Figure 12.5
A DVD writer as used in a personal computer.

Even as the DVD was becoming the standard for consumer optical computer data storage, few were using writable DVDs to create video discs because of the difficulty in managing the enormous video data. Computers were still slow, and hard drive storage was expensive enough that video editing was out of reach for most consumers. Even businesses who mastered DVDs had to spend a premium to be able to master them. Around 2002, this started to change. By 2004, DVD writers were cheap, and consumer computers were fast and capable of sufficient storage. Producing DVDs on a consumer machine was finally within reach for consumers.

The DVD Format

Because Hollywood standardized on DVD before consumer software was available to make DVDs at home, the format for DVD was fairly well set. This is not to say that the DVD format is perfect. Most Hollywood DVDs have many technical formatting errors, and most DVD players have quirks that don't honor the DVD specifications. Essentially, everyone is violating some amount of the DVD specifications. To make a DVD playable across more players, publishers have to break some of the rules in the DVD specifications to avoid common player problems. However, with enough effort, a software publisher can publish software that creates DVDs that will play on nearly all players. DVD support has become ubiquitous.

The DVD standard had to adhere to television standards that were developed in a world without digital computers. When NTSC was designed, some assumptions (that don't fit well with digital systems) were made about how the video signals should be structured. For example, the NTSC video format uses video that is 720×480 pixels but with an aspect ratio of 4:3, which means the pixels aren't square. This is no problem at all for analog electronics. If the pixels were square, the resolution would have been 640×480 or 720×540. On an NTSC disc, the pixels for a 4:3 video are actually slightly taller than they are wide.

To make DVD even more bizarre, some of the world uses the PAL (or SECAM) standard instead of NTSC. The reason for this distinction lies mainly in the frequency that alternating current (AC) power is delivered in different countries. Britain, for example, uses 50Hz power instead of the United States' 60Hz. The designers of television broadcasts decided to use the frequency of the power to control the frame rate of the video because it is a readily available oscillation that could be used to synchronize the television and make televisions cheaper to build. But because the frequency to distribute the video data was to be the same, there is more data per PAL frame, so PAL uses more lines on the screen to compensate. For this reason, PAL discs use a resolution of 720×576, which is—you guessed it—exactly 60/50, or 6/5 of the resolution of NTSC. But NTSC discs share the same aspect ratio: 4:3. For this reason, PAL and NTSC discs have the same pixel data rate for a given amount of time, but they have a different frame rate and different resolutions. Again, the pixels of a PAL disc are not square—they're slightly wider than they are tall.

The designers of DVD were smart to add one more confusing thing to the mix: *anamorphic* video. The DVD designers declared that both NTSC and PAL video must be displayable at 4:3 or 16:9 resolutions. The only thing necessary to make this distinction was a marker in the video stream. In other words, the DVD specification requires the player to be able to play video files not only in a 4:3 aspect ratio like older televisions, but also in the 16:9 aspect ratio. Keep in mind that

when the DVD format was specified, nobody had 16:9 televisions. The people specifying the DVD format knew that the industry was going to standardize on 16:9 televisions in the future. For as much of a technical nightmare as anamorphic video is, it was a smart move that has paved the way to better standards like flat-screen TVs and Blu-ray discs.

Unfortunately, the designers of the DVD format couldn't find ways around problems with frame rate compensation to get rid of the difference between NTSC and PAL formats. This is because there is no acceptable ways to do it. This has caused all sorts of problems, but the short answer is that DVDs must be either NTSC or PAL formatted. A little known tip is that NTSC discs are playable on about 95 percent of the DVD players worldwide because most PAL DVD players can read NTSC discs and convert the output to something that a PAL television will display well. The reverse is not true; PAL discs are not playable on nearly as many NTSC players.

The big variable that you have control over when mastering a DVD is the data rate per second, which determines how much video you can store expressed in time. With a high data rate, the disc fills up faster so you have less time. With lower data rates, you have more time but less data and therefore less quality.

DVD Compatibility

The DVD specification says very clearly that all DVD players must be able to support data rates of well over 10 million bits per second. In real life, a small percentage of them cannot even handle 9 million. This is why ProShow defaults to a "safe" variation of the HQ (high quality) mode for DVD output. The safe version is a nonstandard, scaled-back data rate that is playable on almost all DVD players. It is about 8 million bits per second. Be aware that if a DVD player cannot play a well-maintained, properly created HQ DVD at the full data rate, the player is not compatible with the DVD specifications. Unfortunately, players with this problem are out there. If you are distributing DVDs, you should use the safe HQ setting or lower.

Lower-quality settings like SP or SLP use much lower data rates and allow you to store more video on the disc. The cost is quality, and you'll most likely see the difference. ProShow supports all the standard data rates that are specified by the DVD specifications to be complete. In practice, few people use the lower settings because the video quality suffers significantly. There is no way around this problem because only so much video can be compressed without losing quality.

The DVD specification calls for all NTSC DVDs to contain audio encoded with pulse code modulation (PCM) or Dolby Digital audio. The PAL standard requires PCM, Dolby Digital, or audio encoded in the MP2 (MPEG Layer 2) format.

PCM audio is not compressed, so it consumes a considerable amount of data. In short, if you use PCM audio, more of the data is used for audio and the video quality suffers. ProShow defaults to using MP2 audio with NTSC discs even though this is technically nonstandard. The majority of DVD players have no problem with this in their default configuration. The few DVD players that have issues with the PCM format have configuration settings available through the remote control to enable MP2 audio playback. If you are at all concerned about this, consider using PCM audio, but be aware that the quality of your video will suffer.

DVDs can be coded for a playback region to limit piracy. Unless you are doing mass production, your discs should be region-free. ProShow writes region-free DVDs, so you should never have a region issue with any players.

DVD Media and Compatibility

Would you believe that not all DVD players can play all professionally produced Hollywood movies? I've run across a couple that wouldn't work in one DVD player but would work in another. Some have trouble with many players. From my experience with the details of the DVD format, I know why. The answer is in the formatting of the DVDs and the firmware in some players. Most of these problems are long gone, but there are still some players with some pretty severe firmware bugs in them. They might not play discs that nearly all others will play. Figure 12.6 shows one of our "problem player" test racks we use at Photodex to test some picky DVD players.

An example of a DVD player test rack

Figure 12.6

Testing many players shows less DVD compatibility than you'd think.

Before I get into the specifics of the different DVD media types, let me explain one caveat about DVD players related to the state of the industry, early in the adoption of writable DVDs. Some manufacturers—especially Sony—were resistant to allowing consumers to play DVDs that were not professionally stamped using DVD-ROM media. I imagine this had something to do with Sony owning its own motion picture studio and working with other studios to prevent piracy. As more and more customers started writing DVDs and playing them on DVD players, the lesser-known DVD manufacturers allowed playback of DVDs that were not professionally produced—in other words, they allowed writable media. Sony was perhaps the last manufacturer to give in and allow it. I suspect consumers started choosing which DVD players to buy based on writable media support. There are some players out there which, although very old, will not play discs that are written to writable media even though the player is capable of it. For this reason, there is no way to get a writable DVD to play on certain older players. *Bitsetting*, described in a moment, overcomes the problems with nearly all of these older players.

The types of DVD media are DVD-ROM (read-only), DVD-R (write-once; read many), DVD-RW (readable and writable), DVD+R (write-once; read many), DVD+RW (readable and writable), and DVD-RAM (random access.) Professionally manufactured DVDs are DVD-ROMs that are created with an entirely different process from the rest of the DVD media. DVD-ROMs are stamped using a glass master, which is expensive to create. This is why professional manufacturing costs more to master but is much cheaper for high-volume production.

DVD-RAMs aren't used very much and are intended for computer applications that require the ability to write to small parts of the disc randomly, much like how a floppy disk works. You won't hear much about DVD-RAMs, and I wouldn't recommend using them with mainstream players. Some of them support the format, but support is limited.

The other four formats are split into two categories and two types. The categories are the *minus* and the *plus* groups—DVD- and DVD+. Beware of people—even experts—saying one is more compatible than the other. They're both more compatible than the other depending on your evaluation. DVD- discs are written to more often, but I'm about to explain why you should use DVD+ discs instead.

DVD- discs were introduced before DVD+ discs and got a huge head-start in the market. I suspect this is the only reason they are still used more often than DVD+ discs. The R and RW in the media types simply mean that they can be written to once (R) or they can be written to over and over (RW). DVD- discs are slightly less desirable than DVD+ discs for two reasons. One reason is that DVD- discs use a slightly different light reflectance than DVD-ROM and DVD+ discs. DVD+ discs were designed to be indistinguishable by the DVD players—the players

literally cannot tell the difference between a DVD-ROM disc and a DVD+ disc by the way the bits "look" to the laser. The second reason DVD+ discs are preferable is because of a process called bitsetting.

Every DVD has a reserved area at the innermost area of the disc that contains a signature describing the physical characteristics of the media and the type of disc. The manufacturers of the media preset the media types in this area, and DVD writers read this information to help calibrate the intensity of the laser to be compatible with slightly different media chemistry. The other part of this reserved area is the signature for the media type, which is defined by the DVD standard as necessary to write properly, so the player knows what kind of disc it is. With DVD- media, this inner area is preset in a read-only way so that a DVD writer cannot overwrite the media type or media signature. DVD+ discs are designed to require this signature be written as part of the normal writing process. In other words, with DVD+ discs, the DVD writer has to write what type of disc is being written.

Bitsetting is the process of lying to the DVD player by writing an incorrect signature to this reserved area. The DVD specifications require that DVD+ discs be written in such a way that the disc says it is a DVD+ disc. But guess what? The writer can write anything it wants! If the software happens to write "DVD-ROM" as a signature instead of "DVD+R" or "DVD+RW," it has performed bitsetting.

Remember that the data bits on DVD+ discs are virtually indistinguishable from DVD-ROM discs. This means that a DVD+ disc that was written with bitsetting is virtually indistinguishable from a professionally manufactured disc. Recall that even Sony tried to keep people from playing writable DVDs by looking at the media type. Bitsetting avoids even this, leaving the only incompatible players as the ones that have firmware problems or old drive mechanisms.

Between bitsetting and the optical characteristics of DVD+ discs, I heavily recommend DVD+R written with bitsetting enabled as the preferred format of disc to be used by anyone distributing writable DVDs. Not all DVD+ drives support bitsetting. ProShow detects all known drives that support bitsetting and default to enabling bitsetting for DVD+ discs.

Photodex performed extensive empirical tests to find out which media worked the best across all players. We tested all major DVD variants using DVD-R, DVD+R without bitsetting and DVD+R with bitsetting enabled and tested with hundreds of DVD players. DVD+R won the compatibility tests by a wide margin: 99.2 percent success. In second place was DVD-R: 96 percent success. Third was DVD+R without bitsetting, and although I cannot remember the exact percentage, it was close to DVD-R. So, you see, DVD+ and DVD- are both the best format depending on whether your DVD writer supports bitsetting.

If possible, write to DVD+R discs and use bitsetting.

Which Brand Is the Best?

I get asked this question frequently. Fortunately, there is a simple answer. Media quality is the single biggest problem with writing DVDs, bar none. Really. Some spindles of 100 discs have 90 discs in them that will result in bad writes. Buyer beware: cheap media is often bad media.

Unfortunately, expensive media isn't necessarily good. Sometimes you don't get what you pay for.

The best media I know of is Taiyo Yuden. Taiyo Yuden manufactures its own materials—it does not buy the discs from other sources and simply rebrand them. I believe this is why its media is consistent. Because it owns the whole process from materials to final product, it has better quality control and cannot be the victim of a bad batch of materials from an outside supplier. This kind of problem plagues every other media manufacturer.

The second best, or so I've been told, is Verbatim. Apparently, Verbatim buys materials from other manufacturers and packages them, but its quality control is very good compared to the other manufacturers. Verbatim has great success rates reported on websites that monitor media manufacturing and quality control.

All other media brands that I am aware of buy their blank media from a separate manufacturer and have lower quality control results. This explains the strange inconsistencies in results. Even well-known manufacturers like TDK have had manufacturing runs with horrible failure rates. I would imagine this is expensive for them not only in brand damage but in returns. Even a 10 percent failure rate means that 1 out of every 10 discs you burn will end up with an error in it and you may never detect it before it is too late. Also, the more data you write to a disc, the more likely you will run across a problem because the writing process depends on more of the surface area of the disc.

As of the writing of this book, I am not aware of any retailer that carries Taiyo Yuden media. You must order it online. Most online media resellers carry it because it is in high demand. Verbatim media is available at a lot of stores in the United States. I am not sure about the availability of Verbatim media in other countries. If you can wait for the shipping delay, get Taiyo Yuden media.

BD—Blu-Ray Discs

Blu-ray (BD) discs are the next big standard for distributing video discs. This section gives you some history and information about Blu-ray. Figure 12.7 shows a Blu-ray disc in standard Blu-ray disc packaging.

Figure 12.7

A Blu-ray disc in standard Blu-ray disc packaging.

BD History

In the mid-2000s, flat screen televisions had outpaced the older cathode-ray tube (CRT) televisions in sales and HDTV prices started to plummet. Within the span of only a couple of years, prices had dropped in half, and a big flat screen was what most of the Westernized middle class had their eyes on for their next big purchase.

High-definition television standards had been in the works for more than a decade and had been delayed repeatedly. The HDTV formats were fairly well settled at that time. While the formats were being standardized, the newly invented blue laser was being refined, and new optical media technologies were being developed. The older CD and DVD optical disc formats used a red laser with a light frequency of 650 nanometers (nm)—billionths of a meter. The new blue-violet lasers could emit light with a frequency of 400nm. Because the light frequency is smaller, a laser using blue-violet light can focus on a much smaller point than the older red lasers. This enables quite a bit more data to be stored on an optically sensitive disc.

In anticipation of the HDTV medium becoming a reality, huge groups of companies formed two factions—the HD-DVD faction led by Toshiba and the Blu-ray faction led by Sony. The HD-DVD group had the advantage of the name recognition of DVD, but the format was so radically different that it wasn't really an extension of DVD at all—it became a completely new format. The Blu-ray group started from scratch and specified a completely new format that was very well thought out in comparison.

As the market heated up, the two groups fought for support from major motion picture studios and consumer electronics companies. It was a fight for the future of entertainment revenue, so there was an enormous amount of money at stake for entertainment companies. Sony released the PlayStation 3, containing a Blu-ray player in every unit. Microsoft released the HD-DVD drive for the XBox 360 as an add-on. Most weeks saw a new major motion picture from each faction trying to sway sales one way or the other. Many high-dollar deals were made. Both formats were selling and were close enough that no winner could be easily called for more than a year, although Blu-ray was pulling ever so slightly ahead.

The tipping point came when Warner Brothers, who had earlier pledged support for both formats, announced that it would drop HD-DVD support in favor of exclusive Blu-ray support. In the view of Warner Brothers, the format war was hurting the whole industry, and it had the marketing leverage to end it with one decision. Warner Brothers held some 30 percent of the movie titles that people wanted, so this announcement came as a death blow to the HD-DVD group. Shortly afterward, Toshiba conceded defeat and dropped the HD-DVD format.

If you were rooting for the HD-DVD camp, I offer my condolences. I was lucky enough to guess correctly, so the money I'd spent on Blu-ray movies was safe. Many bet on HD-DVD and were stuck with movies that would end up with no future.

Blu-Ray Compatibility

The Blu-ray medium was brought to market very differently from the DVD medium. Even before the first mass-produced Blu-ray movie went on sale, Sony had already released Blu-ray disc writers and media in both BD-R and BD-RE variants. The writers were cheap compared to early DVD writers. Developers could get writers and work with the format, and even with rewritable BD-RE discs.

The specifications for Blu-ray discs are tighter than the specifications for DVDs. There are fewer ambiguities, which should lead to better compatibility over time. Sony does not currently prevent the playback of Blu-ray movies on writable media. I suspect it has learned from the history of DVD and is not making similar tactical mistakes.

One nice thing about Blu-ray is that the baseline specifications are high enough to be impressive, and all Blu-ray players are required to support them. Blu-ray supports 720p and 1080p, and all players are required to play all of the format variants including different frame rates. Blu-ray does support some odd formats, like legacy DVD formats and 1440×1080 modes used for 4:3 aspect ratio content, but these formats won't be interesting to most. These details are not particularly useful for those creating slide shows. If you do have a reason to know all about the Blu-ray format, I suggest a quick Internet search for more information.

Another nice thing about Blu-ray is, with the exception of legacy formats, all pixels in Blu-ray formats are square. This means that handling video between computers and televisions is now uniform and easy to do.

Blu-ray discs can store a lot more than DVDs. A single layer Blu-ray disc stores 25GB of data while a dual layer Blu-ray disc stores 50GB. With this amount of storage, even a single layer Blu-ray disc can easily hold a couple of hours of high definition video.

> **Note**
>
> I am disappointed that Blu-ray did not include support for 1080p/60 (1920×1080 video at 60 frames per second) even though the PlayStation 3 is capable of playing it. However, I suspect that the technological requirements for requiring this one final format would have increased the cost of the baseline BD player by an unacceptable amount. I also suspect that a future version of Blu-ray will support this format. Once you've seen true 1080p/60 video, it is difficult to want anything less. The smooth motion at 60 frames per second is intoxicating. I also believe that when Blu-ray is extended to support 60 frames per second, motion picture studios will start producing feature films at 60 frames per second for the smoothness. 24 frames per second will be a thing of the past. However, this may be a decade or more away.

Blu-Ray on DVD

What happens if you write a Blu-ray formatted disc image to a standard writable DVD? The answer is that sometimes it works!

You can write Blu-ray video data onto a standard DVD if you're careful. On some players, results are quirky. Some players will play them and others won't. I have never found a player that I have exhaustively tested that cannot play a DVD with a Blu-ray image on it. I do know that some players are sensitive to the data rate, and only lower data rate Blu-ray streams will work when written to a DVD. If you can't get a DVD with a Blu-ray image to work, try lowering the bitrate to something below 10 megabits per second and try it again.

I sincerely hope the Blu-ray community makes an issue of supporting DVD media with Blu-ray-formatted video data. A lot of DVD writers out there could be used to make discs that would be compatible with the new players. With 4.7GB of data storage on a single DVD, there is plenty of space for consumer slide shows, which are usually only 3–10 minutes long. I believe this support would boost Blu-ray adoption, not stunt it.

Disc Packaging

The idea of giving someone a CD, DVD, or BD sounds easy at first, but most people underestimate the attention to detail necessary to work out all the details of packaging it. This section is for do-it-yourself packaging. If you are expecting high-volume disc replication, look into professional packaging with a high-volume disc replication company.

Packaging is similar to gift wrapping. Compare the overall process to giving a person a new tie as a gift. Handing someone a tie by itself would be awkward and just wouldn't feel finished. For gifts, we are all familiar with the idea of gift wrapping. Figure 12.8 gives a good contrast between no packaging and professional packaging. Which product looks worth more?

Basic packaging vs. professional packaging

Figure 12.8

Well-done packaging makes the same item look more attractive.

Choose packaging that is reasonably priced for your purposes. It should have enough space for additional messaging you may want to add. It should have a size and shape beneficial to the expected needs for shipping, use, and storage. It should be easy enough to deal with that you'll be able to effectively manage it through the process. Finally, it should yield results that look good enough for what you need.

Disc Labeling

The first thing to consider is how you'll mark the disc so anyone can know what it is. This can be as easy as writing on the disc with a Sharpie or as complex as having silk-screened blank discs custom manufactured. Figure 12.9 shows some common ways to label discs.

Various methods of labeling discs

| Labeled with pen | LightScribe | Ink-jet on white disc | Printed label | Silk-screened |

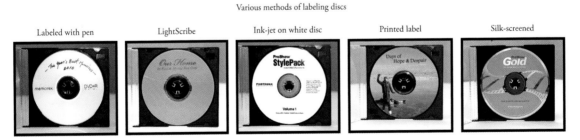

Figure 12.9

Discs labeled with a pen, printed with LightScribe, ink-jet printed on a white disc, a printed label, and silk screened.

The Sharpie

Chuckle all you like, but writing on a blank disc with a Sharpie marker works pretty darn well! Depending on what you're doing, it may not be the most professional thing to do, but it certainly solves the problem of labeling. If you have bad handwriting, this option can be damaging to your target audience's perception. On the other hand, if you are careful about your handwriting, this method works better than a lot of people might think. Your audience may care more about the video on the disc than whether your disc looks slick. They may even appreciate your not wasting resources on something that doesn't matter to them.

> **Note**
>
> Imagine spending 10 minutes to burn a DVD and then screwing up what you write on the CD. You find you've just wasted a disc and have to burn it over again. *Curses!*
>
> Instead, write on the disc before you burn. If you screw it up, at least you didn't waste the time burning the disc. Also, if you get distracted, you've already labeled the disc so you know what you were doing when you return.

If the messaging you must convey can be put into other parts of the disc packaging, consider spending the effort on different parts of the packaging and come up with a simple label to write on the disc with a Sharpie. If the only thing that is different about a given shipment is what you write on the disc, then everything else can be mass-produced with lower cost.

Depending on the situation, your target audience simply may not care if the disc itself looks any better than an off-the-shelf writable disc with some Sharpie writing on it.

Adhesive Disc Labels

I'll get right to the point: don't use adhesive disc labels. At first, labels seem like a cheap and easy way to go until you realize that there are three considerations that aren't immediately obvious. Figure 12.10 shows some common disc labels designed for ink-jet printers.

The first consideration is that a properly labeled disc needs to have the label affixed precisely so the label is centered. If it is not, the weight of the label can cause a poorly designed player to oscillate and vibrate in violent ways. This isn't common but is potentially severe. When a labeling tool is used to properly affix the labels to the disc, I have never witnessed this being a problem. Still, the weight of the label is a consideration, even if only theoretically.

Common ink-jet-printable adhesive labels

Figure 12.10

Commonly available disc labels designed for ink-jet printers.

The second consideration is that the adhesive holding the labels may not hold the label on as well as you might think. If the adhesive is heat sensitive, leaving the disc in a car on a warm day or in the sun may allow the label to lift off the surface of the disc. This isn't necessarily a common problem except that, once lifted, a label spinning very fast inside of a player can catch the air inside the player and become a *wing*—suddenly flying upward and sticking to something inside the drive mechanism. I have read stories about people who have had labels come partially unglued inside of a player and jam the player up so badly it needed to be disassembled to get the disc out. To be fair, I've also overseen the production, shipment, and use of tens of thousands of labeled CDs and never once had this kind of problem with them. So, I'm not sure if this consideration is more of an urban myth than reality. That being said, the labels I was using were custom made for what they were being used for, and the adhesive was chosen to prevent lifting even at high temperatures. Most people buy standardized labels and therefore have little control over the adhesive.

The third and last consideration should be all you need to know about labels and should firmly convince you that using labels is just not worth considering. Ink-jet printing on a label costs the same amount as printing on a white disc, because either way you're printing the same artwork. To make this even more pronounced, the ink is far more of the cost than a label or a white disc. The printing has the same surface area and consumes the same amount of ink. Color ink-jet printing costs around 10–20 times as much as a label for each disc. When you print directly on a white disc, you have no vibration problems and no cost for the label. So the only difference is the cost of the label compared to the cost difference between white discs and silver discs.

A potentially novel solution to the cost of ink is acquiring color laser printer–compatible labels. This is trickier and harder to come by than it seems because nearly all CD labels use paper designed for ink-jet printing. Laser toner doesn't stick to ink-jet paper properly. Even if you go to all the effort and cost of having

custom labels manufactured with glossy paper designed for laser printing—*and I have*—one hard learned issue still arises: laser printer toner tends to flake off over time due to temperature and humidity fluctuations. This is a potentially serious problem that isn't apparent for months or years later. After any wear at all, laser-printed discs will look worse than ink-jet-printed discs. Also, you don't want the potential of distributing flakes of printer toner inside your customers' players. I heartily recommend against laser printing on disc labels.

The cost of a label compared to the increased cost of white discs is trivial compared to the overall cost of the disc and the printing. The hassle and risks of labels aren't worth the savings, and ink-jet printed white discs look more professional.

White Ink-Jet Printable Discs

Ink-jet printable white discs are a much better solution than hand-writing or sticking labels on discs. The ink-jet ink costs around the same amount as the disc itself, so keep in mind that you're doubling the cost of the disc by printing to it.

You'll need an ink-jet printer that supports printing on white discs. These printers are common and affordable. Figure 12.11 shows a white disc being printed.

Figure 12.11
A white disc being printed in an ink-jet printer.

You'll need to become familiar with the software to print on these discs, so experiment and print some disc images until you develop a routine you can repeat.

LightScribe Discs

Hewlett-Packard developed an interesting technology called LightScribe. The LightScribe technology uses a writing head on the opposite side of the disc to heat up the surface of the LightScribe disc, darkening the surface of the disc. You must use special, thermally sensitive LightScribe discs for this to work. LightScribe discs are more expensive than white discs, but the process of printing is cheaper overall than ink-jet printing, so the cost of a printed LightScribe disc is significantly cheaper.

The whole process of printing a LightScribe disc takes a few minutes, but the results are satisfactory if you can accept a single color for printing. Figure 12.12 shows a LightScribe disc before and after printing.

Figure 12.12

LightScribe disc before and after printing.

To use LightScribe discs, you need a CD, DVD, or Blu-ray writer that supports printing LightScribe discs. These writers are relatively easy to find and are not much more expensive than non-LightScribe writers. The cost of the writer shouldn't be a major deciding factor unless you already have a non-LightScribe writer.

One advantage of the LightScribe process is that you can write the disc data and print it in one operation, which may make your manufacturing process more reliable or lock-step.

Silk-Screened Writable Discs

If you're going to be producing a lot of similar discs and the information on each disc doesn't need to change or only needs to change with one piece of information that can be handwritten, consider having custom silk-screened discs produced. In volumes of 500 or more, you can have 1-color, 2-color, or full color artwork screened onto them affordably. Because this is a commercial order in volume, the cost may even be cheaper than the cost of silver discs bought in a retail store. Be prepared to spend some time finding and working with a good manufacturer. Figure 12.13 shows a couple CD-R discs that have been professionally silk-screened for quick, low-volume production.

Many disc replication companies have the equipment to do this and may not even advertise the service because it isn't a mainstay of their business. They have the equipment to accomplish the task because the main part of their business is mass replication of stamped discs, which also need to be silk-screened. The silk-screening process is often the same regardless of whether the discs being screened are stamped or blanks. This may be an easy way a company can get an order from you that it otherwise would not have gotten.

Figure 12.13

CD-R discs that have been silk-screened for quick, low-volume production.

Make sure you know what kind of media a company uses for your order, and get it to use Taiyo Yuden media if possible. Sometimes you can even order the discs yourself and have them shipped to the replicator as part of the deal.

If you do have information that needs to change on each disc, like an order number or customer number, just leave room in your artwork and write it on each disc with a Sharpie. I suggest leaving a blank area in the artwork so you'll be writing directly to the surface of the disc instead of writing on the ink. Make sure whoever does the writing has decent handwriting, or the resulting disc will look unprofessional.

Slip Covers

By far the cheapest way to package discs is using slip covers. These are simply paper or plastic envelopes that may or may not have a circular cellophane window in them to see the disc through. Regardless of whether there is a window, it is best to label the disc itself rather than labeling the slip cover and not the disc. If the disc ever gets separated from the slip cover, the label on the slip cover won't help. Figure 12.14 shows windowed and nonwindowed slip covers.

Figure 12.14

Slip covers come both with and without a cellophane window.

Even though they're a tad more expensive, I recommend using slip covers with a cellophane window in them. You can easily see most of the DVD this way, so your slip-cover doesn't necessarily need art on it.

You can also have slip covers printed by various manufacturers if you want a more polished look. In my opinion, this is more costly than it is worth; it is a better bet to go with some other form of packaging if you're going to incur the printing cost of a custom-printed slip case.

Jewel Cases

Most are familiar with CD jewel cases, as shown in Figure 12.15. These hard plastic cases are made out of polystyrene, which cracks and breaks easily. It is possible and somewhat easy to add printed material to the inside front of a jewel case if the paper is cut to the right size. Optionally, you can put artwork in the back of each jewel case if you pry the middle and back pieces apart, but this takes practice to get good at, and the whole process to me is painful for what you get.

Figure 12.15

Standard jewel cases are compatible with all CD-sized media.

I strongly recommend buying jewel cases in quantities of 100 or more from an online supplier; you can get them a lot cheaper than anything you'll find in a retail store.

I prefer DVD packaging to jewel cases. For me, a jewel case is effective, but it somehow seems dated and cheapens the result. This is only my opinion, so if jewel cases are a perfect fit for your application, don't let my bias get in your way.

DVD Packaging

DVD packaging was designed with all the knowledge and experience the industry gained from CD jewel cases. The DVD case design is elegant, slightly larger than jewel cases, and easier to work with. The evidence of how good the DVD case design is can be seen in Blu-ray packaging, which is functionally identical. If there were a good way to improve it, the Blu-ray folks would have done it.

DVD cases are made from one main piece of plastic with a clear piece of plastic fused to it that creates something of a window for a cover artwork insert, as shown in Figure 12.16. The window holds an optional piece of paper. When the case is

opened all the way, the window is easily separated from the body of the case enough that the paper can be inserted or removed quickly and easily. During normal use, the paper stays exactly where it should. This makes working with DVD cases extremely easy and convenient. Try removing the paper from a DVD movie, and you'll see just how brilliant the design is.

Figure 12.16

The window insert design of DVD media is easy and remarkably functional.

The size of the paper insert is slightly smaller than standard paper sizes, so expect to trim your printed artwork. I recommend using a straight cutter so you don't have crooked edges. Crooked edges are highly noticeable, so if you're trying to be professional, spend the extra $20 and buy a straight cutter. If you're really motivated, look into cutters with circular cutting edges. They are far more precise than the cheaper arm-based edge cutters. It is also more difficult to cut yourself with a circular wheel cutter.

DVD cases are so common that you can get them in quantities of 100 for not all that much more than jewel cases. I strongly recommend buying DVD cases in quantities of 100 or more from an online supplier because you can get them a lot cheaper than anything you'll find in a retail store. See Figure 12.17.

A box of DVD cases in volume

Figure 12.17

You can find DVD cases in volume packaging and even in some retail locations.

Online resellers also sell DVD cases that are designed with mountings for multiple discs in one package.

Blu-Ray Packaging

The main reason I mention Blu-ray packaging is because Blu-ray cases are slightly smaller than DVD cases but function the same way. Using a format that is associated with a newer technology might help you differentiate yourself from the form factor of a DVD, even if that's what you're delivering. Blu-ray packaging is shown in Figure 12.18.

Blu-ray cases are slightly smaller than DVD cases but otherwise function the same.

Figure 12.18

Blu-ray packaging functions identically to DVD packaging but is slightly smaller.

Blu-ray packaging is still a bit more expensive than DVD packaging, but I expect as Blu-ray becomes more popular, the prices will drop. The same pricing difference and price drops happen with every new format.

Professional Packaging

If you've never researched custom disc packaging solutions before, you're in for a treat. There is an entire industry supplying special-purpose disc manufacturers with high-quality solutions for delivering discs. These aren't just jewel cases or DVD cases. The solutions range from cheap to expensive and include leather bindings, multiple places for photograph inserts, and even integration with other gadgets like pen holders, clocks, and calculators.

By doing a Google search for *dvd custom photo album*, you will find hundreds of suppliers offering all sorts of cases made of everything from leather to wood to metal. Vary your search terms to fine-tune your search. It may take a little time to find exactly what you're looking for, but if you want something high quality that separates you from the rest, the time will be well spent.

Many professional suppliers of custom albums do not list prices on their websites. I agree with this practice in this market because of the typical Internet sales behavior that happens when price becomes the only thing customers are looking at. Often, price competition becomes the main thing that customers look at, and they get inferior products and service as a result. If a supplier has a good-looking site and you want pricing information, take the time to call or write to get more

information. The prices for disc albums and other disc-related products are usually reasonable. Get samples of different products before settling on one. What you actually end up with in your hand might be quite a bit different from what you thought you were looking at on a web page.

If you want to see a wide range of products in person before you commit, I strongly suggest spending the time and effort attending an industry trade show where suppliers of this type will be displaying their products. These vendors are successful at photography trade shows, so that's where to find them. The two best photography industry trade shows in the United States are ImagingUSA and WPPI. You can find more information about the ImagingUSA trade show, sponsored by the Professional Photographers Association (PPA), at www.imagingusa.org. You can find more information about the WPPI (Wedding and Portrait Professional International) show at www.wppionline.com.

If you are interested in a supplier's products, ask the supplier what shows it will be attending so you can see its products in person. Ask if the supplier has a printed catalog it can send you. Most reputable suppliers attend local trade shows and have printed product catalogs that often give you a much better idea of what you're getting than what you can see online.

GP Albums is a supplier I've worked with before. It has been serving professional photographers for more than 50 years, helping them deliver custom photo albums. An example of custom products offered by GP Albums for disc delivery is shown in Figure 12.19. The company offers a range of disc packaging solutions and can be reached here:

GP Albums
4045 North Rockwell Street
Chicago, IL 60618-3797
+1 (800) 888-1934
www.gpalbums.com

Some professional packaging solutions from GP Albums

Figure 12.19

Example of custom disc packaging from GP Albums.

Professionally Manufactured Discs

Any time you need to deliver large numbers of shows in a physical form, consider professional replication and packaging. Quality control and cost both improve with larger numbers. An example of spindles of mass-produced discs is shown in Figure 12.20.

Figure 12.20

High-volume disc replication is cheap when you need thousands of identical units.

I wouldn't consider professional replication for fewer than 100 or even 500 discs because most of the cost of professional replication is in the one-time mastering process instead of the cost of each unit. Don't be surprised if you are quoted a mastering price charged separately from a per-unit price. The pricing for most professional disc replicators starts getting reasonable at volumes of 500 units or more. As you approach tens of thousands, the prices approach the physical cost of the materials the replicator uses—this is probably less than your cost would be even if you bought the raw materials yourself.

With standard packaging, the pricing for the packaging and the labor to insert standard artwork will be lower than anything you could do yourself unless you don't count the cost of your own time to do it.

Of course, if you start requiring extras or nonstandard packaging, the cost will go up quickly. Anything the replicators aren't used to doing in high volume will cost a premium.

One helpful service that some replicators offer is graphic design. At the very least, they should have a person in house who understands their exact requirements and can fix up artwork for your disc and packaging so it fits the specs of what they need. Many replicators have graphics artists they can use to create custom artwork. This kind of service is usually billed on an hourly basis costing anywhere from $30 per hour and more—often much more. Good artwork is rarely cheap. Figure 12.21 shows some artwork for a professionally produced disc. Unless you're used to creating production artwork, you will need someone to help you.

An example of a professional disc label design

Figure 12.21

Unless you are used to creating production artwork for packaging, you'll need some help.

Don't just call one replicator and go with that company. Call several and take notes. Call back if you have more questions as you get a better sense of what you need. Spend a few hours to research your options before you decide to go with one of them, because you'll end up spending hours going back and forth with them before the job is complete. Choosing the right replicator can save you hours and headaches down the road. You especially need to find a replicator you feel comfortable with, who understands what you need, and that you feel will work well with you.

Video Files

Sometimes you need to deliver a slide show to someone else in a video format. In the following section, "The Internet and Web Shows," Facebook, YouTube, and Vimeo are discussed as websites that support the storage and playback of video files. Even though these websites are supported directly by ProShow and you don't need to know exactly how they work to use them, behind the scenes, ProShow is merely encoding a video file and uploading it to their servers for you.

I'm going to run through some of the background explanation of exactly what video is to explain some fundamentals. If you're not familiar with exactly what video is, please try to digest as much as you can so you can understand my point near the end of the section.

A *video file* is a formatted stream of video and almost always audio. Video data is a set of encoded still images, usually encoded cleverly to eliminate enormous amounts of redundant information that the video player reconstructs. For example, DVD video files use about 2/3 of the data in the compressed video stream for around 1/18 of the still images. The rest of the still images—most of the actual video you see—is reconstructed by the player in clever ways that I won't explain in detail.

Suffice it to say that modern video encoding is mind-bogglingly complex. Even most expert videographers aren't aware of the complexity in the actual video encoding process.

Audio and video data streams are shuffled together to create the video file. This shuffling is called *multiplexing*, which has many different forms. DVD uses one form of it. A slightly different type of multiplexing is used in Blu-ray discs. Older formats of MPEG 1 video use simpler forms of multiplexing. For example, just because you have an MPEG 2 file doesn't mean every MPEG 2 decoder will be able to play it. The decoder has to be able not only to support the variation of MPEG 2 in your video stream contained in the file, but to support the multiplexing scheme used to interleave the video and audio data.

The audio in a video file also has its own data format, which can vary greatly. There are many audio compression schemes. Compressed audio in a video file is similar in concept to an MP3 file, although the format of the audio data is usually different.

Video has one huge problem when it comes to slide shows: quality. Video files depend on fantastically clever compression algorithms to convert a series of arbitrary still images into a stream of highly compressed data. To do this, they use sophisticated motion algorithms to find redundant information that can be used at different times and in different spaces to reconstruct the original. Because finding exact matches doesn't happen often enough to make it useful, the video formats allow a certain amount of *error*, which results in lower quality. The more you compress a video file, the more quality will be lost.

It is possible to encode video at such a high data rate that a human cannot see the quality loss produced when encoding the file. This is similar to how a high-quality setting for a *.JPEG file can produce an image that no one could detect as a compressed image. However, even with *.JPEG images, when the compression is set at such a high quality, the resulting file size is large.

Raw video data, or uncompressed video data, is enormous. For example, a 1080p image contains 2 million pixels—6 million bytes of useful image data. At 24 frames per second, a raw video data stream will therefore consume 144 megabytes of data per second. Remember that this example contains no audio, which is extra. Blu-ray discs usually use a bitrate of about 18 megabits per second, which is about 2.25 megabytes per second. That's a ratio of 64:1. Almost all the video data is being reconstructed cleverly, which understandably results in quality loss.

The problem of quality becomes noticeable with Internet data rates. For practical purposes, there are few Internet users who have Internet capabilities to receive anything even close to that kind of bandwidth. So instead, lower-resolution video is used, as is video at extremely high compression ratios. The results are blocky video and video that has slower frame rates.

In regards to choosing a video file format, it simply depends on what you need the video file for and what is available to decode the file. Whoever is requiring the video file should be able to tell you what you need. I won't explain the technicalities of various video formats because it is well beyond the scope of this book.

The Internet and Web Shows

Delivering shows on the Internet is a subject that could have an entire book written about it due to the vast possibilities of every possible way a show could be delivered online. Many of the more complex issues that can be a factor for show distribution aren't covered here because they are far beyond the extent of this book. I do not discuss possibilities for creating show presentation mechanisms with web standards like Java or JavaScript. Although it is possible to present shows this way, if you know enough to understand them, you're a specific type of web developer and you already know how to find information about them.

Instead, this section focuses on the common ways that typical consumers can deliver shows and the pros and cons of each delivery tactic.

If you are interested in using video files with the Internet, make sure you've read the previous section, "Video Files," before you continue.

Photodex Show Sharing

Perhaps the best bang for the buck in show delivery is had by using the free show sharing on the Photodex website. This is built in to ProShow and requires the use of the Photodex Presenter software for viewing.

Presenter provides the best quality and the smallest data size of any other Internet delivery mechanism for slide shows. Preparing the show for uploading happens faster than any other format, and uploading is faster. When your audience goes to the URL to view your show, they will spend little time waiting for the show to download and will have a great show experience.

Photodex *.PX Format

Photodex Presenter displays slide shows that have been stored in the *.PX file format. *.PX files are used with the free show sharing offered by the Photodex website. Figure 12.22 shows a file stored in the *.PX file format.

You can output your show in the *.PX file format and play these files on your machine using the Photodex Presenter, which is called pxplay.exe. All the plug-ins for the web browsers are based on pxplay.exe, but with code specific to each browser that provides the interface for the web browser.

Figure 12.22

*.PX file stored on the hard disk. Double-click these files to view them with Presenter.

Once the Photodex Presenter has been installed on a machine, you can double-click on any *.PX file in Windows Explorer to view the file. This kind of playback is exactly the same as if an executable show had been created, except the player (pxplay.exe) is not included with the show stream. Executable files are actually just a combination of a special version of pxplay.exe and a *.PX file stream, all balled up into one executable file.

Follow the instructions in ProShow's documentation and user interface for including the HTML code into a web page to facilitate proper playback. These standards can change over time, and documenting the process here would be redundant and potentially wrong in the future. Figure 12.23 shows a ProShow Presenter show playing in a web page.

Figure 12.23

A *.PX file being played by ProShow Presenter in a web page.

Facebook, YouTube, and Vimeo

In recent years, new types of websites have emerged and become popular. These new sites support the storage and playback of video files uploaded by users. Most of the sites that are successful support free accounts or have generous limits before they require you to pay for the service. YouTube, for example, is trying to sustain its business through the display of advertising to avoid having to charge users for the bandwidth and storage their videos cause.

Facebook is an incredibly popular social networking site that also added support for video playback. YouTube and Vimeo are video-sharing sites that are adding more social networking services to their primary purpose of video sharing. Figure 12.24 shows each of these sites as they look as of the writing of this book.

Figure 12.24

Facebook, YouTube, and Vimeo websites.

ProShow supports uploading directly to these services. Behind the scenes, ProShow has been preconfigured to render video into a known compatible format and upload to these services directly. This way, you do not need to know anything about the technicalities of the site to use them. With your account information, ProShow will do all of the dirty work for you.

These sites are an excellent way to deliver video shows on the Internet. The only caveat is that, because these sites use video to deliver the shows, the size of the data will always be bigger and require a faster Internet connection from your audience, and the quality will always be lower than the Photodex Presenter plug-in.

Flash Video Output

ProShow supports outputting to a video format, which is compatible with Adobe's Flash plug-in. Flash is compatible with most Internet browsers in use. The disadvantages compared to Photodex Presenter are the same as every Internet video solution: the size of the data is larger, and the quality is poor. Because the data is larger, it requires a higher speed connection to view the video without the experience becoming untenable.

On the other hand, if you don't need high quality or the size of your show playback can be small, many people already have the Flash plug-in. Flash requires a specialized plug-in just like Photodex's *.PX format, but most people already have this plug-in installed. Just remember that this is a streaming video, so you won't get high quality or low data size. Figure 12.25 shows a Flash show playing in a web page.

Figure 12.25

A Flash video playing in a web page.

Although it is extremely common, Adobe's Flash plug-in is wrongly assumed to be present and functional on every computer. The Flash plug-in is conceptually similar in function to Photodex's Presenter, but it's much simpler in design. The operative practical difference here is that Flash has gained massive market penetration, and most people already understand and trust it.

Flash video support uses two files: an *.SWF file that the Flash player looks at to get the location of the video data and an *.FLV file with the video data in it. Follow the instructions in ProShow's documentation and user interface for including the HTML code into a web page to facilitate proper playback. These standards can change over time, so refer to the documentation for the version of ProShow you are using.

Live Shows

If you intend to display a slide show to a live audience, be prepared. On the Internet, if something goes wrong, you can fix it before others get to the site. In person, you often are stuck in a situation where fixing a simple problem isn't practical because it would take too much time. I've presented live many times before, as shown in Figure 12.26, and I can assure you that being prepared is far easier than the alternative.

Figure 12.26

This is me giving a live presentation. Being prepared is easier than the alternative.

The most important tip I can think of is to find out as much as you can about the technicalities of the presentation situation. Will you be using a projector? If so, is it your projector? What kinds of video inputs does it have? Do you have cables or a converter that makes the computer compatible with it? What kinds of audio outputs do you have on your computer? Is there a sound system? What kinds of audio inputs does the sound system require?

I've seen so many stories about people assuming that just bringing their laptop to a meeting would be enough, only to find out that they were missing a cable for video or audio. This kind of simple oversight will most likely destroy your ability to deliver your show.

Another problem happens when using someone else's computer. Use your own computer if you can, and practice with it before you go just to make sure your computer is capable of it. Laptop and especially netbook computers are much slower than desktop computers, and their hard drives are usually many times slower than desktop computers. Don't blindly copy a show file onto your netbook computer and expect it to work when you get there. Practice first to see if you'll have a problem later.

If you have to use someone else's computer, make sure the computer has enough CPU speed and hard drive speed to play back the show in question. If you have any concerns at all, bring a video file as a backup in case the *.PX file or *.EXE file won't play back smoothly. Remember: video files are rendered and encoded

when you create them, so they require less CPU power and system synchronization to play back properly. I recommend using these only as a backup for your presentation should something go wrong, because they're lower quality than the *.PX and *.EXE files.

A safe fallback strategy for a live presentation is to take a DVD of your show as a backup in case all else fails. I know people who take a DVD player and the appropriate cables with them in case the venue doesn't have them. You can buy DVD players for less than $50 these days. You can even plug a DVD player into a television if you cannot get the projector working. When technology fails, the best solution is often low-tech. If you can't even get a standard DVD to play at a venue, just remember that at least you did everything you could.

Arrive at the location, set everything up, and play the entire show before the event begins. This is the only way you'll be able to see what the show will look like before it is time to play it. Plug in the audio and play it to make sure it works. Taking the time to practice this kind of live presentation before the event can save you a lot of embarrassing stress if something doesn't work and you have a room full of people waiting for you to make the show work properly.

Review

Whether you deliver your shows in person or remotely, using PC Playback or video streams, via the Internet or on a disc, there are pros and cons to all combinations. None of the distribution methods solves all problems, but some combinations are excellent for certain needs.

Regardless of your choice on how to deliver your show, the final step should be thought through completely. This is the step that the audience sees, and your choices can reflect on you well or badly. Even with the best show ever made, a poor delivery tarnishes the experience.

You've done your research and you're ready to create and deliver a great show to your audience. I hope I've helped you, and I hope that you find slide shows as rewarding as I do.

Guest Experts and Their Insights

We reached out to a diverse group of ProShow users and asked them to share their top tips about how they use the software. Each one was asked to provide us with best practices for creating slide shows—anything from the editing process to selecting the perfect soundtrack. The following pages give you real-world insight from 10 experts. You'll hear from professional photographers, avid ProShow instructors, and casual users creating slide shows for fun.

Kelli Etheridge

www.etheridgephotographic.com

Kelli Etheridge is a professional family portrait photographer in Lantzville, BC, Canada.

Great slide shows begin before the photographer picks up the camera. Having a clear idea about your slide show from the beginning will give it a more professional and artistic look.

Photographing for a slide show is vastly different from photographing for a single image, requiring you to employ different strategies when creating images. When capturing a single image for printing, you are trying to encapsulate the entire story within that one photograph. When photographing for a slide show, you need to consider the timeline of the story and photograph in a collective way to convey the message.

It is helpful to create a storyline for your slide show before photographing, because that will help you determine which images you will need and give your imagery direction. Consider music options in advance as well to establish the mood of your show and help you photograph to convey this mood.

Use some of the following ideas while photographing to bring your slide show to the next level:

- **Image orientation**—Before digital slide shows, most of my images were vertically oriented; now that slide shows are a common use of my images, I photograph most often with a horizontal orientation so that I can fill the frame in my slide show. I find it more visually appealing to eliminate the empty black spaces. For maximum versatility, I shoot both vertical and horizontal images.

- **Shoot for titles**—Photograph with empty space for text in your slide show. Images with negative space or simple backgrounds work well for captions. Always make sure your text is easy to read on top of the image. Photograph signs that can be used as a title (or information from them can be used within your presentation). Also, consider possible end slides while shooting, as well as self-portraits for credit slides.

- **Background images**—Blurred images or simple textures work well for backgrounds with either text or images on top of them. I have created a folder in my computer for background images so that I always have an image with which I can personalize my slide show.

- **Sequences**—Photograph a rapid succession of images of moving subjects. It is important to use a tripod to ensure there is a well-focused and consistent visual anchor throughout the sequence. Place them together in your slide show with a short duration and a simple crossfade for a movie-like effect. Examples are people running toward the camera, jumping, moving clouds, and water.

- **Selective focus**—This is a simple, but effective technique. Using a tripod, take two or more images with a different part of the subject in focus. This works especially well with macro photographs. Try a long crossfade between images, and you will feel as if you are moving into the subject as the focal point shifts.

- **Details**—Photograph the details of your subject, because they will help tell the story. Although each of these images on its own may not encapsulate your subject, each has contextual relevance within the slide show narrative. And be sure to photograph from different angles for variety.

- **Sound effects**—Record sounds with a digital audio recorder from the environment in which you are photographing for inclusion in your show. Use an external microphone to ensure good sound quality. Sounds can range from ocean waves, rain, and crowd noise to a baby laughing.

Jennifer Clark

www.choicebackgrounds.com

Jennifer is the owner and founder of choicebackgrounds.com, a company that sells video backgrounds, show templates, and slide styles for ProShow products.

There will always be some debate in the slide show world regarding when and how to add music to your shows. Which comes first: the music or the photos? Obviously, ProShow is a *photo* slide show program, so your inclination may be to say that the photos should come first. I agree—*outside* the program, but not inside.

In other words, your photos should come before you even open ProShow. Pick the ones you're going to use, edit the ones that need editing, and get them in the general order you'd like to see them appear in your show.

Once you're *inside* ProShow, always start with your music. Why? Because although your photos may be telling your story, it's your *music* that sets the tone and feel for the entire show. If you have football photos, you're not going to set them to a slow classical song, are you? Of course not. You want something fast and action driven. So, why can't you pick an appropriate song and drop it in after you've animated your photos? Because you don't want your audience to just see your video. And you don't want them to just hear it. You want them to *feel* it.

If you drop your music in before you add your photos, you can sit back and listen to the song with your eyes closed and visualize what you might see with each phrase, crescendo, or cymbal crash in the song. Your song should actually tell you *how* to animate your photos. To completely draw your audience into your final show, you have to bring together their senses of sight and sound as though they are dancing together. If you treat your photos as one element to be animated and your music as something to just drop underneath and make it fit, your audience will find your final video disjointed to watch.

Photos and music were meant to love one another. Don't forget to marry them.

Barbara Coultry

www.theframelocker.com

Barbara Coultry has had dual careers in art and writing, but her favorite is being the owner of The Frame Locker.

Captions have two equally important characteristics: meaning and design. Ignore one in favor of the other, and a caption may fail. In view of this, here are some considerations:

- Before you read a caption, you see it. Treating it as an image helps you choose its size, shape, placement, and color so it becomes an integral part of a slide's composition.

- Fancy fonts are fun, but not when they're difficult to read. You know what the caption says, but your audience doesn't.

- A caption is there to be read, but if the audience squints at it, they may not read it at all. The words need not leap off the screen, but there should be enough contrast for the eye to be drawn to them.

- Fonts can describe the theme. A fancy script is formal like a wedding; a hand-printed font is casual like the family pet. When choosing a font, ask yourself what each one reminds you of. Strength? Femininity? Lightheartedness? Does the font have a modern feel, or is it more old-fashioned? Typography is a study in itself, but this doesn't mean you can't "feel" a font.

- Larger blocks of text such as poems are more easily read when you use serif fonts. Short captions and titles usually work best in sans serif.

- A caption's color should fit in with the show's color scheme. The caption doesn't have to be one of the specific colors, but it should blend well with them. For instance, if the show's color scheme is made up of pastels, a deeper shade of one of the pastels will blend far better than a stark black.

- If a series of slides has captions, place them in the same position in each slide. It's disruptive if the audience must hunt for the caption each time a slide changes.

- When using motion, and unless a caption is merely a word or two, pause it long enough for comfortable reading.

- There are various ways to figure out how long a caption should remain on the screen. Here's yet another: figure a half-second per word.

- Are you a font collector? To ease the pain of finding the right font in Windows, consider investing in a font management program. It will save time and sanity.

Leslie Gray

www.Photodex.com

As the head of the Creative team at Photodex, Leslie is involved in the design and production of ProShow demo presentations, built-in/add-on effects, and marketing collateral.

Working at a company that specializes in slide show tools, and using those same tools to sell more of them, has helped me relate easily with professionals who use ProShow—especially those who use slide shows to *sell* something. On the other hand, I have made plenty of personal slide shows, to the extent that sometimes I feel kind of like 'that guy everyone knows with the truck,' except the thing on loan here is my slide show–making skill, not my hauling capacity. Because you're reading this book, I'm assuming you've probably been there, too. Having created slide shows from both perspectives (commercial and personal), I've found that my approach to the design and construction of slide shows is unique to each type, depending on the purpose of the show. Because "slide shows as commercial presentations" is a use that's often underrepresented, I'll share a few of my own practices:

- **Never start without writing a creative brief/outline**—Even a seemingly simple 30-second video requires a plan, and the longer the commercial, the more opportunity for it to unravel into an epic, boring, confusing mess. Your outline should not be long or wordy. However, it should account for all the critical things your commercial must communicate, and it must dictate the order in which you convey these points. Why is this so important? Because it's too hard to see the big picture when you're deeply immersed in the small-picture details of building any given slide in your show. The outline keeps you on track. Also, don't script out every word or graphical concept in advance; it's good to leave some room for serendipitous discoveries along the way. With that said, there is a big difference between leaving room for spontaneity and lacking a general plan.

- **Watch the clock, and adjust as you go**—Establish an ideal length for your commercial once you've written your outline. Then budget time per section or per message so you can realistically hit your goal and not run over. Because you're making a commercial, you don't have the luxury of an endless attention span like you would if your audience was watching their personal photos. Also, your commercial's length might be limited by media-related factors. The goal is to be as concise as possible while still being effective. As you build your show, you'll quickly get a feel for how long each message requires for full comprehension. Regularly check the time as you build.

If everything is requiring more run-time than you budgeted, you'll need to either extend your final video length, or more likely, further edit the content. There's always something you can cut, even when you don't think there is. I'm always amazed by how many rounds of simplification and refinement my original content typically distills down to when time and space become limited.

- **Use repetition to improve comprehension**—Unlike personal shows and conversations, in commercials, it's good to repeat key words and phrases multiple times to ensure they stick. In fact, your audience will be appreciative of this, because it makes their job easier in terms of interpreting the value of your video. Repetition is especially important when the information you are conveying is complex. Now, keep in mind that repetition in a slide show is best executed when you introduce variations on the delivery. For instance, try to rephrase the sentence when you're repeating. Or, if it's just a single word you want to emphasize, make a duplicate of the word, but make it visually contrast from everything else around it so it stands out. Exact repetition is annoying in most cases and should be avoided. Try envisioning your commercial as a book the audience is quickly skimming. To help them skim effectively, pick the words and phrases you'd want them to read and remember above all else. Then repeat and emphasize those items in your video.

- **Never present more than one sentence at a time**—Even if you give the audience 20 seconds to read two normal-length sentences that appear at the same time, it will always be preferable to read the first sentence alone for several seconds and then have the second sentence appear. The lesson? If someone is going to feed you, wouldn't you prefer it if the food was already cut in bite-sized portions versus one whole unwieldy piece? Make your content as manageable (and as digestible) as possible.

- **Sometimes it's good to lean on effects; sometimes it's not**—Here's when it's okay to hide behind an array of flashy effects: 1) if you're stuck making a commercial with photos/video clips that are, unfortunately, not high quality (for example, slightly blurry images, low-res images, amateur photos), or 2) the item that is being promoted or the photos that are being used have little inherent appeal despite good photography. (Keep in mind, though—you could have a ton of great photos of a specialized piece of machinery that may not be interesting to you but could be very useful to a person who is familiar with that type of product. Don't forget the audience here.) At any rate, for such unfortunate cases in which the product doesn't easily sell itself by nature or via the quality of promotional assets, you'll need all the help you can get to inject the necessary drama and verve into your show. No problem. Use all the effects you need—judiciously selected, of course.

However, perhaps the thing you are selling is already exciting in nature. Let's say you are promoting an ice cream shop, and you are lucky enough to have tons of amazing, professionally shot images of ice cream waiting for you to show off. The appropriate thing to do is to let the appeal of the product photos do most of the talking. Although it wouldn't hurt to have a few impressive effects to kick off or end the commercial, avoid using quick, flashy effects and frenetic, jumpy motion. Instead, let the photos of the ice cream draw the viewer in. Focus on deep, long zooms to mimic the experience of savoring each decadent bite. Let the content dictate your approach to the effects you use, and you'll never compromise its own natural ability to sell.

Roberta Przybylski

www.austincomputer.org

Roberta Przybylski is the director and digital darkroom instructor for the nonprofit Austin Computer Learning Center. She is a creative digital storyteller, specializing in photography applications, with an emphasis on legacy projects. When introduced to Photodex for creating multimedia slide shows, she immediately knew it would capture the students' stories.

Our computer lab has been on the forefront of helping other nonprofits in our community get their stories noticed for fund-raising awareness, better branding, or clients needing help to relive an episode of their lives. Storytelling is an encapsulated snippet of an event remembered. It is totally different from vacation travel shows.

Preplanning is vital to a cohesive story. Talk to your client, determine the purpose of the slide show, and look at the available 2D and 3D materials the client has. Planning the story is 70%; execution is 30%.

ProShow is effective in showcasing a child reciting a poem with graphics and reading her creative stories with her illustrations. Jog the memory of an Alzheimer's patient with favorite childhood songs, read a storybook by an absent parent or grandparent, or have the returning soldiers create a show for their armored unit as a way of remembering and healing. Our students' photo journals of events include foster girls' Quinceanera videos and church members' life stories while they still are part of the congregation. A video from a camcorder captures that moment in time, but combining digitized 3D artifacts, still photos, and video tells the whole story.

Here are a few tips for producing a successful emotion-packed story:

- Don't try to tell a whole life story in 5 minutes. Choose the one topic that best reflects the character of what you are trying to communicate. An example might be capturing returning Vietnam pilots' 100th flight mission. It meant they were finished bombing and probably would make it home.

- Episodes are better stories than chronologically based timelines.

- Keep captions to a minimum to avoid changing the flow of the show.

- The poorer quality photos need more movement, and the better photos need their own space. If you have a series of fast motion slides, a still slide will be emphasized automatically.

- Typically, a line of lyrics stops at 5 to 7 seconds. Time your transition to the pause.

- Don't overprocess the photos found in the shoebox. They display and tell the story better as is, with all the cracks and spots intact.

- Consider intergenerational storytelling, which brings a newer perspective to the story. In our Grandparents Multimedia Camp, a 90-plus-year-old relived her ice skating career in the Ice Capades for her granddaughter. Grandma tells her history on several slides along with the music of the 1940s, the story of costumes, and the Hollywood studio experience. It was an opportunity to see the "real" skates and glamour of her grandmother.

- Use headphones, a written script, and a bidirectional microphone along with recording software to capture the voice that might need amplification.

- Read the script in paragraphs, stopping to save each paragraph as a separate audio file. This means fewer do-overs or retakes. It gives you flexibility in timing the sounds on a slide.

- Insert your slide sound with a fade-in of 2 seconds if you want it to start on the slide and not in the transition. Insert a blank slide of .2 seconds after the slide with the sound to keep the voice levels consistent.

- Keep the stories short—less than 10 minutes.

- Include headlines of the day, a clip from an old radio show, or a look at the house then and now with current satellite mapping.

- End with a quote. It slows down the pace.

- Consider "outtakes" after the final slide. These might be funny family photos that didn't make the cut.

Noncommercial use of ProShow in the nonprofit arena has opened many doors to professional-quality products that are easy to create for all age levels.

Dale L. Fenimore

www.FenimorePhotoVideos.com/PSP

Dale is a nature and outdoor photographer who runs the company Fenimore's Photo Video Productions, where he sells training videos and slide styles for ProShow.

This is a basic introduction to setting zoom values in numbers that aren't whole.

Generally, ProShow only allows setting an image zoom (size) in whole numbers. What if you need to increase a layer's size by less than 1%? You can do this using one of two methods.

The first and simplest method is to directly enter the decimal zoom value into the zoom-x or zoom-y boxes. This works for both Producer and Gold. In each program, ProShow changes the entered decimal value to a rounded-up or rounded-down whole number. You can make zoom changes as small as 0.01%. The program uses a decimal value, although it appears to have rounded the entered value to a whole number. You just lose knowing the actual value. So, for instance, if the layer has a zoom of 40% and you need 40.75, put 40.75 into zoom-x and zoom-y. The values are rounded up to 41. What you get, however, is a nice way to give your layer a thin outline to an image's duplicate when the ProShow outline is too large. Change the layer's color, change the contrast, and make sure it's in a layer below the original layer to ensure you get a thin image outline. Although Producer users can use a gradient or solid color layer for this purpose, Gold users must use a copy of the original image layer. This little trick is a nice and easy way to give an image a thin outline.

The second and more involved technique involves using a constant modifier. It also requires ProShow Producer because Gold has no idea what a modifier is. As in the manually entered decimal zoom value case, zoom is changed in increments as small as 0.01%. This approach requires some simple math and will probably look worse than it really is for some of you. What is important is that it forms the basis of a more complex treatment of how ProShow handles a modifier-based zoom. Understanding this treatment is crucial to forming a fuller understanding of how ProShow handles zoom. That leads to a more effective use of modifier-based zooms for use when creating effects. That's a topic for another day.

A constant value modifier increases a layer's zoom by a percentage of the zoom box's value. That is, if zoom is 30 and a constant modifier of 1 is added, the layer's effective zoom is 30.30. (1% of 30 is 0.30.)

When you increase the value of any number by a percent, you're using the following relationship:

starting zoom plus (starting zoom × percent of increase) = ending zoom

Stating it mathematically, you get the following:

A + Ax = B (Eqn 1)

A is the starting zoom value. B is the ending zoom value. x is the decimal equivalent of a percent change from the starting zoom. (That is, x represents a number divided by 100.) In other words, you start with a zoom of 40 and want to increase it by 15% using a modifier. Plugging these numbers into the equation gives you 40 + (40 × 15/100) = 40 + 6. So, B (the ending zoom) is equal to 46.

Now that you know how that works, what if you want to find out what modifier value you need for a specific zoom value? You do that by rearranging equation 1. First, you add –A to each side of the equation:

(A + Ax) – A = B – A.

Because A minus A is 0, the resulting equation is Ax = B – A

Next, you divide each side by A to get Ax/A = (B – A)/A

Because any number divided by itself is 1, the resulting equation is this:

x = (B – A)/A (Eqn 2)

So, if you want a layer to increase your layer's zoom from 30 to 45 using a modifier, you plug these numbers into equation 2. You get the following: x = (45 – 30)/30 = 15/30 = 0.50.

Because x represents a number that's divided by 100, you need to multiply it by 100 to get a percent value. Modifiers represent percent values, so your modifier here is 0.50 × 100 = 50.

Say that your starting equation is x = (modifier/100) = (B – A)/A.

If you multiply both sides of your equation by 100, you get (modifier/100) ×100 = ((B – A)/A) × 100.

That reduces to this:

modifier = ((B – A)/A) × 100 (Eqn 2a)

"Why would anyone want to do this?" you ask. Well, it's a way to get thinner outlines around a layer than a ProShow outline can give you directly. It's also a technique you can use to automatically change the zoom of one layer and have it affect the zoom of all other associated layers (using modifiers). That is an advanced technique that's beyond the scope of this article. However, say the base zoom of your image is 30 and it fits your mask perfectly. You have multiple copies of the image (because that's what your effect requires). Then you decide to use the same effect with an image that has a different aspect than you designed the effect with. This new image requires an increase in image size from 30 to 45 before it fills the mask. If designed appropriately, this 15% increase can be automatically passed on to the other image copies rather than your having to change the zoom on multiple layers (and risk breaking something).

That's the basics of it! Have fun!

Jean-Pierre Druffin

http://couleurs.breizhbleu.com

Jean-Pierre lives in the western part of France and runs the audiovisual company JeeeP Prod. He also sells numerous products for ProShow users, including slide styles, training DVDs, and translated user guides.

Adding the moon as a new layer over a night shot demonstrates ProShow's ability to create realistic effects from scratch:

1. Import a night shot on the slide list.

2. Add a new gradient layer over the photo.

3. In the gradient editor, choose Masks as Presets and Plasma as Type.

 Choose a square resolution such as 720×720 or any other square ratio. A seed value of 148 gives a very realistic effect.

4. Now transform the square into a perfect circle in the Vignette function, choosing Ellipse instead of Round rectangle.

5. Zoom out the moon to get a perfect size according to the photo.

6. Add a more realistic effect by adjusting sharpness to 100% and white balance to 60%. These two parameters are up to you.

7. You can colorize the moon, because it may take specific colors in specific situations (yellowish, reddish, and so on).

8. Remember that this is a layer that you can move along.

9. Want a first quarter? No problem. Add a new vivid color layer. Select its color with the color picker in the sky near the moon to get the most accurate dark color. Choose a square resolution.

10. In the Vignette function, turn it to a circle with Ellipse Type.

11. Adjust its size to partially cover the moon to have a crescent shape.

Have fun with ProShow!

Stacey and Kelly Chance

www.discoverybaystudios.com

Stacey and Kelly Chance are husband and wife wedding photography specialists, serving the San Francisco East Bay and beyond.

ProShow is fantastic software for combining still images with video clips. In our wedding photography business, we have used ProShow extensively to create slide show/videos called photofusion videos.

Short video clips of just a few seconds can do wonders to spice up your average slide show montage. We generally like to intersperse the video clips every ten or so images. The spacing really depends on the music you use and the ratio of video clips to images you have.

ProShow allows you to use the "Ken Burns effect." ProShow can automatically pan and zoom each image for you, or you can custom-manage your own panning and zooming. We like to gradually pan and zoom to the subject within each image. This can be done with video clips as well. However, you must be careful not to zoom too much; otherwise, the video quality suffers.

Another great tool is keyframing. We use keyframing to make an image fade to white, black, or blur. These effects work well when you use them to convey a transition in time or mood. Again, this works best when synced with changes in music tempo. Of course, music choice is critical to convey proper overall mood.

In our wedding photography photofusion videos, we normally go for a smooth look, so we lean heavily on dissolve transitions. But ProShow offers a wide array of interesting and fun transitions to spice up any kind of video you would like to make.

Drew Cowan

www.drewcowan.com/

Drew is a photographer and avid traveler. He has spent the past five years traveling across the North American continent, photographing the entire journey along the way.

Every presentation is a story. The difference between a carnivalesque nightmare of images and a fluid, visual emotion has everything to do with the flow of the work. Before I even begin to create a presentation, I try to have a cohesive idea of what I want to accomplish. What kind of feelings do I want to convey through the subject, what sequence of images fits the mood of the presentation, and what is the best way to transition those photos to complete the story?

The feeling of the show is the most important element, but how do you get people to feel a certain way when they see your work? To start, select images that fit the theme of the presentation, and arrange them in an order that won't confuse the idea. Regardless of the style packs you use or the amazing transitional tricks you invent, taking all your images in random order and placing them in a show will lose the attention of your audience. Decide what images you want to be in the show, and then decide how each photo makes you feel. Then try to arrange the sequence of images to play off those feelings.

A simple trick is to ease into the presentation. Never begin a show with the best photos. It's like going to a movie and seeing the climax in the title credits. Think of it as a music album. The first song is always good, but it's rarely the best song on the album. Intersperse the most powerful images throughout the show, and try to avoid placing them one after the other.

Once you have the sequence you want, decide how you want to transition the show. An important component to this is music selection. Music, more than anything, sets the mood of the show, and it is important that the music fits the work. In other words, don't select your favorite pop song about relationship revenge for an engagement video. Transitioning to the selected music can be a powerful tool. Timing the transitions with specific changes in the music increases the impact of the presentation. There are several ways to accomplish this. The easiest way is to create the transitions you want and then go back to tweak slide timing to sync with the music. Another way is to specifically create transitions step by step to the music. Finally, for the musically inclined, you can create the show and then compose something yourself to go along with it.

There is a slippery slope here. Tweaking times too much can ruin the flow; just make sure the slide timing still fits the frame. In other words, don't make a single drastic change in one keyframe; spread out the change over several of the keyframes. This helps with the continuity and prevents bogging and choppiness. It may take a little extra time, but it helps dramatically in the final output.

In all honesty, just do what feels right. If complex, multiple movements and layers timed to specific note changes fit the show, that's awesome. If simple fade transitioning with someone humming a tune for the soundtrack fits, that's even better. It just comes down to how the overall package makes you feel. Fancy does not mean better, and in some cases it can be detrimental. Play around with ProShow, and experiment as much as possible. That's the best way to learn how to use the software, and you might create something amazing along the way.

Simona (Mona) Wiener

http://seemonasblog.blogspot.com

Mona is the owner and graphic designer of SeeMona's Blog, where she sells ProShow slide styles, transitions, and templates. She lives in the central area of Israel, not far from Tel-Aviv.

I enjoy working with multiple layers in one slide and creating attractive picture arrangements and animations.

In animations, the order of layers in the list is important because, as a rule, the upper layers cover the lower ones. The challenge is to find a good work-around for this limitation. There are many possibilities, including resizing the images, using masks, introducing images at different times, and playing with the opacity.

My preferred work-around is to trick the eye of the viewer. It's not what you actually see that matters; it's what you think you see.

I use this technique mostly in effects with picture stacks, where one image is pulled out of the stack, is displayed full screen, and then is put back in the stack, while another image gets to be displayed.

In such effects, no matter how carefully you arrange layers, some of the images will always collide in their way out of the stack. It is also quite obvious that a picture cannot be in two places at the same time: once under the pictures in the stack, and once on top of them, for the larger display.

To solve this problem, duplicates of each image are created and placed in the upper layers, above all the rest. Each main image performs all the motions that occur at the level of the stack. The duplicated image takes over when the picture needs to appear above the other pictures in the stack.

The trickiest part of this effect is to find the right spot and the right point in time where such a switch of images can take place, without the viewer noticing. This spot can be outside the screen area or on the screen, when the motion stops for a brief time. The switch can be accomplished through keyframes alone or a combination of keyframes and transparency.

When this effect is done right, the viewer believes that he sees just one picture that comes out of the stack and is being shown to him.

Index

A

accelerating motion, 190

access, Internet, 30

adding

 borders, 130–136

 linear motion, 91

 modifiers

 picture frames, !32–134

 styles, 63–64

 text to images, 138

 vignettes, 140–143

adhesive disc labels, 245

adjustments. *See also* modifying

 oscillation, 216

 transitions, combining, 210

ad speak, 10

albums, photographs, 252

aliasing, 180

aligning

 captions, 57–58

 images, synchronizing, 182

 objects, 45

 orientation, 183

 transitions, 165

alternating images, 52–53

amplifying emotion with music, 160

anamorphic video, 235

angles, shooting images at different, 121–122

angular agreement, 46

animation

 applying, 108–110

 captions, 59, 155

 GIFs, 110

 travel path, 212–214

applications, editing video, 3

applying

 animation, 108–110

 audio, 110–113

 canned effects, 143–144

 captions, 103–108

 crossfades, 97

 fake masks, 144–149

 images

 chopping up, 150–153

 multiple, 173–198

 pointers, 109

 sound effects, 170–172

 styles, 32–35

artistic styles, 17

attention, controlling, 149

audiences, 7–9

 storytelling to, 15–20

audio. *See also* music
 booths, 169
 formatting, 110–113
 motion, 68–69
 need for, 157–159
 reinforcement of emotions, 159–163
 synchronizing, 157–172
avoiding
 jumping, 196
 mixing sequential portrait and landscape
 images, 53
 pops, 168
 special effects, 61–62
 unnecessary words, 19–20

B

backgrounds, 41
 blurring, 202
 captions, 103, 137
 images, 89–91, 265
 modifying, 151
 motion, 71–72
 moving, 154
 music, applying, 160
 patterns, 91
 transparency, 187–188
 video, looping, 196–198
 vignettes, 141
balance, space, 43–36
barriers, 50
basic techniques, 77–115
 animation, 108–110
 audio, 110–113
 backgrounds, 89
 beginnings and endings, 78–85
 captions, 103–108
 common mistakes, 113–115
 image presentation, 85–95
 transitions, 96–103
beats, 163–166. *See also* audio; music
beginnings, 15, 78
 curtains, opening, 78–80
 movie reel intros, 80

best guesses, 34
bitsetting, 29, 239
black-and-white images, 65, 94–95
black points, 93
blending horizontal images, 184–187
Blu-ray discs, 27–30, 232, 240–243, 251.
 See also discs
blurring
 background images, 202
 radial soft focus, 204–205
 vignettes, 140–143
bobbing, 216
booths, creating audio, 169
borders, 42
 adding, 130–136
 photos, 92
 vignettes, 142–143
brightness, 221
broadcasting, 163
bullet points, 36, 107
 highlighting, 109
business, 40
buying music, 163

C

cameras
 point-and-shoot, 124
 shooting. *See* shooting photographs
 SLR (Single Lens Reflex), 124–126
canned effects, 143–144
captions, 19
 clarifying, 20
 formatting, 54–59
 Full Pan Up, 83
 keyframes, 201
 layers, animating, 155
 motion, 136–139
 motion picture-style, 80–81
 panning, 137–138, 201–202
 slides, 20
 styles, 33–34
 techniques, 103–108
 timing, 73–74

cellophane windows, 249

Chance, Stacey and Kelly, 277

checkerboard mask depth, 223

chopping up images, 150–153

chroma keys, video, 223

circular motion, 218

Clark, Jennifer, 266

clipping, 158–159

collapsible curtains, 203

colors, 94–95
 backgrounds, 90
 borders, 131
 captions, 56–57
 fading through, 99

color television, troubleshooting resolution, 31

combining
 adjustments with transitions, 210
 delivery methods, 230–231

common mistakes, 113–115

compatibility
 Blu-ray discs, 242
 DVDs, 29, 236–237

composition, 3
 cropping, 50
 illustrations, 47
 letterboxing, 42
 multiple images, 184

compression, video, 228

conflict, 11, 48

connections, troubleshooting, 30

consistency
 backgrounds, 90
 of captions, 59
 of timing, 72

content, 5
 deleting, 62–63
 optimizing, 117–124, 129–155
 selecting, 62

control flow of focus, 68

controlling attention, 149

copying
 images, 35–37
 templates, 83

copyrights, music, 161

Coultry, Barbara, 267

Cowan, Drew, 278–279

crane shots, 119

credits. *See also* captions
 scrolling, 83–85, 225
 still, 82–83

cropping
 images, 118–119, 130
 landscape images, 50

crossfades, 96, 97
 time-lapse photography, 127
 troubleshooting, 114

cues, transitions, 143–144

curriculum, 11

curtains, opening, 78–80

customizing
 multiple images, 191–196
 photograph albums, 252

cut transitions, 95–98, 101–102

D

dead time, 110

death by slide show, 21

defaults, captions, 34

delay, 111

deleting
 content, 62–63
 edges, 133
 specific sections of images, 150–153

delivery
 slide shows, 227–262
 techniques, 27–30

density, 40

depth
 of field, 125
 layers, creating, 148–149

design, 3

details of subjects, 265
dialog boxes
 Producer's Vignette, 132
 Slide Options, 33, 69, 167, 181
digital photography, 1
Digital Versatile Disc. *See* DVDs
dimensions, pixels, 25
discs
 packaging, 243–253
 PC playback, 233
 professionally manufactured, 254–255
 types of, 232–255
displays, widescreen, 50
dissolves. *See* crossfades
distractions, 150
distribution techniques, 27–30
documentation, 5
dollies, 119
dots per inch, 28
double images, troubleshooting, 86, 113
downloading trial copies, 77
DPI (dots per inch), 28
dragging transitions, 165. *See also* moving
dramatic stories, 16
drawing attention to, 149
Druffin, Jean-Pierre, 276
duration, modifying, 197
DVDs (Digital Versatile Discs), 27–30,
 228, 232–240
 Blu-ray on, 243
 compatibility, 29, 236–237
 packaging, 250–251

E

edges, 41–43
 deleting, 133
 vignettes, 140–143
editing, 25
 images, 128
 space, 60–61
 video, 3

effects, 2
 basic techniques, 77
 canned, 143–144
 fake masks, 148. *See also* fake masks
 Ken Burns Effect, 66
 keyframes, 86
 Layered Curtain Opening, 79
 panning, 137–138
 puzzle, 152
 sounds, 170–172, 265
 special, avoiding, 61–62
eliminating unrelated subjects, 18
elliptical motion, 218
emotions, 11–12
 audio as reinforcement of, 159–163
 stories, 14–15
encoding processes, 228
endings, 78
 formatting, 81–85
 of stories, 16
enlarging subjects, 177–183
enunciation, 167
equalizing volumes of tracks, 159
Etheridge, Kelli, 264–265
executable (*.EXE) output, 229
exploding text, 224
exporting styles, 34
eye candy, 47–48
eyedropper tools, 107

F

Facebook, 29, 259
faces, 48–49
 zooming, 67
fading. *See also* transitions
 audio, 110
 blank slides, 98–99
 captions, 106
 colorization, 99
 crossfades, 96–97
 multiple images, 181–193
 music, 81
 vignettes, 140

fake masks, 144–149

falling pieces using keyframing, 211

feedback, 166

feelings, 18. *See also* emotions

Fenimore, Dale L., 273–275

field of view, modifying, 44

files. *See also* images

 formatting, 229

 GIF, 110

 video, 255–257

film transitions. *See* transitions

Fisher, Jeffrey, 169

Flash video output, 259–260

flow of focus, control, 68

fly-ins/fly-outs, 106

focal flow, 46

focal points, 66

focus, 41

 cameras, 124. *See also* cameras

 radial soft, 204–205

 selective, 124–125

fonts

 selecting, 55–56

 two-font rules, 96

formatting. *See also* layouts

 animation, 108–110

 audio, 110–113, 157–159

 backgrounds, moving, 154

 beginnings and endings, 78–85

 canned effects, 143–144

 captions, 54–59, 103–108

 common mistakes, 113–115

 credits, 83

 delivery of slide shows, 227–262

 DVDs, 235–236

 endings, 81–85

 fake masks, 144–149

 files, 229

 full frame images, 87–89

 gaps, 172

 images, 85–95, 150–153

 layers, depth, 148–149

 multiple images, 173–198

narration, 166–170

picture frames, 132–134

processes, 23–25

progression, 53

sections, 20–22

sound effects, 170–172

spinning out and in, 99–100

transitions, 96–103

video, 228–229, 255–257

vignettes, 140–143

forums, 37–38

fps (frames per second), 28

frame rates, troubleshooting, 31

frames, 41–43

 glass, 203

 per second. *See* fps

 photos, 92

full frame images, 87–89

Full Pan Up caption, 83

fuzzy images, vignettes, 140–143

G

gaps, formatting, 172

glass frames, 203

goals, 5, 7–12

graphics, captions, 137. *See also* captions

Gray, Leslie, 268–270

grayscale images, 94–95

group pans, 71

H

HDTV, troubleshooting resolution, 31

head shots, 174–183

highlighting

 bullet points, 109

 images, 110

 subjects, 176–183

high-resolution, scaling images, 25

history

 of Blu-ray discs, 241–242

 of DVDs, 234

Hogan, Harlan, 169

holes, fake masks, 146–148
horizontal image blending, 184–187
hot keys, 35
human beings
 faces, 48–49
 portrait images, 50–54
humor, 9

I

ideas, 23. *See also* **projects; workflow**
illustrations, 47. *See also* **images**
images
 adjustments/transitions, combining, 210
 alternating, 52–53
 angles, shooting images at different,
 121–122
 backgrounds, 89–91, 265
 black-and-white, 65, 94–95
 blurring, 202
 borders, 92, 130–136
 canned effects, 143–144
 chopping up, 150–153
 cropping, 118–119, 130
 double, troubleshooting, 86
 editing, 128
 falling pieces using keyframing, 211
 frames, 92
 full frames, 87–89
 GIFs, 110
 highlighting, 110
 landscape transitions, 101
 modifiers, 214–219
 modifying, 90–91
 morphing, 155
 moving, 44
 multiple, 173–198
 head shots, 174–183
 horizontal image blending, 184–187
 objects, 174–183
 optimizing, 191–196
 orientation, 183
 transparency, 187–191
 video backgrounds, looping, 196–198

object wipes, 209
optimizing, 117–124
orientation, 264
parts of photos, modifying, 210–211
portraits, 50–54, 101
positioning, synchronizing, 182
presentation, 85–95
previewing, 27
quick image morphs, 208–209
radial soft focus, 204–205
rapid-fire shots, 126–127
reflections, 207–208
resizing, 25–27
scaling, 42
sequences, 126
shooting. *See* shooting photographs
side-by-side, 51–52
sliced adjustment layers, 207
sliced masks, 205–206
stylization, 143–144
subjects, moving around, 119–120
text, adding, 138
travel path animation, 212–214
upward panning, 224
vignettes, 140–143
importing styles, 34
ink-jet printable white discs, 247
Internet
 access, 30
 slide show delivery, 257–260
invisible layers, 220

J–K

jerkiness, troubleshooting playback, 31
jewel cases, 250. *See also* **packaging**
jumping, avoiding, 196

Ken Burns Effect, 66
keyframes, 86
 captions, 201
 falling pieces using, 211
 images, positioning, 182
 layers, 87

masks, 206
motion, 136–139
spinning out and in, 100
keys, hot keys, 35
Kodak, 2

L

labels
adhesive disc, 245
discs, 244
landing zones, 105
landscape images
cropping, 50
transitions, 101
layers
captions, 103, 155
curtain openings, 79–80
depth, creating, 148–149
invisible, 220
keyframes, 87
masking, 144
picture frames, creating, 134
sliced adjustment, 207
stacks, 206
subjects, enlarging, 180
video, 153–155
layouts, space, 46–50
length of slide shows, 22
letterboxing, 41–43
licenses, synchronizing, 162
LightScribe discs, 247–248
linear motion, adding, 91
live shows, slide show delivery, 260–262
looping video backgrounds, 196–198
lossy compression, 228
low-resolution, scaling images, 25

M

managing
production, 20
visuals, 17
workflow, 23–37

masks
fake, 144–149
rectangular, 206
sliced, 205–206
spotlight, 149
vignette, 185–186
master slides, creating, 83. *See also* **slide shows**
media, compatibility, 236–237
mediums, 8
messaging, 9–11
microphones, 168
Microsoft PowerPoint, 229
middles, 16, 78
mistakes, common, 113–115. *See also* **troubleshooting**
modifiers, images, 214–219
modifying
backgrounds, 151
duration, 197
field of view, 44
images, 90–91, 130
parts of photos, 210–211
sliced adjustment layers, 207
subjects, 177–183
transparency, 104
volume, 167
montages, symmetrical, 193–196
morphing
images, 155
quick image, 208–209
motion, 65–75, 71–72
accelerating, 190
audio, 68–69
backgrounds, 89, 154
captions, 136–139
examples, 70–72
flow of focus, control, 68
group pans, 71
history of, 65–66
keyframes, 86, 136
move and hold, 70
purpose of, 66–67
slow, 212

motion picture-style captions, 80–81
mouse hot keys, 35
Move and Hold, 70, 85–87
movement. *See* motion; moving
movie reel intros, 80
moving
 around photo subjects, 119–120
 backgrounds, 89, 154
 captions, 57–58, 136–139
 images, 44
 keyframes, 86
 Move and Hold technique, 85–87
 spinning out and in, 99–100
multilayer false perspectives, 221
multiple images, 173–198. *See also* images
 head shots, 174–183
 horizontal image blending, 184–187
 objects, 174–183
 optimizing, 191–196
 orientation, 183
 transparency, 187–191
 video backgrounds, looping, 196–198
 vignettes, 142–143
multiple subject overlays, 175–176
music, 5, 11–12, 110–113. *See also* audio
 copyrights, 161
 emotions, 160
 fading, 81
 and pacing, 75

N

narration
 captions, 74. *See also* captions
 optimizing, 166–170
 voice-over, 69
negative delay, 111
nested target depth, 223
NTSC standards, 32

O

objects
 aligning, 45
 highlighting, 176–183
 multiple images, 174–183
 positioning, 43–46
 sizing, 43
 wipes, 209
offsets, 110–111
online forums, 37–38
opening
 layered curtain, 79–80
 movie reel intros, 80
 simple curtain, 78
optimizing
 audio, 157–159
 multiple images, 191–196
 photos, 117–124
 source material, 129–155
 voice-over narration, 166–170
options, scrolling, 83
organizing
 visuals, 17
 workflow, 23–37
orientation
 images, 264
 multiple images, 183
oscillation, adjustments, 216
outlines, 56–57
overlapping music tracks, 111
overlays
 multiple subject, 175–176
 single subject, 175
ownership of music, 161

P–Q

pacing, 11
 music and, 75
 timing, 72–75
packaging
 Blu-ray discs, 251
 discs, 243–253

DVDs, 233–234, 250–251
 professional, 251–253
panning. *See also* **motion**
 captions, 137–138, 201–202
 fake masks, 145
 full frame images, 87–89
 group pans, 71
 transitions, 102–103
partial transparency, 188–189
parts of photos, modifying, 210–211
pasting, 35–37
patterns, backgrounds, 91
PC playback discs, 233
pendulums, 216
people. *See* **subjects**
perspectives, multilayer false, 221
Photodex, 21, 28, 30
 resources, 37
photographs
 albums, 252
 borders, 92
 editing, 128
 frames, 92
 glass frames, 203
 moving, 44
 optimizing, 117–124
 portrait images, 50–54
 post-processing, 128
 resizing, 25–27
 shooting. *See* shooting photographs
 stacks, 135–136
 time-lapse, 127
picture frames, 132–134. *See also* **borders;**
 images
pixels
 dimensions, 25
 resolutions. *See* resolution
placement of captions, 57–58
planning workflow, 23–37
playback, 227–262
 PC discs, 233
 real-time, 229–231

 troubleshooting, 31
 video, 227–229
plot twists, 17–18
point-and-shoot cameras, 124
pointers, applying, 109
points, 93
Polaroid borders, 132
pops
 avoiding, 168
 video backgrounds, looping, 196–198
portrait images, 50–54
 transitions, 101
positioning
 captions, 57–58
 faces, 67
 images, synchronizing, 182
 invisible layers, 220
 masks, 205
 objects, 43–46
 orientation, 183
post-processing photographs, 128
PowerPoint (Microsoft), 229
presentations
 images, 85–95
 rich-media, 2
pressed discs, 29
previewing
 images, 27, 44
 resolutions, 26
processes, 4–7, 23–25
Producer (ProShow)
 techniques, 199–226
 blurring background images, 202
 collapsible curtains, 203
 panning captions, 201–202
 photo frame glass, 203
 Vignette dialog box, 132
production sections, 20–22
product packaging, 40
professionally manufactured discs,
 254–255
professional packaging, 251–253

progression
 formatting, 53
 of images, 126
projectors, 29
projects, organizing, 23–37
Przybylski, Roberta, 271–272
purchasing music, 163
purpose of motion, 66–67
puzzle effects, 152
***.PX formats, 229, 257–258**

R

radial soft focus, 204–205. *See also* focus
ranges, volume, 159
rapid-fire shots, 126–127
Read-Only Memory, 29
real-time playback, 229–231
rectangular masks, 206
reflections, images, 207–208
regions, 44
**reinforcement of emotions, audio as,
 159–163**
related subjects, shooting, 122–124
removing. *See* deleting
rendering
 captions, 105
 video streams, 228
resizing
 captions, panning, 201
 images, 25–27, 130
 subjects, 177–183
 vignettes, 142
resolution
 frame rates, 28
 images, scaling, 25
 previewing, 26
 troubleshooting, 30–32
resources, searching, 37–38
reusable picture frames, 134. *See also*
 picture frames
rich-media presentations, 2
Ridout, Mark, 21

right-to-left transitions, 103
road trips, 108
rolling wheels, 217
ROM (Read-Only Memory), 29
rotation, 66, 222
royalty-free music, 162, 163. *See also*
 music
rules
 rule of thirds, 43–45
 two-font, 96

S

scaling images, 25–27, 42
scrolling, 201
 credits, 83–85, 225
searching resources, 37–38
sections, production, 20–22
segues, 172. *See also* **transitions**
selecting
 colors for borders, 131
 content, 62
 fonts, 55–56
 music for emotion, 160
 themes, 17
 transitions, 96
selective focus, 124–125
sepia tone images, 94–95
sequences, 126, 265
settings, 15
shadows, 56–57
shaking, 215
shapes
 transitions, 102
 vignettes, 140
sharing slide shows, 257
Sharpie markers, 245
shifting transitions, 102. *See also*
 transitions
shooting photographs, 117–124
 angles at different, 121–122
 cropping, 118–119
 horizontal shots only, 117–118

post-processing, 128
rapid-fire shots, 126–127
related subjects, 122–124
subjects, moving around, 119–120
side-by-side images, 51–52
silence, 172
silk-screened writable discs, 248–249
simple curtain openings, 78
simple photo borders, 131
simplicity, space, 60
Single Lens Reflex, 124–126
single subject overlays, 175
sizing
captions, panning, 201
full frame images, 87–89
images, 25–27, 130
masks, 205
objects, 43
subjects, 177–183
vignettes, 142
slices
adjustment layers, 207
masks, 205–206
Slide Options dialog box, 33, 69, 167, 181
slides
captions, 20
fade through blank, 98–99
spinning, 99–100
templates, 36
timing, 107
transitions. *See* transitions
slide shows
audio, need for, 157–159
canned effects, 143–144
definition of, 1
delivery, 227–262
endings, 81–85
fake masks, 144–149
images, 117–124. *See also* images
layered curtain openings, 79–80
length of, 22
motion picture-style captions, 80–81
movie reel intros, 80

multiple images, 173–198
narration, 166–170
photo stacks, 135–136
sharing, 257
simple curtain openings, 78
sound effects, 170–172
styles, applying, 32–35
tools, 129
slip covers, 249
slow motion, 67–68, 212
SLR (Single Lens Reflex) cameras, 124–126
smooth progression, 53
software, editing, 3
songs, 110. *See also* **audio**
sounds, 5–7, 11–12
effects, 170–172, 265
soundtracks
music. *See* music
narration, 166–170
source material, 129–155. *See also* **images**
space, 39–59
balance, 43–36
captions, 54–59
editing, 60–61
focus, 41
layouts, 46–50
portrait images, 50–54
simplicity, 60
special effects, avoiding, 61–62
spam, 11
special effects, 2
avoiding, 61–62
techniques, 220–226
specific sections of images, deleting, 150–153
speed, motion, 67–68, 190
spinning out and in, 99–100
spotlight masks, 149
stabilizers, 120
stacks
layers, 206
photographs, 135–136
standards, NTSC, 32

still credits, 82–83

still photography, 125. *See also* **photographs**

stories, 5, 13–22

 emotions, 14–15

 endings, 82

 telling, 15–20

streams, video, 228

structure of stories, 15

styles. *See also formatting*

 adding, 63–64

 applying, 32–35

 artistic, 17

 canned effects, 143–144

 captions, 33–34

 images, 143–144

subjects

 details of, 265

 highlighting, 176–183

 moving around, 119–120

 multiple overlays, 175–176

 shooting related, 122–124

 single overlays, 175

symmetrical montages, 193–196

synchronizing

 audio, 157–172

 beats, 163–166

 licenses, 162

 positions of images, 182

T

target audiences, 7–9

target masking, rotation, 222

techniques, 1–12

 adjustments/transitions, combining, 210

 animation, 108–110

 audio, 110–113

 backgrounds, 89

 basic, 77–115

 beginnings and endings, 78–85

 canned effects, 143–144

 captions, 103–108, 137–138

 common mistakes, 113–115

distribution, 27–30

fake masks, 144–149

falling pieces using keyframing, 211

images

 chopping up, 150–153

 presentation, 85–95

microphones, 168

modifiers, 214–219

Move and Hold, 85–87

multiple images, 173–198

narration, 166–170

object wipes, 209

parts of photos, modifying, 210–211

photo stacks, 135

Producer (ProShow), 199–226

 blurring background images, 202

 collapsible curtains, 203

 panning captions, 201–202

 photo frame glass, 203

quick image morphs, 208–209

radial soft focus, 204–205

reflections, 207–208

selective focus, 124–125

slices

 adjustment layers, 207

 masks, 205–206

slow motion video, 212

sound effects, 170–172

special effects, 220–226

spinning out and in, 99–100

transitions, 96–103

travel path animation, 212–214

vignettes, 140–143

television

 resolution, troubleshooting, 31

 widescreen displays, 50

telling stories, 15–20

templates

 copying, 83

 slides, 36

text, 19

 captions. *See* captions

 exploding, 224

formatting, 54–59
images, adding, 138
themes, 47
music, 75
selecting, 17
thoughts, 17–18. *See also* **emotions**
time-lapse photography, 127
timeline view, audio synchronization, 164
timing, 65–75
multiple images, 186
pacing, 72–75
photo stacks, 135
slides, 107
titles, 264
tone, 8
tools, 129
eyedropper, 107
topics, 21
segues, 172
tracking layers, 153–155
tracks
music, 110–113
volumes, equalizing, 159
transitions, 53
accelerating, 190
adjustments, combining, 210
captions, 105
crossfades, 97
cues, 143–144
cut, 95–98
double images, troubleshooting, 86, 113
dragging, 165
landscape images, 101
layered curtain openings, 79–80
panning, 102–103
portrait images, 101
puzzle effects, 152
right-to-left, 103
rotating, 66
shapes, 102
simple curtain openings, 78
techniques, 96–103

transparency
backgrounds, 187–188
caption graphics, 137
edges, deleting, 133
fake masks, 148
images, highlighting, 110
modifying, 104
multiple images, 187–191
partial, 188–189
sliced masks, 205–206
vignettes, 140
travel path animation, 212–214
trial copies, downloading, 77
tripods, 127
troubleshooting. *See also* **optimizing**
audio, 157–159
common mistakes, 113–115
connections, 30
crossfades, 114
double images, 86, 113
playback, 31
resolution, 30–32
two-window problem, 145
twists, plots, 17–18
two-font rule, 96
two-window problem, 145
types
of borders, 130–136
of cameras, 124
of discs, 232–255
of DVD media, 238
of files, 229

U–V

unnecessary words, avoiding, 19–20
unrelated subjects, eliminating, 18
upward panning images, 224

versions, 77
video
anamorphic, 235
backgrounds, 91, 196–198

video *(continued)*
 chroma keys, 223
 compression, 228
 editing, 3
 files, 255–257
 Flash video output, 259–260
 layers, 153–155
 letterboxing, 41
 playback, 227–229
 slow motion, 212
 transitions. *See* transitions
videographers, 9
viewing widescreen displays, 50
views, audio synchronization, 164
vignettes, 131, 140–143
 masks, 185–186
Vimeo, 259
visuals, 5–7
 organizing, 17
***Voice Actor's Guide to Recording at Home and On the Road, The,* 169**
voice-over narration, 69
 optimizing, 166–170
volume
 clipping, 159
 modifying, 167

W–X

waveforms, audio, 158–159. *See also* **audio**
websites, slide show delivery via, 257–260
Weiner, Simona (Mona), 280
white points, 93
widescreen displays, 50
windows
 cellophane, 249
 fake masks, 145–148
wipes, objects, 209
words, avoiding unnecessary, 19–20
workflow, managing, 23–37
writers, DVDs, 234

Y–Z

YouTube, 29, 228, 259

zones, landing, 105
zooming, 66
 faces, 67
 fake masks, 145
 spinning out and in, 99–100